MW00480212

WOMEN OF VICTORIAN SUSSEX

THEIR STATUS, OCCUPATIONS, AND DEALINGS WITH THE LAW

1830-1870

ALL RIGHTS RESERVED. NO PART OF THIS PUBLICATION MAY BE REPRODUCED, STORED IN A RETRIEVAL SYSTEM, OR TRANSMITTED IN ANY FORM OR BY ANY MEANS ELECTRONIC, MECHANICAL, PHOTOCOPYING OR RECORDING OR OTHERWISE WITHOUT THE PRIOR WRITTEN PERMISSION OF THE PUBLISHER. © HELENA WOJTCZAK 2003

The Hastings Press

PO Box 96 Hastings TN34 1GQ
hastings.press@virgin.net
www.hastingspress.co.uk

Published December, 2003

ISBN 1 904 109 05-5

Set in Garamond 11pt.
Printed and bound by T. J. International, Padstow.

Covere: A wealthy lady, typical of the kind who carried out philanthropic or charity work. Wearing a beautiful watered silk dress, she was photographed at the studios of Hennah & Kent, King's Road, Brighton, in 1864. Reproduced courtesy of Roger Vaughan.

WOMEN OF
VICTORIAN SUSSEX

HELENA WOJTCZAK

The Hastings Press

HELENA WOJTCZAK BSC (HONS) was born in Shoreham-by-Sea and grew up in Brighton and London. While working for the railway she took a degree in social sciences, specialising in psychology, followed by three years' postgraduate study in social and oral history. She has been a Consultant Historian to the National Railway Museum, for which she co-wrote a major exhibition on female railway workers in 1996-7. In 1998 St Mary-in-the-Castle Arts Centre, Hastings, displayed her research on the suffrage movement and in 2002 she wrote and produced an exhibition on Victorian Working Women for Hastings Museum. Helena has written and designed two award-winning history websites: *Railway Women in Wartime* and *Women of Hastings and St Leonards* and has contributed to several others including *The Victorian Web* and *Encyclopedia Titanica*. She has been featured in newspapers and magazines, and has appeared on BBC television and Radio 4. Helena has previously written for the Oxford University Press, the Railway Ancestors Family History Society, the Hastings Press and Hunter House Publishing, as well as for various magazines. She lives in St Leonards.

Forthcoming books:
Railwaywomen: The Story of a Forgotten Workforce (2004)
Down and Out in Victorian Sussex (2005)

CONTENTS

ACKNOWLEDGEMENTS

I am grateful to Denise Davies, Kevin Carias, John Owen Smith and Tom Gillham for help with computing; to Eric Bond Hutton for reading through an early draft; and to Adrienne O' Toole for repairing the cover photograph.

Thanks also to Gordon Cowell for practical assistance including cross-county chauffeuring and for helping to search some primary sources in Chichester and Brighton.

HELENA WOJTCZAK
ST LEONARDS - ON - SEA, DECEMBER 2003

PREFACE

Sussex is bounded on the north by Kent and Surrey, on the east by Kent, on the west by Hampshire, and on the whole of the south side by the English Channel. It is oblong, measuring about 75 miles by 28. Having its long side on the coast, it is hardly surprising that fishing and shipbuilding have loomed large in the county's history.

Sussex grew wheat, beans, cabbage, oats, hops, barley and turnips, and its sheep, oxen and cattle were renowned. It produced oak timber, limestone, gunpowder, potash, and salt. Owing to the mild climate, figs were cultivated at Worthing. Among the county's manufactured goods were paper, brushes, brooms, beer, cider, coaches, gloves, candles, brick and tiles, pottery and tobacco-pipes. Sussex folk were engaged in currying and tanning leather, distilling, soap-boiling, charcoal and coke-burning, and flour grinding.

However, by the 1860s the county's most important industry was tourism, chiefly sea-bathing.

The population of Sussex more than doubled between 1801 and 1851. Brighton was the fastest-growing town in Britain: between 1801 and 1841 its population increased from 7,000 to 46,000 and then to 90,000 over the next 30 years to become the largest settlement in Sussex. Hastings was the second largest town; it grew from 10,000 inhabitants in 1831 to 23,000 by 1861. The county's only city, Chichester, had just under 9,000 inhabitants in 1861, while the capital, Lewes, was home to 9,500.

A Note on Sources

My research encompasses the years 1800 to 1870, but little relevant material is available before the 1830s. From then the census, local newspapers and trades directories began to make their appearance. Over the next 40 years the population grew exponentially, creating a massive increase in trade, employment, and crime. Slim trade directories became fat tomes and the census grew to enormous proportions. An increasing number of newspapers was produced and they increased in volume. From 1870 the amount of available material had become unmanageably large.

Prior to the introduction of National Insurance in 1911, little documentary evidence existed in relation to employment and particularly to that of women. Most surviving records relate to areas of economic activity in which women rarely featured – for example income tax, apprenticeship indentures, pensions, and civic appointments.

The most obvious sources of information are the censuses, but these are not as useful or reliable as one might wish. A census was taken only once every ten years, and anything that began and ended in between two censuses went unrecorded. It was quite usual for a business to be owned by a woman for less than ten years. A spinster might open a shop and give it up upon marriage; a widow might run a business from the death of her husband until her eldest son took over.

Censuses relied heavily on people's honesty and accuracy, and some were prone to lie, especially if they objected to officials prying into their private affairs. A good many people, especially the illiterate and the destitute, did not know where or when they were born. (One man enumerated in Hastings in 1851 did not even know his name.)

Historians now accept that the mid-19th century censuses grossly underestimated women's employment. *This was partly because social factors led people to lie or to withhold information, but also because of regulations about recording wives' paid work. (More will be said about this later.) While the censuses should be treated with caution, they still provide the most extensive information regarding employment.

Street and trades directories are a fruitful resource. Every available directory for Sussex from 1800 to 1871 was searched in the preparation of

* See Edward Higgs' *Making Sense of the Census* and Stephen Inwood's *A History of London,* p445.

this volume. Although they are riddled with inaccuracies, omitted more businesses than they included, and were published at irregular intervals, they are a rich source of information on women in business. David Foster kindly let me see his PhD Thesis: *Albion's sisters: A study of trades directories and female economic participation in the mid-nineteenth century*, (University of Exeter, 2002). Mr. Foster discovered women following 774 different trades in 626 towns, either as proprietors or employers.

The third most useful source of information was newspapers, although reading them was rather like looking for a needle in a haystack. The sections richest in information about women's occupations and their involvement with the law were the magistrates' and county court reports and the classified section. The latter revealed details of jobs offered and included advertisements from women publicising their businesses.

I had already searched every issue of Hastings' local newspapers from 1848 (the first issue) until 1870 for an earlier project (*Women of Victorian Hastings*). As a result, this book contains an abundance of material from that area, especially within the chapter on crime. It was clear from reading newspapers covering the rest of the county that the activities of women in Hastings were no different from those elsewhere in Sussex. Hastings was the county's second largest town, and although Brighton was larger, it was too cosmopolitan and too susceptible to outside influences to be considered typical.

Very few unpublished documents were found. The most fruitful source in this category were the historico-biographies, histories and anecdotal reminiscences of Thomas Brandon Brett, a journalist residing in St Leonards in the 19th century. These are held in Hastings Reference Library. I also found a considerable amount of data in Hastings Museum relating to female licensees, compiled by the late John Manwaring Baines. Lastly, Hastings Library holds an unpublished diary of a girl who worked in a milliner's shop in the 1860s. Neither of the county record offices nor other local studies libraries held any primary sources similar to these.

The internet was the most accessible source. It yielded a list of workhouse matrons' duties, a description of a gaol-keeper's work, an article on prostitution, and some details of two Sussex women hanged for murder.

The least useful sources were other secondary source publications, even local history books. However, a few passing references to Sussex women were found and are included.

All of the trade advertisements and press cuttings are from Sussex newspapers and trade directories of between 1830 and 1870.

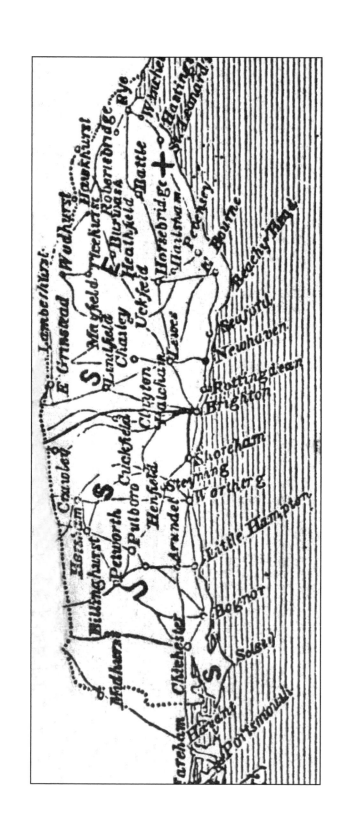

A MAP OF SUSSEX IN 1837

◆

THE STATUS
OF
WOMEN

◆

THE FOX AND THE GRAPES

ELDERLY SPINSTER. 'So you're going to be married, dear, are you? Well, for my part, I think nine-hundred-and-ninety-nine marriages out of a thousand turn out miserably; but of course every one is the best judge of their own feelings.'

Punch magazine's comment on Old Maids, 1861.

1: THE STATUS OF WOMEN

The history of men has been palmed off on us as universal history.

DEIRDRE BEDDOE
PROFESSOR OF HISTORY, 1998

History books specifically about women are needed to rectify the omissions of other works. The history of women is not adequately covered by books that focus on men because, since records began, women were subject to special laws and social customs which governed every part of their lives. History books usually concentate on the people with power and, as most women had none, they are largely absent. Omitting to explain that women were straight-jacketed at every turn by legal disabilities and man-made social structures may lead readers to assume that women's absence from civic life, big business and the professions was voluntary. It was not.

Our knowledge of women's past has been obscured by most published social history. When writers mention a farmer, a shopkeeper, a publican, or a philanthropist, for example, they habitually cite men and the reader is led to believe that no women existed in those categories, and to assume that they were all either housewives, mothers or domestic servants. Even books specifically about women generally focus on monarchs, courtesans, or those involved with the arts.

Owing to women's near-absence from most local and national history books, we are heavily dependent upon primary sources to discover our female predecessors. However, these can be misleading. For example, the 1792 Sussex Directory seems to indicate that the county was devoid of women. Not one female name appears; even the midwives were male! In fact, women were the majority of the population. The problem was that the only people listed were under the headings: corporation, magistrates, overseers, jurats, freemen, clergy, physicians, and law, and women were barred from all civic positions and all professions.

In 1831 Sussex was home to 135,325 males and 137,002 females. The

latter comprised 50.3% of the population. By 1851 the female majority had risen to 50.8%, with females outnumbering males by 5,300. Ten years later 53% of the county's inhabitants were female.* This figure was not uniform throughout the 20 districts. In the eight where men predominated, it was by 1-2% but, in the nine female-dominated areas, the difference was as great as 10.3%. There were more men in rural areas, where the work available was mainly agricultural, and many young women had left for the lively and exciting seaside towns, where domestic work was plentiful. The most male-prevalent area was Horsham, where men comprised 52.8%; the most female-prevalent area was Hastings, where 60.3% of the residents were women. Brighton was 60.2% female, Steyning 56%, and Worthing 54%. In Hastings, women outnumbered men by 3,174; in Brighton, by 9,202; in Steyning, 1,613; and in Worthing, 965.

There are several reasons why Sussex had a gender imbalance greater than the national average. The county's temperate climate and beautiful watering places attracted rich spinsters and widows. Among the wealthy there were twice as many females as males living in Brighton and Hastings, and these ladies employed a large number of domestic servants, the vast majority of whom were female.

The districts in which two-thirds of the population was female were in Brighton, central Hastings, and St Leonards where in one area (that encompassing Marina, Caves Road, West Ascent and Gloucester Lodge) there were 554 males and 1098 females — and that included two boys' boarding schools, which bolstered the number of males.

In central Hastings in 1871 there were 831 females and 462 males, and women comprised 80% of the residents of its prestigious Wellington Square. The owner of a millinery shop at 4 Castle Street was the sole male in a household of 14, comprising his wife, five milliners, two saleswomen, two dressmakers, a mantle-maker, a cook and a housemaid. In St Leonards, the heads of 14 of the 16 households at Upland Views and The Lawn were female, and only 10% of the villas' residents were male.

Another factor that boosted the number of women in certain seaside towns was the large number of institutions – such as schools and convalescent homes – located there. As well as having many female inmates, female nurses, orderlies, matrons, schoolmistresses and servants were employed in them, and many had female proprietors.

* In that year, 1861, females outnumbered males nationally by over half a million.

Women were concentrated at each end of the social scale: in Hastings in 1851, 78% of the gentry, and 90% of the paupers were female.

The numerical superiority of women was obvious to the most casual observer, for the streets were busy with servants on errands, and women served in most shops and filled the churches. One visitor remarked in the *Hastings & St Leonards Chronicle*:

> Everyone knows that St Leonards has this similarity to Paradise: 'that there is neither marrying nor giving in marriage', the female population prepondering (sic) at the rate of about five to one.

To correct the numerical imbalance in the sexes, some wanted to send husbandless women to the colonies, where many men lacked wives; indeed, in 1848 the *Hastings & St Leonards News* published a notice urging 'surplus' women to emigrate, and the *West Sussex Advertiser* carried advertisements offering female servants free or assisted passage to Australia.

WOMEN'S SPECIAL STATUS

Victorian England was a class-ridden society. Most of us are aware of the 'Upstairs Downstairs'* image of social divisions, but popular history tends to gloss over the other fundamental division in society: the huge gulf between the social and legal status of women and men.

All women shared a special status as *females,* and all women suffered particular disadvantages with regard to law, marriage, money, business and employment, regardless of social class. It could be contended that women had no social class on their own account, but derived it from fathers and husbands.

In 1887 Eleanor Marx and Edward Aveling wrote, 'Women are the creatures of an organised tyranny of men, as the workers are the creatures of

* A television programme set in the early 20th century, depicting the contrast between the toil and drudgery in the servants' gloomy basement *Downstairs* and the lives of luxury and privilege led by their employers *Upstairs*.

an organised tyranny of idlers'.[1] There is much powerful evidence to support that view. Men established certain rules and customs that severely hindered women from owning, earning or inheriting wealth, forcing most to be dependent upon, and subservient to men for their survival. Although, owing to loopholes in the system, a small proportion of women did inherit money or property, the odds were stacked heavily against them, because fathers routinely bequeathed to sons (partly because anything left to a daughter would later pass to her husband). Sons also succeeded to hereditary titles and family businesses.

Positive discrimination is widely believed to be a modern idea; in fact Victorian men practised it with great zeal, reserving for themselves every position of power, authority or influence, with the single exception of monarch. Even then the system was devised so that a woman succeeded to the throne only in the absence of a male sibling. And when a woman did become monarch in 1837 it did not improve the status of her female subjects. Queen Victoria chose to concentrate on being a wife and mother and was, from 1861 until her death in 1901, in mourning for her late husband. Worse, in middle age she emerged as a fervent and vocal opponent of the women's rights movement. When Lady Amberley expressed her views on the emancipation of women, the Queen wrote:

> I am most anxious to enlist everyone who can speak or write to join in checking this mad wicked folly of 'Women's Rights', with all its attendant horrors, on which her poor feeble sex is bent forgetting every sense of womanly feeling and propriety. Lady Amberley ought to get a good whipping.[2]

Only men could be MPs, town commissioners, councillors, freemen, aldermen, members of Boards of Guardians, judges, magistrates, overseers, coroners, jurors, solicitors, police officers, journalists, civil servants, university professors, physicians or clergy.* Every decision about public policy, every law and bylaw, every rule and regulation was made by men without consulting women and only men were permitted to interpret and administer the decisions of the men in power.

Until the 20th century, only men could vote for members of parliament. Entitlement to vote was, historically, based on property qualifications, yet a

* The only female Lord of the Manors of Brighton was Lady Amherst. Research is needed to establish what (if any) power or influence this gave her.

female landowner such as Lady Frances Elphinstone of Ore Place – a widow with 530 acres who employed 15 men – was denied the vote, while some of her own labourers were enfranchised in 1867.³ Some progress was made in 1869, when the Municipal Reform Act gave female householders the vote in municipal elections – but only if they were spinsters or widows.

Woman's place in society was a battlefield upon which competing ideologies strove for dominance. Some people challenged the narrow lives of women and argued for greater opportunities; others believed vehemently that women should be restricted to domestic work and child rearing. This subject (known as 'The Woman Question') was discussed endlessly in newspapers, magazines and journals, in parliament and at home. A single issue – that of women being trained and employed as watchmakers – dominated the letters pages of one Sussex newspaper for several months in 1857. Few jobs were performed by both sexes and, where they were, women were paid about half the wages of men for the same work.

Every aspect of women's behaviour and personality was scrutinised, manipulated and governed by rules and directives to a degree never attempted with men. Frances Power Cobbe pointed out in 1869 that while men could be whatever they turned out to be, women had to be moulded into what men wanted them to be:

> That a woman is a Domestic, a Social, or a Political creature; that she is a Goddess, or a Doll; the 'Angel in the House,' or a Drudge… all this is taken for granted. But, as nobody ever yet sat down and constructed analogous hypotheses about the other half of the human race, we are driven to conclude … that she is made of some more plastic material, which can be advantageously manipulated to fit our theory about her nature and office …
>
> We have nothing to do but to make round holes, and women will grow round to fill them; or square holes, and they will become square. Men grow like trees, and the most we can do is to lop or clip them.⁴

Coventry Patmore, a one-time Sussex resident, wrote a very popular poem in the 1850s entitled *The Angel in the House*, in which he presented his submissive wife as the stereotype to which all women should aspire. Meek, humble and tranquil, she lived only to please her husband. Women who fell short of this idealised stereotype were heavily criticised.

Men regarded women as intellectually inferior to them and held this to be self-evident. Women were expected to live contentedly in a state of

perpetual childhood, passively accepting the actions and decisions of men, to whom they were supposed to be happily subservient. Many women accepted this. One, Eliza Lynn Linton,* reflected a view of women that was popularly held when she wrote in her 1860s book, *Ourselves*:

> No true-hearted woman that ever lived, who loved her husband, desired anything but submission. It is the very life of a woman's love – her pride, her glory, her evidence of self-respect.

Women and men were believed to be completely different, and this was reflected in every aspect of public and private life, even in relation to fairly trivial matters. It was deemed, for example, that female railway travellers needed women-only carriages and waiting rooms; some hotels – notably the Queen's at Hastings – offered separate coffee rooms for men and women, while some churches – such as Christ Church, St Leonards – had separate pews for each sex.

Cultured men pretended to defer to women, using gallantry and flattery, but this was a matter of class not gender. As Marian Ramelson has pointed out: 'The same gentleman who would stoop to pick up a lady's handkerchief would pass a maid struggling to carry an over-loaded coal scuttle without a thought that he should assist her.'[5]

The only aspect of life in which women were expected to be superior to men was morality, particularly with regard to sexuality. Women were supposed to be pure of heart, mind and body, which entailed pre-marital chastity and marital submission without enjoyment. While men fell easily into immorality, women were expected to uphold moral standards. This expectation made it even more shocking when women showed themselves to be human, too, and fell from grace.

Women's poor status was not entirely the result of ancient legislation. For example, an Act of 1835 ended the right of unmarried women who were qualified (by property) to vote in parish-based elections (such as for Poor Law Guardians), and an Act of 1857 reaffirmed that men, but not women, could obtain a divorce solely on the grounds of adultery.

* Eliza Lynn Linton (1822-1898). Well-known anti-feminist writer and novelist.

THE EDUCATION OF GIRLS

In every social class and level of income, boys' education was considered to be of greater importance than that of girls.

Poor children learned what little they needed to know about life from parents or grandparents. Some attended a school run by an unqualified 'Dame'; these were of dubious educational worth and acted more as crèches for the under-sevens. Education was not taken seriously and would be abandoned as soon as any paid work was offered. Fathers who had skills educated their sons or apprenticed them to their own trade, while neglecting their daughters, because their 'trade' was marriage. As part of the training for her future career, a daughter had to help with the household chores and was frequently kept away from school to assist mother with the weekly wash.

Schools concentrated on teaching boys academic subjects while girls were directed towards domestic work. At Duke Street Charity School in Brighton, for example, 'the boys are instructed in reading, writing and arithmetic, and the girls receive that education whose tendency is to render them virtuous and useful members of society.'

As a result of the lesser importance of girls' education, literacy was lower amongst girls than boys, especially in the earlier part of Victoria's reign. Between 1837 and 1838 prisoners in the Lewes House of Correction were tested on their reading and writing skills. Only 10% of those who could read and write well were female. Of the eighteen female inmates in Hastings Gaol in 1850, half could neither read nor write. As late as 1871 a quarter of English brides (compared with one in ten bridegrooms) were illiterate to the extent that they could not even sign their names and had instead to write an X beside their names in the parish register.

Well-off families engaged a resident governess until the children were old enough to attend a private seminary or boarding school. While boys learned a wide range of subjects including moral philosophy, Greek, Latin, geometry and science, girls were taught domestic and arts subjects with the overt intention that they would make pleasing and useful companions to men and graceful ornaments in society generally. Frances Power Cobbe's parents sent her to Miss Poggi's 'Exclusive Establishment for Young Ladies' at 32 Brunswick Square, Brighton, a fashionable and expensive boarding school, for two years (1836-8). The fee was £1,000, the same as it cost to send a boy to Oxford University for three years. Despite this, she found

'There was no solid instruction, no real mental training'.[6]

Some middle class girls never attended school but were taught charming accomplishments by a governess at home, after which they might attend a finishing school, perhaps in France or Switzerland.

The exclusion of girls from large inheritances, academic education and highly paid trades was considered both fair and acceptable because a woman was expected to marry and be supported by her husband. Therefore, the best way for parents to help their daughters was to teach them how to attract a marriage proposal from a man with a title, wealth or, at the very least, good prospects. Because females outnumbered males, young women were in fierce competition with each other to secure the best men. To win, a girl had to be (or to pretend to be) exactly what men wanted: feminine, modest, chaste, meek and, above all, compliant to the wishes of others.

Given the numerical imbalance of the sexes, not all women could marry, leading Jessie Boucherett to call the system 'wicked and cruel, and based on a fallacy'.[7] She and many other feminists argued that women should be allowed to attend training colleges and universities, so that they could follow a career if marriage proved elusive. However, doctors claimed that women were mentally and physically unsuited for education. Too much thinking and studying would overstrain their brains, and it would almost certainly render them infertile. Besides all this, an educated woman with opinions was a fearsome prospect for most men and her matrimonial prospects were negligible. As historian Lee Holcombe put it, ' "Strong minded" was one of the most abusive terms that could be applied to a woman.' [8]

Girls were raised to obey and any sign of rebellion was swiftly crushed. It was legal for parents to beat children and, in the late-18th century, Judge William Blackstone had ruled that husbands could administer 'moderate correction' to disobedient wives. Indeed, the greatest control an Englishman in the mid-19th century could gain over another human being was by marriage.

MARRIAGE

Under exclusively man-made laws women have been reduced to
the most abject condition of legal slavery in which it is possible
for human beings to be held ... under the arbitrary domination of
another's will, and dependent for decent treatment exclusively on
the goodness of heart of the individual master.

DR FLORENCE FENWICK MILLER. [9]

Despite its romantic image, marriage in the early-19th century was hardly
better than slavery, hidden under many layers of hypocrisy. Like a slave, a
wife lost her identity, was stripped of her property, had no rights to her own
children and could not leave without her master's permission.

Although marriage was disadvantageous to them, most women wanted
to marry. Spinsterhood constituted failure, and women were indoctrinated to
believe that marriage was their God-given purpose in life. It was essential for
a woman to be married in order to be seen as both mature and respectable.
In the mid-19th century, 86% of women married at least once.

Women were under considerable monetary as well as social pressure to
marry. A middle class woman without an inheritance had so few
employment possibilities that she was obliged to marry for financial support.
In 1854, the Sussex-born feminist Barbara Leigh Smith described this as
'legal prostitution' because a wife could not withhold consent to sex.

A wife lived under 'coverture'. This meant she surrendered her legal
existence upon marriage: she was a *feme covert* (from the Anglo-Norman: *feme*,
'woman' and the Old French *covert*, 'covered', or 'hidden'.) In 1765 Judge
William Blackstone had explained a wife's legal position:

> By marriage, the husband and wife are one person in law: that
> is, the very being or legal existence of the woman is suspended
> during the marriage, or at least incorporated and consolidated
> into that of the husband: under whose wing, protection, and
> *cover,* she performs every thing; and is therefore called ... a *feme-
> covert.*[10]

Wedding vows were devised by men. They included a promise by the wife to obey her husband.* Such a promise, sworn before God, was considered binding by most women. In return, men vowed 'with all my worldly goods I thee endow', but, ironically, the opposite was true. Upon marriage, a woman's personal property, that is, money from her earnings or investments and belongings such as furniture and jewellery, was automatically transferred to the control of her spouse, who could dispose of it however he saw fit. All income from a woman's real property (that is, property held in the form of freehold land), also passed under common law to her husband, though he could not dispose of it without her consent.

If a married woman had a business, it belonged in law to her husband, even if she alone had provided the capital and ran it without his involvement. Her husband was entitled to its profits and was responsible for its debts. A married woman's legal inability to make contracts in her own name made running a business difficult in some circumstances. She could not enter into a business partnership after marriage. She could not sue or be sued unless her husband was also a party to the suit; nor could she sign contracts unless he joined her.

Wives had no right to execute a will. Only with their husbands' consent could they bequeath property. A husband could bequeath his property as he chose, including that which had been his wife's before marriage. He could even bequeath his house and leave his widow homeless.

To prevent a rich woman's family's assets from passing to her husband, a prenuptial marriage settlement could be made under equity law to enable a wife to retain control over her property. This was the only separate property that married women could own. Settlements could be obtained only by wealthy women, because the courts would not deal with any cases involving less than £200. As Master of the Rolls Sir George Jessel put it in 1869: 'The laws of this country were made by the rich and for the rich and wealthy women had no cause of complaint.'[11]

Many men felt that wives should not be allowed any money of their own and a fiancé might refuse to agree to a marriage settlement. In 1849 the House of Commons received a petition advocating the abolition of settlements, calling them 'the most fertile source of domestic unhappiness'

* Only since the late 20th century could women omit that promise from their wedding vows.

and arguing that by 'placing her in a position of independence' they enabled a wife to 'break the vows she made at the altar': that is, the vow to obey.[12] In 1860 *The Times* argued that 'such settlements are not to be encouraged ... They tend to destroy the true relation between husband and wife ... The power which a woman obtains is too great'.

The wages, savings and any windfall received by a working class woman belonged exclusively to her husband. Barbara Leigh Smith pointed out the injustice of this in 1854:

> Upon women of the labouring classes the difficulty of keeping and using their own earnings presses most hardly. In that rank of life where the support of the family depends often on the joint earnings of husband and wife, it is indeed cruel that the earnings of both should be in the hands of one, and not even in the hands of that one who has naturally the strongest desire to promote the welfare of the children.[13]

Stripping women of property had both social and psychological consequences. It served as a constant reminder of their lowly position in society, as historian Lee Holcombe explains:

> By depriving married women of property the law deprived them of legal existence, of the rights and responsibilities of other citizens, and thus of self-respect ... In short, the law placed married women in the same category with criminals, lunatics, and minors as being legally incompetent and irresponsible.[14]

While a wife was obliged to hand over all her money and property to her husband, her spouse was legally required to provide her and their children only with bed and board. This was mainly to prevent them from becoming dependent on the parish. A man was obliged to support his wife only if she lived in the conjugal home; if a battered or otherwise ill used wife left her husband, she forfeited her rights to his financial support.

The Poor Law Relief Act of 1834 provided that the cost of any parish relief – including bed and board in a workhouse – was to be considered a loan repayable by the husband. One man, George Prince, obliged the parish to maintain his wife and five children by leaving them in Westhampnett workhouse in 1857, even though he earned a good wage (£35 a year). He preferred 14 days' hard labour to having them back, saying his wife was 'too extravagant'. James Geering of Hastings left his wife and six children in

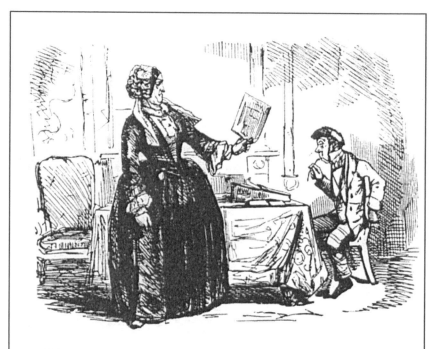

FILLING UP THE CENSUS PAPER

WIFE OF HIS BOSOM. 'Upon my word, Mr Peewitt! Is this the Way you Fill up your Census? So you call Yourself the "Head of the Family" – do you – and me a "Female?"'

Punch magazine, 1861.

1870. He too was summoned to court to repay the parish the money given to his family, who had been living in the workhouse. In his defence he explained that his wife prostituted herself, and the shame led him to work his passage on a fishing vessel to Devon, where he set up home. He invited her to join him in Brixham, where no one knew of her notoriety, but she refused. Nevertheless, he had to reimburse the parish £13.

Under coverture a husband was responsible for any debts his wife incurred with tradespeople and shopkeepers. This was known as 'pledging a husband's credit' and it covered only food, lodging, clothing, medical attendance and medicines, all of which had to be suitable to the couple's social class and station in life. If his wife left him, a husband was required to publish a notice in the local newspaper stating that he was no longer responsible for her debts. This would act as a warning to tradespeople not to give her any more goods on credit, but it brought shame upon the family for it publicly displayed a marital breakdown.

The law considered a husband responsible for his wife's actions as though she were a child. Charles Dickens alluded to this aspect of coverture when he wrote in *Oliver Twist*: 'The law supposes that your wife acts under your direction,' to which Mr. Bumble made his now-famous retort: 'If the law supposes that, the law is a ass – a idiot'.[15] One example of this law in action concerns Jane Young and Anna Churchill. They had a brawl and were brought in front of the Chichester magistrates in 1855, who bound over their husbands in sureties to guarantee the good behaviour of their wives for six months.

The requirement for a wife to obey her husband in all things was put forward as a powerful reason to refuse women the parliamentary vote. The argument ran that it would be giving every married man two votes, since his wife had to obey him. In the House of Commons in 1867, when John Stuart Mill MP made the first speech and presented the first petition demanding votes for women, the Attorney General, Sir John Karslake, argued that married women would be excluded because of 'the husband's dominion over his wife's movements.' Worse, perhaps, was the prospect of a wife making up her own mind. Sir John asked Mr. Mill how he proposed to deal with political differences between 'the head of the family and her whom the poet called "the lesser man".'[16] *

* At the end of the debate, 73 MPs voted for women to be enfranchised, while 196 were against.

SURNAMES AND TITLES

In common with African slaves in America, 'the lesser man' was expected to abandon her surname and take her husband's, but women were also expected to take his forename and be known as, for example, 'Mrs. John Smith', to signify that her identity had been completely obliterated by that of her husband. Newspapers would announce a child born to 'the wife of John Smith' rather than to 'Jane Smith'. An interesting exception occurred in town directories, where workhouse and gaol* matrons married to masters were nearly always given the dignity of a separate listing, as in: 'John Smith, Master; Jane Smith, Matron'.

A single instance of a couple being known as Mrs. and Mr., rather than the other way round, was discovered in an advert in the 1870 Sussex trades directory, placed by the Bakers, a couple in business as clothes dealers in Duke St, Brighton.† Their advertisement is reproduced on page 57.

MARITAL STRIFE

Brutality to wives, common in former centuries, was becoming taboo by the Victorian era, at least among the educated classes. When in 1849 a London man petitioned parliament 'to restore the ancient and venerable institutions of our ancestors, in the shape of the whipping post and the ducking stool … as a punishment for all undutiful and runaway wives',[17] no support was forthcoming. And yet a certain amount of violence by husbands was permitted, but only if his wife 'deserved' it, and provided that he used no more force than was necessary to bring about obedience. It was widely believed that a man could legally beat his wife provided that, if he used a cane or stick, it was no thicker than his thumb and only if he felt it was justified. Such 'justification' could include an unsatisfactory meal or his wife's refusal to obey a trivial command.

Marital breakdown was a source of shame and embarrassment for genteel persons. Among the wealthy, estranged couples would sometimes discreetly lead separate lives rather than let the world know of their marital failure. Having a spacious home meant a warring couple could keep well away from each other in separate rooms, suites or wings. The aristocracy might even live in separate houses. Well-brought-up gentlemen and ladies did not enter into public slanging matches; although mental, emotional and

* The Victorian spelling of jail, which will be used throughout this book.
† The 1871 Census confirms that they were a married couple and not, for example, mother and son.

physical abuse occurred, it was easier to keep private. Exposing such behaviour in the courts would have severely damaged a family's reputation.

Among the poor, in their huddled tenements and cottages, there was no escape from the spouse with whom relations had broken down. One or both parties might seek refuge in alcohol, which served to fuel tempers further. Noisy domestic fights were so common that women's screams were routinely ignored in rough neighbourhoods. A certain level of violence was the norm in working class communities and most people were ready with a fist if provoked. Parents, teachers and neighbours hitting children and husbands beating wives constituted, in most cases, what was considered no more than routine chastisement. If a woman felt that her husband's violence was excessive she might seek protection from magistrates, who would bind him over in sureties to keep the peace. Failure to comply could lead to a prison sentence.

If an unhappy wife ran away her husband could capture and imprison her in his house and 'enforce his conjugal rights' – i.e have sex without her consent – with the blessing of the law. It was not until a test case in Clitheroe in 1891 that a judge ruled that a husband's imprisonment of his wife was illegal. This ruling, said one observer, 'Without any change by statute, reformed the common law and set the woman free'. He continued, 'Old-fashioned lawyers were shocked, and asserted that this was the end of marriage'.[18]

A man who deserted his family might serve three months with hard labour – a heavier sentence than was given in some cases of sexual assault – if he forced her into dependence on the parish.

SEPARATION AND DIVORCE

Until 1857 divorce was available only to the wealthy because it cost about £700 (about 14 years' wages for a poor man or nearly 25 years' for his female counterpart) and required an Act of Parliament; indeed, only four British women had ever obtained a divorce. From 1857 the cost had reduced to about £80, placing it within the reach of some middle class people.* A man had only to prove his wife's adultery, but adultery alone was insufficient grounds for a woman to divorce her husband. Indeed, a man might openly flaunt a string of mistresses and spend his wife's earnings or inheritance on them, while his wife was powerless either to prevent it or to divorce him.

* The poor were eventually catered for by the Matrimonial Causes Act, 1878, which allowed a less costly judicial separation but without the right of remarriage.

When a working class marriage broke down, leaving to set up home elsewhere was not an option for the vast majority of wives. Not only was it almost impossible for a woman to financially support herself and her children, but also she would be a social outcast. Sometimes the wife went 'home to Mother'. In Hastings in 1851, Mrs. Veness' father sued his son-in-law for £13, the cost of feeding and lodging his daughter and her children after she left her husband. He lost the case because he should have sent his daughter back to the marital home.

Even after 1857 divorce was still too expensive for the working classes. Edward Warden, a Sussex fisherman, was taken before magistrates for refusing to maintain his wife, who was living in adultery with another man. When he explained that he could not afford the £80 needed to divorce her, the magistrate advised him that the only way to evade prosecution was to invite his wife to return to live with him.

If a husband left his wife he was legally entitled to reappear at a later date and take any furniture, possessions or savings that she had worked for and accumulated in his absence, together with any money she may have inherited, and any earnings, and leave her again, even taking the children with him, if he felt so inclined.

Partly owing to a campaign founded by Barbara Leigh Smith, from 1857 a husband who deserted his wife lost his right to her earnings. However, the new law applied only to a husband who had deserted his wife. If the husband repeatedly left but returned within a specified period of time, he was still deemed to be the legal owner of everything she had, as Mrs. Betteridge of Eastbourne discovered in 1866. She applied to be protected from her estranged husband, who was due to be released from prison. He had returned three times before, and each time had sold everything that she possessed. She pleaded for a protection order to prevent her husband from robbing her a fourth time. The magistrate declined, saying, 'The bench have no power to do that, as your husband has not deserted you'. Mrs. Betteridge replied, 'No Sir, I wish he had,' eliciting peals of laughter from the heartless spectators in the public gallery. The magistrate explained that he had 'no authority to grant such protection'. If she could not come to an arrangement with her husband for them to live separately, she had better 'resort to the Divorce Court'.[19]

One marital breakdown that scandalised Sussex concerned the elopement of Mrs. Heaviside, a mother of three young children who was one of the leading fashionable ladies of Brighton. She lived with her husband, Captain Richard Heaviside, a magistrate, at 15 Brunswick Square.

In 1840 she ran away with the Reverend* Dionysius Lardner, a well-known scientist and professor of Natural Philosophy and Astronomy at London University. The powerfully built, 6-foot-6-inch Captain Heaviside, his father-in-law and four manservants followed the couple to the *Hotel Trouchet* in Paris, where they forcibly removed Mrs. Heaviside. After giving the Reverend Lardner the worst beating of his life, as a final insult, they threw his wig onto the fire. The Paris press commented that 'rarely has a fracas given more satisfaction'. On their return to England, the husband was hailed as a hero: 'Everybody in Brighton expresses himself highly delighted with the course pursued by Captain Heaviside', remarked a local newspaper. Heaviside sued Lardner at Lewes Assizes and won £8,000 in damages.

Brighton historian Antony Dale noted that:

> The aspect of the whole affair that seems to have most shocked contemporaries was that Mrs. Heaviside was bound to inherit £13,000 on the death of her parents, and could not be prevented from doing so by any legal means in her parents' or her husband's power.[20]

Mrs. Heaviside ran away a second time with Lardner. They went to the USA, where he undertook a lecture tour that earned him £40,000. On their return, Lardner was cited in the Heaviside divorce case and was forced to pay damages of £38,000 to the captain. In 1849 Mr. Lardner married Mrs. Heaviside (they'd had to wait for his marriage to be dissolved) and they settled in Paris, where they had two children.

The most titillating divorce case in Sussex during the mid-Victorian era was that heard at the Court of Probate and Divorce in 1872. The plaintiff was a well-known perfumer and hairdresser called Charles Septimus Ravenscroft. He was the inventor of hair gel, and his patent rotatory hair-brushing machine was exhibited at the Hastings Industrial Exhibition in 1865. Secretly he pursued many extra-marital affairs behind the façade of his respectable hairdresser's shop at 33 White Rock Place, Hastings, (now Salmon's bookshop).

His life of 'whoredom, adultery and profligacy' with clients and staff began soon after his marriage in 1863. An affair with Annie Stent was

* He was not a clergyman; he had once been a college chaplain. He is best remembered today for his writings on the dangers of railway travel, which is curious because Captain Heaviside was a director of the London & Brighton Railway.

followed by one with Miss Cox (described in court as 'a sufferer of *nymphomania*'). She made out a will in his favour and, shortly afterwards, died mysteriously in Ravenscroft's house, leaving him a handsome bequest. (Later, he used this money to attempt to bribe witnesses not to testify against him in his divorce case.) More affairs followed. Shop assistant Miss Blackman secretly witnessed Ravenscroft engaging many times in sexual intercourse with Mrs. Wood in the kitchen of his salon during 1866. An affair with Miss Noriss was followed by another with ladies' maid Julia Sharpe, with whom 'relations' took place during her brief visits to his shop while on errands for her employer. She later became his house-servant and they had a daughter in 1867. The court heard that he gave her 'a certain illness arising from illicit intercourse.' His next liaison was with Miss Holding, resulting in a child born at Brighton in 1869. His shop assistant Miss S. Mecklereid, a Scotswoman fifteen years his junior, twice became pregnant by him, miscarrying once and producing a child the second time.

Having enjoyed at least seven affairs resulting in four pregnancies and three children during his seven-year marriage, Ravenscroft divorced his wife in 1870 on the grounds of *her* adultery with two men (simultaneously). One, a boy of 16, was ordered to pay £100 damages to Ravenscroft, as the injured party. After his divorce Ravenscroft, then 50, lived with Miss Mecklereid but the 1871 Census shows no child living there.

It is interesting that, despite the prevailing sexual morality and notions of prudishness amongst Victorian spinsters, Ravenscroft nevertheless managed to persuade several single women to have sexual relations with him, even though he was a married man in his forties at the time. The prosecution's explanation was that he 'exercised the most extraordinary, the most sinister influence, on every woman he came across'. It is also interesting that, despite his scandalous behaviour having been made public, Ravenscroft continued to run a successful hairdressing business until about 1885. A serial adulteress would not have fared so well.[*]

[*] During his years of womanising, Ravenscroft was twice summonsed in 1866 for keeping an unruly pet. The newspaper headline: *The Playful Dog of White Rock,* was uncannily apt and, like Ravenscroft himself, the dog was said to have been 'a great favourite with the ladies'.

WIFE-SELLING

The famous wife-selling scene in Thomas Hardy's *The Mayor of Casterbridge* was not as far-fetched as one may think. Some 400 cases of public wife selling are documented in Britain between the 17th and the early 20th centuries. It was widely believed that if a husband placed his wife in a halter, led her through a turnpike gate of a market, and publicly sold her before witnesses, the transaction was legal.[21]

The *Sussex Weekly Advertiser* described several cases. At Ninfield in 1790 a man sold his wife for half a pint of gin, handed her over next morning in a halter, but changed his mind and bought her back 'at an advanced price'. At Lewes in 1797, a blacksmith sold his wife to one of his journeymen 'agreeably to an engagement drawn up by an attorney for that purpose'. At Brighton in February 1799 a Mr. Staines sold his wife to a Mr. James Marten for 5s and eight pots of beer.

Harry Burstow mentions wife selling in his *Reminiscences of Horsham* (1911). In about 1820 a Mrs. Smart was sold for 3s 6d. She was bought by a man named Steere, and lived with him at Billingshurst. She had two children by each of her husbands. Steere afterwards discovered that Smart had parted with her because she had 'qualities which he could no longer endure', and Steere, discovering those same qualities, sold her to a Mr. Greenfield. At Horsham's November Fair, in 1825, a journeyman blacksmith exhibited his wife for sale. A good-looking woman with three children, she was sold for £2 5s, the purchaser agreeing to take one of the children. About 1844 Ann Holland (known as 'pin-toe Nanny') was sold for £1 10s. Some people hissed and booed; others took it good-humouredly. She was bought by a Mr. Johnson, who sold his watch to raise the money to buy her. Nanny lived with Johnson for one year, during which she had a child, then she ran away — finally marrying a man named Jim Smith, with whom she apparently lived happily for many years.[22]

Hardy noted in his *Commonplace Book 3* that in May 1826 a wife was sold at Brighton market for a sovereign and four half crowns. She had two children; the elder was retained by the husband while the baby was 'thrown in' as part of the deal. The sale was entered in the Brighton market register, and the purchaser paid a shilling to the auctioneer, and a shilling for the halter. It was reported that the woman seemed perfectly happy and went off with her new master with her infant in her arms.[23]

LIVING IN SIN

Unmarried cohabitation – usually called living 'in sin' – was widespread among the lower working class. Drunks, the destitute, prostitutes and beggars lived together without being married, the woman sometimes taking the man's surname. The marital status of such persons went unnoticed unless they had some involvement with officialdom. For example, in a child-neglect case at Heathfield, all three couples who acted as prosecution witnesses were found to be raising children out of wedlock. In another case, Mr. and Mrs. Lee were exposed as living 'in sin' only when they were arrested for being drunk and disorderly in Eastbourne in 1865. It emerged that Savina Lee had borne 11 children in 16 years while leading an insecure and unpredictable lifestyle as a travelling scissors-grinder. (They each received seven days' imprisonment, for which 'Mrs. Lee' expressed her thanks to the magistrates.)

Mrs. Swift of Wadhurst left her husband in 1848 and cohabited with Josiah Weeks for 21 years, bearing three children by him. Their situation became known to officials only when Mr. Weeks ceased to maintain the children and Mrs. Swift complained to the magistrates. He was ordered to pay 1s a week for each child until the age of 13, but they ruled that the order would become null and void should Mrs. Swift return to her husband.

The rector of Burwash expressed concern in 1857 about a situation in his parish in which a recently widowed man with several children (including a two-month-old baby) had engaged a young woman as housekeeper. The rector feared that the girl was in a vulnerable position. He wrote: 'The cottage is small & the family large & the chances of sin are very great; indeed the chances that sin is committed become almost a certainty.'[24]

Some otherwise 'respectable' people in the poorer classes did not share the bourgeoisie's belief in the necessity of a wedding ceremony. This was especially the case when one or both had separated from their spouse and taken up with someone else. Had divorce been obtainable, they would have married their new partners.

Harriett Marchant and James Edwards are an example of such a couple. Mrs. Marchant was a widow with small children, and Mr. Edwards was living apart from his wife. They cohabited very happily in Worthing in the 1840s. They were both very hard working – he a fisherman, she a fishmonger – and between them accumulated assets in the form of fishing boats, nets, and good furniture. As a sign of their devotion they each made wills naming the

other as sole beneficiary. When Mr. Edwards was killed (in the Lalla Rookh sea disaster),* Mrs. Marchant died of grief a few weeks later, at the age of 39.

Under the heading 'Housekeepers Beware', the *Eastbourne Chronicle* reported a case in which a woman was accused, perhaps falsely, of living 'in sin'. Mrs. Gray married a Mr. Hickes in 1863. They quarrelled frequently, and she left him in 1865, reverting to her first husband's surname. Two years later, she took a job in Wadhurst as housekeeper to a farmer called Mr. Shackel. In 1869 her husband sued for divorce on the grounds of her adultery with her employer. Several witnesses – among them friends, visitors and indoor servants – testified that they had seen no evidence of impropriety between the two, but the judge awarded the divorce. There was no proof of adultery, but the judge decided that Mrs. Gray was guilty of 'improper intimacy' with Mr. Shackel on the following evidence:

> They took their evening meals together, rode out together, and slept in adjoining rooms. They had a common household and a common purse, and externally lived precisely as man and wife.[25]

Mr. Shackel had to pay all the costs of his housekeeper's divorce, and the judge rebuked Mrs. Gray in the following terms:

> What was her object in taking up her abode in a farmhouse with an unmarried man! ... No respectable married woman, who had a character to preserve, would expose herself to the imputations which must arise from her cohabitation with an unmarried man for such a length of time.[26]

The clergy tried in vain to prevent unmarried cohabitation. The Reverend John Egerton of Burwash found that, at a wedding on Christmas Day 1857, 'The witnesses were a man & woman living in open sin, but we cannot refuse them or if we could the couple to whom they were witnesses would never have been married.'[27]

Living 'in sin' was less common among the superior classes. Marriage was important to them with regard to lineage and inheritance, and living 'in sin' would have outraged their families and their genteel acquaintances. The higher up the social scale, the rarer it was, but examples exist for all classes.

* See page 135

William Eldridge, a brewer and farmer of Tivoli Road House, St Leonards, had four children by Louisa Barnett, a woman 13 years his junior who appears in the 1851 Census as his housekeeper. Benjamin Smith MP (the father of Barbara Leigh Smith) had five illegitimate children with Annie Longden and, after her death in 1834, raised them himself at Pelham Crescent, Hastings.

WIDOWS

Until the early 1800s, widowed women were described as 'relics' of their late husbands and took the title 'Widow' followed by his surname. The change began in the late 18th century; for example, a 1792 Sussex trades directory shows 'Widow Bellingham' and 'Widow Purfield', but 'Ann Dawes' and 'Sarah Boxfold' (who were also widows). By 1830 the practice had almost completely ceased and widows retained the married form: 'Mrs.' (pronounced *Mistress*). Generally, the style 'Mrs. John Smith' signified that her husband was alive, while 'Mrs. Jane Smith' meant she had been widowed; however, this was not set in concrete, for some married businesswomen used the latter style.

The impact of widowhood upon a woman depended on her financial position. Those with wealth might find themselves independent for the first time in their lives. Widows regained the legal status of *feme sole* and were free to manage and establish businesses and to secure freehold land. A widow who remarried could protect her property with premarital settlements. This autonomy made widows less desirable as brides, compared to unmarried women.

A widow was entitled to a dower, which was usually equivalent to one-third of her husband's estate for her lifetime. The Dower Act of 1833 shifted the balance to favour men; it deprived widows of rights over their husbands' estates and allowed the real property to be left to male heirs. Also, a man could convey his property to trustees to avoid dower attaching. Widows usually received substantially less valuable property than male heirs.

Amongst the landless middle or working classes, widowhood could plunge a relatively prosperous family swiftly into destitution and a widow might have to join the ever-increasing ranks of needlewomen and governesses. Widows with small children were usually left in dire straits. In the 1860s Ann Russell, of 1 Lavatoria, St Leonards, had to go out charring to support her five small children (the youngest of which was aged just one month), as well as her mother-in-law, who lived with her. A woman with no one to mind the children was in an even worse predicament. At Clapham,

near Worthing, Mrs. Reeves' late husband had been gardener to Sir George Pechell, upon whose estate they inhabited a tied cottage. When Mr. Reeves died in 1855 his wife and five infant children had to move out. Only the £4 she received from her husband's benefit club stood between herself and the workhouse. The Clapham overseer* promised that the parish would give her 7s 6d a week for a year and advised her to move to Worthing. But on arrival, she was told by the Worthing overseer that she could claim only at Clapham. She returned there, only to be told that, having moved away, she was no longer Clapham's responsibility. In desperation she appealed to Worthing magistrates, who said sympathetically that her reliance on the overseer's statement had 'thrown her on the world as a helpless and hopeless pauper', and they referred the case to their legal advisors for guidance. A local newspaper remarked that Mrs. Reeves had been 'knocked back and forth like a shuttlecock' between the two overseers, adding that 'the woman and her five children are almost starving.'[28] †

Because widows were so often left in a desperate financial situation, they were a popular choice for philanthropy. The Duke of Somerset built and endowed almshouses for 22 poor widows of Petworth, giving each a room and £20 per annum. Margaret Horsfield of Rye bequeathed £100 at 4% interest for the benefit only of widowed women. The fund was administered by the Rye Corporation, the Borough treasurer distributing the interest to about 16 needy widows each Christmas.

* An overseer managed the spending of the parish rates.
† Unfortunately, I have not been able to trace the outcome of this sad case.

SPINSTERHOOD

The unmarried woman is *somebody*; the married, *nobody*.

ANN RICHELIEU LAMB, *OLD MAIDISM,* 1844

The 1851 Census revealed that 30% of adult women were spinsters. Although most would marry eventually, because of the enormous numerical imbalance in the sexes there were insufficient men to go around, and not every woman could find a husband.

In 1850 the Registrar General's statistics showed that women had the highest chance of marrying between the ages of 20 and 25. From 25 to 30 they had a 33% chance and after 30 the figure dropped dramatically and then dwindled until it reached almost zero. Of 27,483 single persons who married in 1848, only one was a spinster aged over 60. However, twice as many widows as widowers remarried, and they appear to have had a taste for 'toy-boys': of those widows aged 50 and over who contracted a second marriage, more than three-quarters married men younger than themselves. Thus, widows were taking some of the 'stock' of eligible men, exacerbating the shortage of potential husbands for younger women.

The spinster was a figure to be pitied. Louisa Garrett Anderson[29] wrote about attitudes in the 1860s:

> To remain single was thought a disgrace and at thirty an unmarried woman was called an old maid. After their parents died, what could they do, where could they go? If they had a brother, as unwanted and permanent guests, they might live in his house.

Not only had a spinster failed in the marriage stakes, she was also thought to be deprived of her chief purpose in life: motherhood. Because of this she was often encouraged to find work involving children – as a nurseymaid or a teacher – to compensate for her loss.

There were few charitable organisations for the spinster, but some women's provident societies were in existence. One, the 'Female Provident Assurance Company', was advertised in the Sussex press. With a capital of £100,000, its aim was 'To secure to women who may be unmarried at the age of 40, or upwards, an independence for the rest of their lives, by

payment of a small premium for five following years commencing at any age from birth up to 30.' Parents could buy this insurance for their daughters, and the policy would pay them either a marriage dowry or a spinster's pension.

UNMARRIED BY CHOICE

While most spinsters were women left 'on the shelf' after all the available men had chosen wives, a number stayed single by choice. Some did so to retain their inheritance and independence, others were members of religious orders. A few 'suffered' from what was then called 'sexual inversion'; that is, they were lesbians. The veil of secrecy over sexual matters in the Victorian era makes identifying them almost impossible, especially as it was acceptable and common for women to set up home with a female friend, and to form close friendships, many of which were platonic love affairs.

One devoted couple was Joanna Thwaites and Mrs. Stevens. Miss Thwaites was born in 1802, the 11th of 14 children and her inheritance was sufficient to support her for life. She became attached to a widow, Mrs. Stevens, and they lived together in Hastings for 30 years. The devoted pair shared a bedroom until 1891, when Mrs. Stevens became ill and the doctor advised Miss Thwaites to sleep in another room. Mrs. Stevens died and Miss Thwaites, heartbroken, followed her less than 30 hours later.

A spinster had control of her property and was not troubled by childbearing. She kept her name and her independence. Those with money were answerable to no one and could do as they pleased.

Frances Power Cobbe, who lived part of her life in Brighton, was a lifelong spinster. After her father's death in 1857 she used her (modest) inheritance to make an eleven-month journey through Italy, Greece, Egypt, Palestine and Syria, defying convention by camping alone in the desert.

Flower painter Marianne North, a daughter of the MP for Hastings, Frederick North, used her inheritance to travel six continents alone, starting at the age of 41. She created hundreds of beautiful paintings and paid for a gallery to be built at Kew Gardens to house them. The North Gallery still stands, and is among the most popular attractions at Kew.

PREGNANCY & CHILDBEARING

'Tis the old, old story,
Told so often in vain,
For man all the freedom of passion,
For woman the ruin and pain.

BALLAD (ANON)

For most women, marriage marked the beginning of a life of repeated pregnancies and childbearing. They had control or choice in the matter only if their husbands chose to grant it them. Wives could not withhold consent to sex; advice on contraception was illegal and its practice considered immoral. Therefore, a large proportion of wives were pregnant or breast feeding from wedding day to menopause. Motherhood was expected of a married woman. It confirmed that she had entered the world of womanly virtue and female fulfilment. A childless wife was the object of pity, and was liable to be labelled inadequate, a failure or abnormal.

In the middle of the 19th century, the average married woman gave birth to six children and over a third had eight or more. Sarah Nabbs bore and raised at least 16 while she was landlady of the *Pilot Inn,* Hastings. Mrs. Isted of Burwash had 13 children in the first 15 years of her marriage (including a set of triplets), and Mrs. Pennals, also of Burwash, had '15 alive & well' in 1859.[30] Fewer children were born to the upper classes, indicating either that some educated people knew about birth control, or that opportunities for conception were fewer.

Babies were born at home, but those of the destitute were often born in the workhouse infirmary. One poor woman even gave birth in a police cell at Rotherfield on Christmas Day, 1868. Working class women were attended by a local unqualified midwife or nurse; the rich were attended by a qualified (male) medical physician. Maternal deaths in 1847 were reported as one in 140 but were actually much higher[31] and one in six children died before its first birthday – they comprised between 26% and 40% of all deaths. It was common for a woman to lose at least one child, although poor Mrs. Emblow of Hastings lost all four of hers in their infancy. Improvements in the conditions of childbirth began around mid-century but it took time for anaesthetics, chloroform and antiseptics to come into common use, and even longer for them to be extended to poor women.

Until 1839, any child born within marriage was the sole possession of

the father. The mother had no rights at all. If he so wished, a father could remove 'his' children permanently from their mother's custody, and deny her any access to them. Only an unmarried mother had rights of custody of her children.

An Act of 1839 allowed a divorced but 'innocent' wife custody of her children up to the age of seven (raised to 16 in 1873).* An adulterous wife had no rights to her children; the same conduct by a husband did not affect his rights.

NON-MARITAL SEX AND ILLEGITIMACY

Contrary to popular myth, there was a lot of premarital sex in the mid-19th century, and also many illegitimate children: they made up about 7% of all births in England around the mid-century.† Statistics for Sussex are not available, but it was recorded that in Burwash illegitimate births made up 8% of the total between 1821 and 1857.[32]

The likelihood of premarital sexual activity was heavily determined by social class. Middle and upper class girls were kept at home and chaperoned when they went out. They needed to be protected from impropriety in order to secure a good marriage by offering themselves as virgins. Working class girls were out in the world, earning their living and going about unaccompanied, and therefore were much more vulnerable to seduction.

The most vulnerable of all were domestic servants. Girls started work as young as eight and were habituated to obey their employers. Servants' domestic duties often obliged them to be alone with a man in his bedroom or in other intimate surroundings. Add to this the economic hold that men held over their servants, and it is not surprising that many thousands were seduced by flattery, false promises, bribery, cajolery, or threats. William Acton wrote in 1870:

> Men who themselves employ female labour, or direct it for others, have always ample opportunities of choice, compulsion, secrecy, and subsequent intimidation, should exposure be probable and disagreeable. They can, for a time, show favour to their victim by preferring her before her fellows; they can at any convenient moment discharge her.

* The Infants Custody Act of 1886 made the welfare of children the determining factor in deciding questions of custody, but even then the father remained during his lifetime the sole legal guardian.

† In 1870 there were 5,000 illegitimate births in London.

Acton also reported that, in rural areas, 'the seduction of girls is a sport and a habit with vast numbers of men, married and single, placed above the ranks of labour.' There were instances in which a girl who was promised marriage by a young man of her employer's class allowed intimacy on that basis; and others in which a girl was brutally raped.

Rarely, a male servant seduced a girl belonging to his employer's family. Miss White was an orphan living with her highly respectable aunt and uncle in Yapton. She was a pretty girl of 18, just 4'11" with delicate features, who had been well brought up and given a superior education. In 1840 she was seduced by her uncle's footman. Shocked and ashamed, she stole £11 and ran away to Chichester, dressed in clothes belonging to her brother (then at Cambridge University studying theology). Masquerading as a man she lived in a lodging house until the money was almost spent. Then she bought a smock – the typical attire of the Sussex farm labourer – and walked the 65 miles to London, begging all the way and sleeping outdoors. She gained employment in the workrooms of a mendicity society,* but soon became too ill to work and entered Kensington Workhouse, where she received medical attention for eight days before her sex was discovered.

Back on the streets, she was later charged with being a rogue and a vagabond and sent to Westminster's Bridewell prison, which was terribly overcrowded and had been heavily criticised for 'the mixture of prisoners of all habits together, the diseased with the healthy, the dirty with the clean, debtors with felons, the moral evils are more distressing than the physical'. The surgeon's medical inspection must have been perfunctory, for Miss White again managed to pass as a man. For six weeks she lived, slept and worked alongside male prisoners, picking oakum† and taking her turn on the treadmill. One day the turnkeys searched the prisoners so intimately that Miss White's sex was discovered. Even then, she insisted her name was 'George White'. It is astonishing that she was not found out sooner, as she was so petite and pretty, and had tiny hands and feet. Indeed, the turnkeys had had difficulty finding shoes to fit her. Lieutenant Tracey, Bridewell's governor, was shocked and bewildered to learn that she had been 'in the large baths at the ordinary times of the male prisoners, and yet none of them had the least suspicion of her sex'. After hearing her story Lieutenant Tracey

* A charitable society that helped beggars and the destitute.
† Oakum picking involved teasing out the fibres from old hemp ropes. The resulting material was sold to the navy or other shipbuilders. It was then mixed with tar and used to seal the lining of wooden ships.

pronounced that Miss White had 'endured every conceivable privation' in the six months since she left Yapton. She explained that she had run away because she had perceived herself to be ruined, having been robbed of her virginity. The case thrilled newspaper readers all over the UK, and the press dubbed Miss White 'The Sussex Boy-Girl'.

Although pre-marital sex was disapproved of, premarital pregnancy was fairly common among the lower working classes, especially in rural areas. If they were of the same social class, the couple usually married; if not, the girl was sent away to give birth and the child given up for adoption, or raised by its grandparents. Among the upper classes girls had less freedom and were chaperoned and so, of course, premarital pregnancies were rare.

Terminating a pregnancy was illegal but this did not prevent desperate women from trying various methods to induce miscarriage. Hot baths and gin were reputed to work, and Kearsley's Original Widow Welch's Pills –'a safe and certain remedy in removing those obstructions' – were advertised on the front page of the *Sussex Gazette*, though their efficacy is doubtful. Back-street abortionists were known to exist all over England, although no evidence was found of any in Sussex during this research.

An unmarried mother was in a pitiful social and financial predicament. It was quite usual for her to be dismissed from her job, outcast from her family, abandoned by her seducer, and excluded from charitable support. As a result, most poor, single mothers faced destitution and the workhouse. Most unusually, 15-year-old Eliza Martin of Ewhurst was allowed to continue working while raising her child, no doubt because it was the result of a seduction by her employer's son, who was ordered by magistrates to give her 2s a week towards the child's upkeep. It was perhaps easier for a woman with her own business; for example, Maria Ranger seems to have brazened it out in the 1830s: she ran a lodging house in Hastings while raising her daughter Elizabeth. Maria was herself the offspring of an unmarried mother. She had been born in 1801 at Crowhurst, where half the births that year were illegitimate.

In a very few cases women had several illegitimate offspring. If the children had different fathers, the women were almost certainly prostitutes. Spinster Selina Dennard of Hastings was recorded in 1866 as raising, single-handedly, eight illegitimate children. In 1851 West Firle Workhouse housed Elizabeth Bullard, aged 31, and her five illegitimate children aged 11, 10, eight, five and twelve months. Similarly, Ann Hall, a former servant, was that year living in Hailsham Workhouse with her four illegitimate children.

AFFILIATION

The Poor Law of 1733 stipulated that a father was responsible for the maintenance of his illegitimate child. This was later thought to encourage female immorality and sole responsibility for such children was shifted onto women by the Bastardy Clause in the Poor Law of 1834. From that time a woman could no longer bring a man to court to induce either marriage or maintenance payments. This was intended to promote chastity but all it did was to make more children dependent on the parish, so the law was reversed in 1844 enabling a single mother to apply to a magistrate for an affiliation order (see page 167). She was required to present corroborated evidence of paternity, which the man could dispute. The women frequently lost the case. A girl whose seducer was a soldier or sailor was in a worse predicament because a man serving in the forces was exempt from affiliation orders. The process was criticised by a social investigator in 1870:

> The law, in its terrible determination to discountenance immorality, does nothing whatever to mitigate the misery of the mother of an 'illegitimate' child, by compelling the father to support either her or her offspring. All he has to do is to keep out of the way; and even if he be discovered, the amount demanded of him is so ludicrously inadequate for the maintenance even of a baby, that the wretched woman would rather rely on his 'generosity,' or on some supposed lingering pity or passion that he may still retain for her, than separate herself from him for ever by appealing to a legal tribunal for her *rights*.[33]

If she was successful, the father was ordered to pay up to 2s 6d a week 'child support', (or 3s for twins). This was supposedly half the cost of raising a child but it did not take into account the woman's dismissal from work, or the refusal of charities to give any assistance to unmarried mothers.* A woman might also claim about 10s from the father to cover the expenses of confinement, including a midwife's fee.

BABY FARMING

Because children 'begotten in sin' were believed to inherit their parents' moral weakness, orphanages refused to accept 'bastards', although they constituted the largest number of destitute children. Some illegitimate babies

* The first charitable homes for unmarried mothers appeared in the 1880s.

were 'farmed out' to a foster mother. This was a private financial arrangement without state involvement. Many of these babies died mysteriously and subsequent court cases and contemporary writings about baby farming make it clear that, in many cases, the mother expected the foster mother to let the baby die by neglect or malnutrition.

Deaths of illegitimate infants under 12 months of age were disproportionately – and suspiciously – high, and were not investigated too vigorously by the coroner. Bastards, as they were called, were likely to become dependent upon the parish and the death of one was regarded by some as a lucky escape for ratepayers.

In 1854 widow Doloris Boura took in a child aged 17 days and was paid 10s a week by its parents, who resided in London. As a wet nurse, she fed the child from her own breast. After its death at the age of about five months the Brighton coroner, unable to establish a scientific cause of death, attributed it to 'a visitation from God'.

The following year the Hastings coroner enquired into the death of nine-week-old Mary Jane Tester Akehurst. An affiliation order had been granted two weeks earlier, ordering George Tester to pay towards raising the child. The baby was left at her uncle's house in Wellington Mews, and was breast-fed by his wife Sarah. The child's mother, Mary Akehurst of Marine Parade, said, 'Either on Wednesday or Thursday last (I forget which) I saw the child and nursed it. It appeared quite well. Yesterday I saw it again and it was then dead'. Sarah explained, 'Some food and the breast were given to it, and it was then put in its basket by the fire, with a shawl partly over it ... In the morning I found the child dead.' The surgeon said that he believed the child died from convulsions. The jury immediately returned a verdict of 'Death from convulsions.' It is interesting to note that the baby was farmed out when just one week old and her mother did not visit daily, despite living close by.[34]

INFANT DEATHS

Infant deaths were particularly prevalent among the poor and inquests revealed considerable ignorance among impoverished mothers. Babies slept in drawers and boxes, or alongside their parents, where they were often crushed or smothered to death during the night. Many were underfed, often by mothers who were themselves desperately malnourished. In 1851 Maria Wenham's third illegitimate child died, aged 24 days. The Hastings coroner declared that the child was emaciated and had starved to death.[35]

Many poor mothers, owing to their own ill health, were unable to

produce sufficient milk and had no idea what to feed their babies as a substitute. Caroline Clifden of St Leonards fed her newborn on boiled bread and sugar until its death a few weeks later. The coroner said that the child had died as a result of being given 'injudicious' food.[36] In 1857 another inquest found that a Chichester child had died from eating 'too hearty a meal of sheep's head, which is very indigestible'. In another case, Frederick Hutson of Firle was an illegitimate child whose mother had left him with his father's parents while she went to London to seek work as a servant. The couple, named Taylor, fed him on beef tea, raisin wine, arrowroot and cake. When the child starved to death aged 17 months he weighed just 14 pounds. The Taylors were charged with manslaughter.

Some children died from being given medicines or drugs. In Newick in 1840, a child that died after being fed two spoonfuls of laudanum by its grandmother was recorded as an 'accidental death'. Lucy Relf of Burwash died in 1858 after being given gin at the age of seven months. The coroner's jury judged the death 'natural'.[37] At Heathfield in 1860, Eliza Piper's illegitimate child died after a well-meaning neighbour administered a homemade plaster of nutmeg, mixed with tallow and lard. In 1870, a 12-month-old died after swallowing a pill of opium, a drug to which his mother, Elizabeth Moore, had been addicted for 17 years. The Brighton coroner recorded death 'by misadventure'.

Louisa Jane Hawkes v Thomas Stowell.— In this case complainant had taken out seven different summonses calling on defendant (a medical man, carrying on business in Church-street) to show cause why he should not contribute towards the support of the same number of illegitimate children, of whom he was the father.—Mr Lamb was about to go into the facts of the case, which he described as one of the worst he ever heard, when Mr Penfold, for the defendant, said he would submit to an order being made.—The Magistrates made the usual order, and also allowed Mr Lamb 10s 6d as his fee in each case.

Dr Stowell of Brighton had at least seven illegitimate children by Louisa Hawkes.

CRINOLINES AND BLOOMERS

In mid-19th-century England, well to do ladies wore gowns and mantles of shimmering silk and taffeta, sumptuous velvet and intricate lace, topped and tailed with lace-trimmed bonnets and delicate slippers. Working women wore hardwearing boots, garments of flannel, heavy cotton and wool, white linen aprons, and plain caps. Girls wearing strong walking boots with excessively bright-coloured dresses and gaudy jewellery were immediately recognisable as prostitutes.

All upper class and middle class women – and those of the lower ranks with pretensions to gentility – were tightly laced into whalebone corsets known as stays. These were hooked in the front and the tightness was adjusted by laces in the back. Stays reduced the breathing capacity of the lungs and crowded the internal organs into unnatural and often dangerous positions; indeed, it was reported in the Sussex press in 1854 that a servant in York had died from the pressure of tightly laced stays.[38] It has been observed that the physical restraints of the corset are a powerful metaphor for the social constraints that inhibited women.

Women wore voluminous and heavy multiple layers of skirts and cumbersome starched underskirts, which trailed along the ground, picking up all kinds of unsanitary matter from the streets. The outfit weighed 15 to 20 pounds and greatly impeded women's freedom of movement. It was common for women to feel breathless and faint. Working girls strove to copy, in inexpensive versions, the attire of wealthier ladies in order to appear fashionable, and also attractive to men whose attentions and consequent marriage proposals they sought. Men found the multiplicity of underskirts intriguingly mysterious, the accentuation of the waist highly erotic, and the swooning, helpless woman very desirable.

The issue of women's clothes became a battleground upon which feminists and anti-feminists fought. The Rational Dress publicised by Amelia Bloomer in the 1850s, became almost a 'uniform' of the women's rights movement.* Indeed, the movement was sometimes referred to as 'Bloomerism'†. It consisted of a jacket and a knee-length skirt over Turkish-style trousers, gathered at the ankle. Gone were the corsets; women would

* Invented in 1851 by an American, Elizabeth Miller.
† The term 'feminist' did not appear until the 1890s.

be able to breathe, and they would also be able to take part in sport and other activities without fear of exposing their legs. The costume was greeted with horror, disdain and squeals of hilarity.

BLOOMERISM COMES TO HASTINGS

Abridged, *Hastings & St Leonards News,* 12 November, 1851

The denizens of our sober town were startled out of all sense of propriety on Wednesday evening by a lecture on this most awful 'social-ism,' at the Swan Assembly Room. A Miss Atkins addressed a crowded meeting on Bloomerism, for about three-quarters of an hour, amid mingled applause and laughter.

… Miss Atkins made her appearance, attired in the new costume, and wearing a Bloomer hat jauntily placed on one side of her head, giving her, with her smiling and rather pretty face, what the ladies called a 'wicked look'.

…It would scarcely be believed (said the lecturer) by future generations, that the women of the nineteenth century crushed their ribs, destroyed their lungs, and entailed consumption on their offspring, by the custom of tight lacing! [Much applause.] We need not wonder at the absurd ambition of the Chinese ladies to pinch their feet into a baby's size, when women in England deform themselves as they do by tight-lacing.

… It was objected that the short dress and trousers were immodest. 'Is it so?' said the lecturer (putting herself into an exhibitory open-armed posture, that the dress might be fully seen by the audience, and eventually getting, by request, on the table, for still further exhibition, amid thundering peals of laughter, and cries of 'bravo' &c.)

…And then followed an energetic and woman-like appeal to woman: 'shall we, or shall we not, be allowed to judge for ourselves? Why should men dictate to us? We never dictate to them – even if they should choose to wear a half-a-chimney-pot on their head, and call it a hat!' [Loud laughter.] 'We can tell the men that we mean to do as we please. [Cheers and renewed laughter.] If the men so much admire the long dress, let them wear it a few days, and see how they would like to be enslaved by it.'

… The ladies were advised next to try the dress indoors at first. After a few days' trial, she was quite sure they would have no wish to go back to the slavery of the old fashion. … Let women be resolved on a reform – regardless of surrounding scorn and derision.

… The prevailing feature of the entertainment was

one of comicality, the really intellectual or useful being quite secondary.

Similar lectures took place in other large towns in Sussex. In Brighton, a Mrs. Knight and her ten-year-old daughter drew an enormous crowd:

> Long before the lecture commenced the room was filled to suffocation; the passages were also so crammed that it was necessary to close the front doors to keep the crowd on the outside, and many persons went away without being able to catch a glimpse of the Bloomer.

In 1857, after Rational Dress had been laughed into obscurity, the French crinoline – a lightweight, hooped cage of flexible steel or whalebone – burst onto the fashion scene. Its size reflected social status – the most chic were 7ft in diameter. It replaced the multiple layers of petticoats and, as the wide skirt made the waist appear small, corsets could be loosened. However, the crinoline prevented any sudden movement and was unmanageable and even humiliating. When sitting down, it sprung up wildly at the front; when walking, a gust of wind would reveal all, and so in windy weather a cape was necessary to weigh it down.

In Sussex, as everywhere, there were dozens of accidents caused by crinolines, some trivial,* others tragic. In Waterloo Passage, Hastings, in 1862, ten-year-old Julia Brazier died from burns after her crinoline skirt touched an open fire and caught light while she was tying her brother's bootlaces.[39]

By the end of the 1860s, nine million crinolines were in use. Once they spread to the masses they lost prestige, and fashionable women adopted the bustle, a steel cage attached just above the hips and fastened around the waist. By the 1870s this had been extended to just above the back of the knees and at the height of its popularity, it was horizontal. Skirts became longer at the back to form a small train. Once again, corsets became excessively tight and petticoats multiplied. Women were back where they had started.

* In 1863 the Staffordshire potteries forbade the wearing of crinolines by their workwomen after, in just one shop, £200 worth of articles were swept down and broken by them in one year.

References

[1] Marx, E., and Aveling, E., (1887) *The Woman Question*, London, Swan Sonnenschein.

[2] In a letter to Sir Theodore Martin, 29 May 1870.

[3] 1836 *Register of Electors*, PNB Publications, 1990. Mrs. Bird and Elizabeth Foster were in a similar situation.

[4] Cobbe, F.P., (1869) *The Final Cause of Woman*.

[5] Ramselson, M., (1967) *Petticoat Rebellion*. Lawrence & Wishart, p54.

[6] Cobbe, F.P., (1894) *Life of F. P. Cobbe, By Herself*.

[7] *English Woman's Journal*, November 1862.

[8] Holcombe, L., (1973) *Victorian Ladies at Work*. USA, Archon, p4.

[9] Dr Florence Fenwick Miller (1854 -1935) Speech at the Liberal Club, 1890.

[10] *Commentaries on the Laws of England*, 1765.

[11] *Ibid*, p.159.

[12] *Shrewsbury Chronicle*, 3 August 1849.

[13] Leigh Smith, B., (1854) *A Brief Summary in Plain Language of the Most Important Laws Concerning Women*. John Chapman, p 15.

[14] Holcombe, L., (1983) *Wives and Property*. University of Toronto Press, p35.

[15] Dickens, C. (1838) *Oliver Twist*.

[16] *West Sussex Advertiser*, 1 July 1867.

[17] *Shrewsbury Chronicle*, 3 August 1849.

[18] Address by Chief Justice Walter Clark to the Federation of Women's Clubs, North Carolina, 8 May, 1913. http://docsouth.unc.edu/nc/clark13/clark13.html

[19] *Eastbourne Chronicle*, 21 December 1866.

[20] Dale, A., (1947) *Fashionable Brighton*, 1967 reprint, Oriel, p138.

[21] In 1841 a 17-year-old was sold at Smithfield cattle market, London, for 30s (£1.50). Susannah Ann Barrett was ill treated by her brushmaker husband and left him. Divorce was impossible but Mr. Barrett said that he could legally sell her to a former suitor, a Mr. Lane, if he led her through a turnstile at Smithfield, with a halter around her waist. This was done, attracting both a crowd and a policeman. Both men ran away, and Susannah was taken before a magistrate, who expressed his astonishment 'that there could be dolts who would class women as a species of cattle', adding that 'if such transfers were legal Smithfield would not be large enough to hold the wives that would be brought for sale'. *Sussex Express*, 29 May 1841.

[22] From www.yeoldesussexpages.co.uk

[23] *Brighton Herald* May 1826.

[24] Wells, R., (ed.) (1992) *Victorian Village*, Alan Sutton, p30.

[25] *Eastbourne Chronicle*, 8 May 1869.

[26] *Ibid*.

[27] Wells, R., (ed.) (1992) *Victorian Village*, Alan Sutton, p31.

[28] *West Sussex Advertiser*, 27 April 1855.

[29] Louisa Garrett Anderson (1873-1943) CBE, M.D., physician and suffragette.

[30] Wells, R., (ed.) (1992) *Victorian Village*, Alan Sutton, pp51 and 85.

[31] Smith, F. B., (1979) *The People's Health*, 1830-1910, pp13-15, 28-31, 55-58.

[32] Wells, R., (ed.) (1992) *Victorian Village*, Alan Sutton, p41.

[33] Archer, T., (1870) *The Terrible Sights Of London and Labours Of Love In The Midst Of Them*. River, p15.

[34] Coroner's Inquest, *Hastings & St Leonards News*, 9 February, 1855.

[35] *Hastings & St Leonards Chronicle*, 18 November 1851.

[36] *Hastings & St Leonards News*, 1 January 1864.

[37] Wells, R., (ed.) (1992) *Victorian Village*, Alan Sutton, p48.

[38] *West Sussex Advertiser*, 1 March 1854.

[39] *Hastings & St Leonards News*, 26 September 1862.

The Bloomer costume, 1850s.

TO WEARERS OF CRINOLINE.

SIR,—Allow me to call the attention of some of your readers to the inconvenience and danger of the above article, in proof of which I beg to state the following :— Being lame, I am compelled to walk with a stick; and while passing through one of your streets the other day, I met several ladies, and before I could move out of their way, the crinoline of one came with such violence that it forced my stick from under me, and it was with some difficulty that I saved myself from falling on the pavement. This is the second narrow escape I have had within a week from those formidable crinolines. To avoid any further collision, I am sorry to say I can see no other alternative than to keep quite out of the way of the fair sex, which would indeed be a great privation to a nervous individual like myself.

By inserting the above, you will greatly oblige, and be doing a public service.

I am, sir,

Hastings, January 12, 1860. A VISITOR.

OCCUPATIONS

WANTED,

IN a private family in Hastings, a PLAIN COOK, who will be required to do a small part of the house work.—For address, apply to M., at the office of this paper.

Wanted,

IN a Gentleman's Family, two miles from Hastings, a good COOK, who understands baking and a dairy. She must be a respectable, trustworthy woman, with a very good personal character. About 30 years of age. A Dissenter preferred.—For name and address, apply at the office of this paper.

Wanted,

IN a Gentleman's Family, a short distance from Hastings, a good PARLOUR MAID. She must be accustomed to the care of plate, glass, and waiting at table. There are four sitting rooms to keep, with stoves. A thoroughly respectable, steady young woman, of religious character, desired.—Apply for name and address, at the office of this paper.

TWO SERVANTS.

WANTED by the 17th May, in a Small Private Family residing one mile from the sea, Two Servants, the one as COOK and the other as NURSEMAID. Each will be required to assist a little in the house. The family consists of a Lady and Gentleman, and three children (the youngest two years of age). Liberal wages.—Apply between two and six in the afternoon, or nine and ten in the evening, to Mrs. Butler, opposite the St. Matthew's Church, Tivoli.

Wanted,

A SITUATION as HOUSEMAID (upper), or as COOK in a small family in Hastings. Three years' character. Address, E. W., at the office of this paper.

WANTED,

A RESPECTABLE Young Person as NURSE to one little Boy, 4 years of age. One who has had some experience in the Nursery, and who would not object to assist a little in the housework.—Apply personally before eleven, or from three till five, at 12 Eversfield place, St. Leonards.

2: OCCUPATIONS

The economical position of women is one of those subjects on which there exists a 'conspiracy of silence.' While most people, perhaps, imagine that nearly all women marry and are supported by their husbands, those who know better how women live, or die, have rarely anything to say on the subject.

<div align="right">

JOSEPHINE BUTLER, 1868

</div>

I n the 19th century, profitable and interesting employment for Britain's working women did not exist. The expression 'women's work' was synonymous with low pay and low status. It was almost invariably without promotion, authority, pension or security. Even nursing was 'disorganised and disreputable' until Florence Nightingale turned it into a profession in the 1860s. There were, however, at least 2.8 million and maybe as many as 3.1 million women working for wages in the 1850s, the highest ever recorded and a proportion not seen again until after 1945. The 1851 Census revealed that three-quarters of spinsters and one-quarter of widows were gainfully employed. The employment of wives is less easily stated, as will be explained later.

It was taboo for well-educated middle class girls to attempt to make a living from their skills because masculine pride dictated that a man should support his family. Take, for example, Brighton resident Sophia Jex-Blake, who in the late 1840s wanted to teach maths. Her father grudgingly allowed her to, but would not permit her to accept the salary. Some middle class women – known as 'distressed gentlewomen' – were forced to support themselves by their own endeavours. Writer Anna Jameson (who moved to Brighton in 1854) noted that if one considered the widows or daughters of 'attorneys and apothecaries, tradesmen and shopkeepers, banker's clerks &c, in this class more than two-thirds of the women are now obliged to earn their own bread.'[1] A few might find employment as a personal companion; for example, Jane Weeks, a spinster of 26, was a 'Company Keeper' in Brightling in the 1850s. Virtually all women had the necessary experience to perform needlework and any woman with a modicum of

Occupations of Women in Sussex, 1800-1870

Apple shop keeper
Artist
Artiste de modes
Artists' repository keeper
Author
Baby linen dealer
Baker
Bandbox maker
Basket maker
Bathing machine proprietor
Bather
Baths manager
Baths proprietor
Beer-shop keeper
Berlin wool dealer
Blacksmith & shoeing
Boarding-house keeper
Bookseller
Boot-binder
Broker
Builder
Butcher
Cabinet maker
Currier
Dairywoman
Dentist
Domestic servant
Drapers
Dressmaker
Earthenware dealer
Eating house keeper
Egg merchant
Embroiderer
Fancy repository keeper
Farrier
Farmer
Feather dresser
Fish carrier
Fish hawker
Fishmonger
Fish seller
Flower seller
French polisher
French shoe dealer
Fruiterer
Furniture dealer

Calenderer
Carrier (of goods)
Chair bottomer
Chair caner
Chair maker
China & glass dealer
Chiropodist
Clear starcher
Cloakmaker
Clothier
Coach maker
Coal merchant
Coffee house keeper
Companion
Confectioner
Cook
Cooper
Copperplate printer
Corn dealer
Corset maker
Cow keeper
Cupper
Curative mesmerist
Furrier
Fly proprietor
General dealer
Glazier
Governess, private
Governess, infant school
Greengrocer
Grocer
Hairdresser
Hatter
Hat trimmer
Hosier
Hotel keeper
House agent
Itinerant fruit seller
Insurance agent
Ironer
Ironmonger
Japanner
Juvenile warehouse proprietor
Keeper of mangle for hire
Kitchenmaid
Labourer

Lacemaker
Lace runner maker
Lace cleaner
Lace joiner
Lace mender
Lace warehouse proprietor
Lady's maid
Laundress
Laundry maid
Laundry proprietor
Library proprietor
Linen draper
Lodging-house keeper
Lunatic asylum proprietor
Manglewoman
Mantlemaker
Marine store proprietor
Market gardener
Matron, gaol
Matron, industrial school
Matron, infirmary
Matron, workhouse
Milk vendor
Miller
Milliner
Millinery hawker
Music (sheet) seller
Musical instrument seller
Needlewoman
Newsagent
Novelist
Nurse
Nursemaid
Omnibus proprietor
Outfitter
Paper-flower maker
Parlourmaid
Pawnbroker
Perfumier
Pew opener
Photographist
Photographic artist
Plumber, glazier, painter
Pony or goat chaise proprietor
Printer
Professor of singing
Professor of music
Professor of languages

Pork butcher
Poultry fancier
Poulterer (licensed)
Publican
Pupil teacher
Sailmaker
Schoolmistress
School proprietor
Scourer
Secondhand clothes dealer
Seamstress
Sedan chair proprietor
Sieve maker
Sempstress
Servants' registry office proprietor
Shareholder
Shell artiste
Shell dealer
Shellfish dealer
Shoebinder
Shirtmaker
Shrimp hawker
Silk worker
Silk weaver
Slop seller
Stationer
Stay maker
Straw hat maker
Superintendent
Tailoress
Tallow chandler
Tea dealer
Tobacconist
Toy dealer
Twine spinner
Undertaker
Upholsterer
Waistcoat maker
Wardrobe dealer
Watchmaker or mender
Wax flower maker
Weaver
Wood hawker
Wine merchant

education could be a governess. These were also seen as 'natural' professions for women and appropriate even for those of the middle class. These were, therefore, very overcrowded occupations.

For working class women there were plenty of jobs performing ill-paid drudgery for their social superiors. Most lived in varying degrees of poverty, despite being employed for 10 to 16 hours a day. For example, although Joanna Taylor worked as a laundress in Hastings for 50 years, she was unable to put anything aside for her old age and, when she became too old to work, she had no choice but to apply for parish relief. The highest-ranking employment that a working class woman could obtain was as matron of a public institution and even then her status automatically dropped a step if a male governor or master was employed.

The impressive list of 180 female occupations on pages 44 and 45 reflects the wide range of small businesses run by individual women in Sussex and is not a guide to their employment opportunities. In fact, over 80% of working women were in just five occupations: domestic service, the clothing trades,* laundering, lodging house keeping and shopkeeping.

David Foster's survey of directories published about 1848† identified women in 150 trades in Sussex. Of these, 22% were in retailing, 24% in manufacturing (mainly in the clothing trades) and 13% in the service sector (such as lodging house keepers and bathing-machine proprietors). In 85 cases, a woman was the only member of her sex in that trade.[2] While towns in other parts of Britain had large factories and textile mills, Sussex had no single large employer of women. In Stedham, some women worked in a paper factory and, in the Worthing area, a small number was involved in brickmaking. According to M. Beswick's study of the brickmaking industry, women were employed only on a casual basis: 'The women of the family were frequently pressed into service in the yard when labour was in short supply.'[3]

In Sussex in 1851 there was no occupation in which the sexes came close to being equal in number. Men comprised 99% of labourers, 98% of the employees of national and local government and the learned professions, and 80% of those working with minerals or vegetables, and possessing or working the land. Women comprised three-quarters of those engaged in 'entertaining, making clothing, and performing personal offices',

* There were 84,000 women (compared with just 28,000 men) in the clothing trade in London in 1851.
† Mr. Foster carried out this research for his PhD thesis. He identified 774 different trades followed by females in 626 British towns.

and two-thirds of those involved in 'literature, the fine arts and the sciences.'

According to the 1861 Census, 63% of Sussex women were 'unwaged or undefined'. This figure included women with annuities, pensions, and allowances given by relations; wives supported by husbands; inmates of workhouses, gaols and asylums; and those receiving parish relief. The remaining 37% (43,235 women) were self-supporting. Of these, 5% derived their income from property ownership and 32% either worked for someone or ran their own business.

Women usually gained more responsibility and status if they could establish a small business rather than being employed. Not only could they keep the fruits of their labour; they could, in theory at least, work in areas that were closed to them as employees. Most women with small businesses were laundresses, needlewomen, milliners and dressmakers, work which they carried out in their own homes. Opening a shop took capital, which few women had or could raise. A lower middle class woman with a small inheritance might establish a millinery shop; a working class woman with a little capital might open a little grocery, usually in a poor area.

UNEMPLOYMENT

If a woman could not work, and had no one to support her, she had few choices. There were no national unemployment or sickness benefits. After 1834 it became harder than before to obtain even a small handout from the parish rates and, in any case, such 'outdoor relief', as it was called, was rarely given to single women. They were supposed to obtain instead 'indoor relief' by entering one of the many grim workhouses that had opened throughout the county (and the country) in the late 1830s. The only alternative was to go 'on the street' as a hawker, beggar, thief or prostitute.

Friendly or benefit societies offered a modicum of financial support to employed subscribers over short spells of illness or injury, but these were mainly for men and the vast majority of working women had no access to them. From the 1850s a few were established for women; one of them, the St Mary's Female Assurance Society, was established in Hastings. It invited applications for membership from 'females whose time is money, and who, in sickness, can ill afford to lose that time'.

WIVES

The idea that in the 19th century all married women did not work is a myth, so far as the poorer classes are concerned. Traditionally, all members of a family were involved in home-based trades, but the process of industrial revolution gradually divided the sexes into 'breadwinner' and 'housewife'. Keeping his wife out of the workplace came to signify respectability for a man and gave him status. It became an ideal to which many members of the ambitious working class aspired, but few achieved. Nonetheless, it led people with pretensions to gentility to conceal wives' paid employment.

The likelihood of a wife's being employed depended on her husband's income. If he was a skilled worker she might devote herself to raising a family; if a trader, she might join him in business. But should she marry a labouring man, or one whose employment was seasonal, or insecure, or who became unable to work through infirmity or alcoholism, she might need to earn money throughout her married life.

It should not be supposed that married women worked for wages only in dire financial circumstances; many Sussex wives were employed, or ran businesses, even though their husbands appear to have been able to support them. In Brighton, for example, feathermaker and French florist Mary Gillman was married to a dyer, while in Hastings egg-merchant Elizabeth Collins was married to a shoesmith. Typically, schoolmistresses were married to schoolmasters and a gaol and workhouse matron was usually married to the governor. Many women combined careers with motherhood; for example, schoolmistress and mother-of-two Jane Smith of Hastings was married to a sexton, and the aforementioned Mrs. Collins was raising seven children while running her egg business. It is interesting to note that working mothers were so prevalent in mid-19th-century Hastings that churches opened crèches especially to cater for them.

The 1851 Census was fundamentally flawed in relation to wives' work. It reported that 2.8 million women* in England and Wales, and 22% of all married women over 20 were in paid work. These figures are now accepted by historians to be underestimates. One reason for the inaccuracy is that census enumerators were instructed that 'The profession of wives ... living with their husbands and assisting them ... need not be set down.' In 1851 the typical business was a family one, and so the number of working wives omitted from the census must surely run into hundreds of thousands. To give just one local example, Harriet Fisher of 56 High Street, Hastings,

* The total female population was then 10.1 million.

advertised, and was listed in trade directories, as a confectioner, and another source* confirms that she worked in, and managed, the shop. However, according to the census, her husband was the confectioner and Harriet was officially recorded as 'unoccupied'.

A second reason for the census's inaccuracy lies with the women themselves. For many reasons, they did not tell the census enumerators that they worked for wages. Some of them wanted to protect their husband's dignity by pretending that he earned enough to support them. Others did not see their work as sufficiently important to be worth mentioning. Typically, wives' paid work was unskilled, part-time, casual, seasonal or domestic. A wife might not declare that she was a paid childminder, went out charring or performed paid work in her own home, for example other people's laundry, needlework, or the manufacture of small items such as boxes. She, or whoever gave the family's employment particulars to the enumerator, may not have deemed such lowly labour worthy of the title 'occupation'.

As the census cannot be relied upon to tell us the number of married women who were employed, we may consider other sources. Harriet Martineau analysed the 1851 Census data and concluded that half of Britain's six million women worked for wages; that is, 200,000 more than the census showed. Bessie Rayner Parkes, a Sussex resident and specialist on female employment, computed that 3.1 million women were gainfully employed in 1860, of whom 1.5 million were married.† She reckoned that 37% of married women worked, compared with the census figure of 22%.[4] As the century progressed, real wages for skilled men rose, and more of them were able to support their wives. Whereas about one in four wives worked for wages in the 1850s, only about one in ten did so by 1911.

Owing to property laws and social customs, official documents – such as deeds and licensing records – also fail to help us discover the extent of wives' work in family businesses. Social custom dictated that only the husband's name be used for publicity, although a few people disregarded this. So, although it was customary for a small shop or business to be run jointly by husband and wife, it appeared only in the husband's name. Often, the only record of wives carrying out such work is hidden, like a needle in a haystack, within documents unrelated to female employment. These sources reveal that wives not only served the public but worked behind the scenes,

* Her court evidence against a shoplifter.
† Of the remainder, Parkes reckoned that 0.4m were widows and 1.2m were single.

stocktaking, ordering and bookkeeping. Only from the reminiscences of Thomas Brett do we know that a woman in Hastings was her husband's chauffeuse. Anna Maria Savery, who married a busy surgeon in 1829, 'was seen almost daily out driving with the doctor in his professional rounds, and taking command of the horse and carriage'.[5] Similarly, during an embezzlement case in Brighton in 1868, it emerged that a Mrs. Maynard worked as her husband's bookkeeper.[*] Such employment was of course omitted from the census returns, because they were instances of 'wives assisting husbands'.

How people organised their finances in the 19th century is a subject worthy of research and is outside the scope of this book, and so I cannot say whether wives working in family businesses were paid a wage or given a share of the takings for their personal use. Everything a woman earned belonged to her husband in any case, so for him to pay her for working in 'his' business, while still legally retaining ownership of her wages, would have been a little absurd. It seems likely that the husband gave his wife an allowance to run the household, regardless of whether or not she worked in the business.

Very few women were recorded in directories and censuses as being in partnership with their husbands. One was Rebecca Fenner of Mayfield: she and her husband were tailors and woollen-drapers who also acted as agents for the Phoenix Fire & Life Assurance company. At Steyning, George and Harriett Mitchell were brewers, maltsters, farmers and coal merchants. Priscilla Brown of St Leonards was a partner in her husband's business (he was a master-bricklayer employing three men) and Mrs. and Mr. Thomas Baker were clothes dealers in Duke St, Brighton.[†]

A pub, small hotel, or lodging house, although listed in a man's name, was usually run jointly by a married couple and, in some cases, the wife had sole charge while her husband followed a different occupation. A married woman could not be a licensee, regardless of the circumstances. Even if her husband took no part whatsoever in the business, it was always licensed in his name. In 1864 Mr. Brockwell, summonsed to court in relation to a Hastings lodging house registered in his name, explained that he knew nothing about the business: it belonged to his wife and he worked elsewhere. Under the laws of coverture, the law found him responsible.[6]

[*] The work of daughters, too, might be hidden and undeclared. How many girls were there like Ann Heath, who used to copy all the entries from the credit-slate into the accounts book every evening at her parents' public house in Horsham?

[†] See page 57 to see why their names appear this way and not with *Mr.* first.

When in 1844 the licensee of the *Horse and Groom* in Worthing – widow Elizabeth Hopkins – remarried, the licence had to be transferred to her new husband, Henry Budd. Elizabeth carried on as landlady, but the records appear to show that Mr. Budd *replaced* Mrs. Hopkins. Jane Cox, whose husband was a complete invalid, supported the whole family, including four children, by running the *Dun Horse* beer-shop at 29 Albion Street, Hastings, for three years from 1857. However, the licence was not transferred to her until after her husband's death in 1860.* These two examples illustrate how women's participation was often hidden so effectively that it is very difficult for historians and family history researchers to uncover. The custom of refusing licences to wives makes it impossible to establish the extent to which married women ran licensed premises.

In businesses that did not require licensing, wives could be listed in the census and other documents as the proprietor, provided she could overcome what Helen Taylor† called women's 'timidity and dread of exposing their names to public observation'.[7]

Women very rarely inherited family businesses from their fathers because they were passed over in favour of sons. It was more frequent for a woman to inherit from her husband.

WIDOWS

The most powerful evidence of wives' involvement in family businesses was the universal practice of their taking over, seemingly automatically, after their husbands' death. Records show that this was the custom long before 1800.‡ Most interestingly, by this method women became the proprietors of trades that were considered unsuitable for them: blacksmith, glazier, plumber, housepainter, builder, butcher, cabinet maker, copperplate printer and harnessmaker. No woman would have been accepted as an employee into any of these kinds of trades, either as a manager, a worker or an apprentice; and yet many women ran such businesses successfully and, in some cases, expanded them as they prospered.

Details of the day-to-day running of small businesses are scarce and it is difficult to establish women's involvement in 'male' manual trades.

* Mrs. Cox's beer-shop prospered and in 1867 she applied for a licence to sell spirits. This was granted and the *Dun Horse* was promoted to the status of a pub.
† The step-daughter of J. S. Mill
‡ For example, when the first trade directory for Sussex was published in 1792, Sarah Boxfold was shown as a blacksmith in Arundel and Widow Purfield as a dealer in malt in Battel [sic].

Prejudice may lead us to assume that women performed none of the work themselves but employed men, yet we have no way of discovering the truth. Modern-day sexist assumptions about Victorian women may be wrong: after all, photographic evidence exists that a widow worked as a gravedigger in Sussex in the 1880s, having taken it over from her late husband.[8] * Conversely, an embezzlement case in 1841 revealed that a widow, Martha Brook, who inherited her husband's milk business at Preston, took no part in the business. She engaged a man as a milk-carrier, while her son was manager and kept the books.

Many women who took over their late husbands' trade clearly stated this in their advertisements. Perhaps they wanted to announce that it was 'business as usual', despite the man's demise, or to reassure society in general that they were widows struggling nobly to support their families, and not 'strong-minded' Bloomerists audaciously setting up in a male trade.

The following paragraphs describe three widows who successfully took over their husbands' businesses in Hastings.

Hannah Morton was born in 1806 in Derbyshire. She and her husband moved to Hastings and opened a china and glass business. By 1841 she was a widow with children aged two, five and 15. The business became very successful, and she removed it from 27 High Street to larger premises at number 43. Later she opened further branches, one at 13 Castle Street and another at 72 Norman Road, St Leonards, where her widowed daughter Mary Ann was manager. Mrs. Morton retired in 1877 and lived above her shop at 43 High Street until her death ten years later. Two of Mrs. Morton's shop receipts, beautifully illustrated with an etching of the Crystal Palace, are preserved at Hastings Museum. The receipts are headed 'H. Morton' and do not, therefore, reveal the gender of the shops' owner – a further example of how women's participation in trade can so easily be rendered invisible.

Sarah Offen was born in Hertfordshire in 1810. She moved to Sussex as a domestic servant, became cook to Lady Lubbock, then cook-housekeeper to Lady Pilkington. She married in the late 1830s and leased 14 Undercliffe, St Leonards, letting it as apartments while raising her children. In 1841 the Offens opened a shop at 3 (now 35) Norman Road West, selling ironmongery, toys, glassware and earthenware. Just three years later,

* I once almost assumed that a railway station mistress in the 1830s could not possibly have lit the signal lamps herself, because it entailed climbing tall signal ladders in lengthy and voluminous skirts. Later I discovered that an eyewitness had watched her do so – and had recorded it in writing.

Mrs. Offen was widowed, and she ran the shop alone for 15 years. Described as 'a cheerful and chatty old townswoman', Mrs. Offen died in 1887.[9]

Charlotte Osborne, née Sargent, was born in 1814. She was involved in many retail enterprises in a career spanning 40 years, as well as bearing 13 children by two husbands. Her first husband was a cabinetmaker, and while married to him she was a furniture seller at 43 George Street. Later she opened a stationer's shop, first at 27 Castle Street and later at Caroline Place. After being widowed she married a printer, and opened a fruit shop at 55 George Street. This was later a Berlin Wool and Fancy Repository in the 1850s. Widowed again in 1861 she took over the printing business, employing her son as compositor. Mrs. Osborne died in 1898 at the age of 84. The printing press is on display at Hastings Old Town Hall Museum where it is labelled as having belonged to Mr. Osborne; Mrs. Osborne is not mentioned.

NORTH-STREET, LEWES.

ANN AMOS, GROCER, &c., 3, NORTH-STREET, LEWES, begs to tender to her Friends and the Public her grateful acknowledgments for the support afforded to her deceased husband, and to announce her intention of carrying on the business, which she hopes to conduct in such a manner as to retain their confidence and patronage.

Lewes, 30th January, 1840.

ANN WOOD,

(WIDOW OF THE LATE JOSEPH WOOD,)

GUN, RIFLE, & PISTOL MAKER,

194, HIGH STREET,

LEWES.

MORTON'S

Wholesale and Retail China, Glass, and Staffordshire Warehouse,

43, HIGH STREET, AND CORNER OF COURTHOUSE STREET, HASTINGS.

H. M., in returning her sincere thanks to the Gentry, Inhabitants, and Visitors of Hastings, St. Leonards, and the vicinity, for the very liberal patronage she has received for the last sixteen years, respectfully begs to inform them she has recently made some VERY ADVANTAGEOUS PURCHASES in CHINA and GLASS, which will enable her to sell at Lower Prices than ever! The whole is of first-rate quality, and will be found, on inspection, at least 20 per cent. cheaper than any other house in the trade.

Without resorting to the usual practice of making long lists of Prices, H. M. would further observe that she has commenced selling at Wholesale Prices for Ready Money.

Several China Dessert sets, splendid patterns; ditto Burnished Gold ditto, very superb. The whole of these are well worth attention, as they are to be sold GREAT BARGAINS.

Always on hand, a large assortment of Fancy Goods.

An early call is earnestly solicited.

☞ Please to observe the Address :—43, HIGH STREET, Close to the Town Clock.

MRS. KELCEY,

MILLINER, MANTLE AND DRESS MAKER,

5, Powis Road, Powis Square,

BRIGHTON.

The newest Parisian Designs regularly supplied.

Millinery in all its Branches executed by French and English hands.

N.B. FURS CLEANED AND ALTERED.

PINKING, CRIMPING, & GOFERING.

MRS. BUSHBY,

GARDENER, FLORIST,

FRUITERER, &c.,

WORTHING.

Greenhouse and other Plants in every variety. Dealer in Seeds.

MRS. MARY MARTIN,

(Widow of the late Geo. Martin),

PORK BUTCHER, POULTERER, &c.,

2, ALBERT PLACE,

SEA-SIDE ROAD, EASTBOURNE,

Begs to return her grateful thanks for the support so kindly bestowed during a period of nearly four years, and especially during her late husband's protracted illness; and now wishes to state that it is her intention to carry on the business as formerly, and that a continuance of the favours previously accorded will be most thankfully received.

ANN GOLDING,

WIDOW,

FRUITERER, GREENGROCER,

AND DEALER IN FOREIGN FRUITS,

No. 16, GEORGE STREET, HASTINGS.

Garden, Flower, and Bird Seeds of every Description.

A FRESH SUPPLY OF VEGETABLES, &c., FROM A. GOLDING'S OWN
GARDEN EVERY MORNING.

St. Clement's Caves will be illuminated at stated intervals, particulars of
which may be obtained of Mrs. Golding. Private parties shown on
application.

Above: In her adverts, Ann Golding made her status as a widow clear.

Below: Mr. and Mrs. Gould ran a shop jointly, but Mrs. Gould's name is much
more prominent in their advertisement.

**CHILD BED LINEN, MILLINERY, AND
JUVENILE DRESS REPOSITORY,**

No. 67, WESTERN ROAD, BRIGHTON.

MRS. H. GOULD,

In returning her sincere thanks to her numerous patrons for their kind
support, begs to call their attention to her new and elegantly-assorted
stock of

**Millinery, French Flowers, Children's Ready Made Dresses
and Baby Linen,**

Including every description of Caps, Robes, Frock Bodies, Cloaks, Hoods,
&c., all of which have been selected from the most eminent Metropolitan
Warehouses, will be found to combine every advantage of fashion, taste,
and quality.

**Ladies' Ready Made Linen and Dressing Gowns in great
variety.**

LADIES' OWN MATERIALS MADE UP.

H. GOULD, in returning his most sincere thanks for the very liberal
patronage conferred upon him, begs again to call their attention to his
newly-selected stock of

**Lace Goods, Collars, and Capes, Canzons, Berthes, Fancy
Handkerchiefs, Scarfs, Gloves, Haberdashery, &c.**

*Also, a splendid variety of Plaids, Gambroons, and Chusans suitable for
Children's Dresses.*

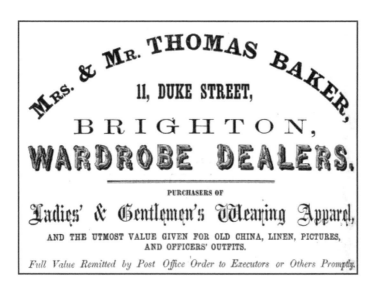

**T. HOADLEY,
TRUSS MAKER,
STATION STREET,
LEWES.**

N.B.—Females and Children attended by
Mrs. Hoadley.

Examples of wives and husbands working together.

Above: Mrs. Hoadley reassured customers that she was on hand to fit women and children with trusses.

Below: This advert is unusual because Mrs. Baker's name precedes that of her husband.

**MRS. & MR. THOMAS BAKER,
11, DUKE STREET,
BRIGHTON,
WARDROBE DEALERS.**

PURCHASERS OF

Ladies' & Gentlemen's Wearing Apparel,

AND THE UTMOST VALUE GIVEN FOR OLD CHINA, LINEN, PICTURES,
AND OFFICERS' OUTFITS.

Full Value Remitted by Post Office Order to Executors or Others Promptly.

BUSINESS AND TRADE

> If a lady but touch any article, no matter how delicate, in the
> way of trade, she loses caste, and ceases to be a lady.
>
> ### MRS. S. S. ELLIS, *THE WOMEN OF ENGLAND,* 1839

A large number of Sussex women owned businesses of varying sizes. The
extent of their involvement in the day-to-day running of the enterprise
depended on the location, size and type of the business, and also on the
social class of the proprietress. It was not acceptable for a well-bred lady to
be involved in trade. An upper class woman with extensive holdings would
hand over all her financial affairs to a male relative, accountant or 'man of
business'. However, a lower-middle or prosperous working class woman
who owned a business may have been directly involved in its management,
or even its day-to-day running.

It may be safe to assume that the Hastings resident who was a
'Proprietor of Coffee Estates in Ceylon' did nothing more than spend the
profits. More difficult to guess is the extent of Charlotte Moore's
involvement in the Pelham Arcade* and the Central Arcade in Havelock
Road when she was their proprietress in the 1870s. They were located in
busy and fashionable shopping areas of Hastings. She may have done
nothing but own the premises, or perhaps she was a constant presence,
patrolling the arcades and collecting rents from the tenant-shopkeepers.

SHOPS AND SERVICES

The quote at the top of this page was echoed by Margaretta Grey in 1853
when she wrote in her diary:

> Men in want of employment have pressed their way into
> nearly all the shopping and retail businesses that in my early
> years were managed, in whole or in part by women. The
> conventional barrier that pronounces it ungenteel [for
> women] to be behind a counter or serving the public in any
> mercantile capacity, is greatly extended. [10]

* 'A spacious, handsome building of stone about 180 feet long, and contains 28
good shops, which are let to Tradesmen for the sale of fashionable merchandise' –
Jones's Pocket Guide, 1828.

As Joan Perkin and Professor Harold Perkin have each pointed out, there were more women in trade at the beginning of the 19th century than at the middle or the end.[11] Nevertheless, between 1800 and 1870 women in Sussex retailed a wide range of goods including tea, meat, eggs, milk, poultry, fish, oysters, fruit, hops, malt, seeds, tobacco, toys, second-hand clothing, baby linen, jewellery, earthenware, furniture, shells, drapery, wool, fancy goods, perfume, pattens, stays, corsets, lace, bonnets, hats, stationery, books, china, ironmongery, wax, tallow and manure. Several women in coastal towns were marine store dealers. A few women held licences to sell game and, in Brighton, Elizabeth Hitchings sold live birds in Edward Street. There were female corn chandlers, spirit merchants, coal merchants and 'chymists' but only one woman timber merchant: she was recorded as trading in Lewes in 1828. Also in Lewes, in the 1830s Ann Wood inherited from her husband a successful sports shop at 194 High Street, listed in directories as an 'archery and cricket warehouse'. Miss Foster conducted a musical repository in Hastings in the 1840s. Her advertisement declared that she had a large number of pianos and other instruments for sale or hire, and at the end it announced: 'Quadrille bands provided.'

Genteel women with capital might open high-class shops in fashionable districts, typically selling millinery to lady clients. Working class women specialised in provision or general shops, mainly in villages but also in the poorer areas of town, where rents were relatively cheap. In Hastings, women held five of the 24 stalls at the Town Fair in 1826 – a year in which it was recorded that three-quarters of the town's fishmongers were female.

By the 1860s, women were serving in the majority of small shops in Hastings. Almost 40% of shops were listed in the name of a sole proprietress and although the rest were listed in men's names, they were mostly family businesses in which wives or daughters worked. In some instances they had the main or sole charge; for example, in circumstances in which the husband followed another career or was an invalid. Some cases exposed in court reports reveal that a number of husbands were habitual drunkards who could not conduct a business properly and were obliged to leave it entirely in the hands of their wives.

Women shopkeepers engaged mainly female staff, in many cases their sisters, daughters, or other female relation. In instances where there was no husband or son they might employ a man to assist with the heavy work, especially if stock had to be carried up from the cellar, no easy task for women in floor-length dresses or, heaven forbid, crinolines. Mrs. Winifred

Stubberfield, for example, employed three male assistants* in her grocery shop at 11 London Road, St Leonards.

Women ran businesses both as sole traders and in various kinds of partnerships. Shoe- and boot-maker Martha Dennet of Chichester was in business with her sons, while Sarah and Elizabeth Ray, unmarried sisters residing in Battle in the 1850s, supported themselves and their widowed mother by carrying on their late father's trade as silversmiths. In Brighton a grocery was owned by sisters Harriet and Mary Ann Langley of 13 Russell Place. In the 1860s four sisters – Millicent, Maria, Marian and Matilda Greenaway – managed (and lived above) a corset and stay shop at 16 Wellington Place, Hastings, which was owned by their father. Further examples from Hastings include widows Sarah Daniel and Mary Jeffrey, stay-makers, who were business partners;† sisters Eliza and Jane Smith, who jointly ran a shop; and the Twiddy sisters, who owned a private seminary at 81 High Street. Stationer Ann Holt was in business with her younger brother from 1838 until the 1870s and straw bonnet manufacturers Louisa and Jane Pollard were mother and daughter. Harriet Waters, a spinster, and Elizabeth Northery, a widow, ran a successful ladies' outfitters in Robertson Street in the 1860s (when it was known as 'the Regent Street of Hastings'). The pair resided above the shop with Elizabeth's two children, a girl shop assistant and a house-servant.

A business might be passed on to daughters if there were no sons. Nanny Golding ran a fruiterer's shop at 16 George Street, Hastings, from where she sold the produce of her husband's market garden. She gained complete ownership of the business through widowhood, and when she died in 1873 she left it to her two daughters.‡ One business was passed from mother to daughter to granddaughter over a period of 70 years. About 1824 Mrs. Oliver opened a fancy shell shop at 6 East Beach Street, Hastings. She was 'a woman of great size' who 'was regarded as a celebrity by the visitors' and whose first customer was reputed to have been Lady Byron, former wife of the poet. Mrs. Oliver died in 1854, whereupon her daughter, Mrs. Dine, carried on the business. When she died in 1888, the shop passed to her unmarried daughter.[12]

Expansion to other towns was difficult; however, ambitious

* In 1862 one of them, Charles Blake, committed suicide on the premises by shooting himself behind the counter.

† And may have also been sisters.

‡ They relocated it to 31 White Rock Place.

Magazin de Fleurs et Bonbons.

Madame De NORMANVILLE,

N⁰ 102, ST. JAMES'S STREET,

BRIGHTON.

Madame De Normanville respectfully begs to return thanks for the very extensive Patronage she has been honored with during her residence in Brighton for the last 19 years, and begs to say that she is continually receiving importations of Flowers suitable for each season.

Bonbons, Fancy Boxes, Eau de Cologne, &c. &c.

MRS. CURLING,

Foreign and British

LACE CLEANER & MENDER,

AND

FRENCH CLEAR-STARCHER,

(By Appointment)

To Her Majesty Queen Victoria

AND THE DUCHESS OF KENT,

67, King's Road, Corner of West Street, Brighton,

AND WOODSTOCK STREET, LONDON.

Gold and Silver Muslins, Coloured Embroidery, Foreign and British Shawls of every descripton Cleaned as new.

Chantilla Veils, Court Laces and Blondes Transferred and Mended by a Parisian.

Kid Gloves, of every colour, Cleaned on the Premises.

No connexion with any other House in Brighton.

HONITON LACE.

MRS. HEALEY begs to inform the Inhabitants, Gentry, and Visitors of Hastings and its vicinity that she is going to retire *finally* from business, and respectfully returns her sincere thanks to those ladies who have been kind enough to patronise her during the past four years.

Old Point, with all kinds of Muslin Embroidery and Chantilly Lace transferred, cleaned, and repaired:

The entire stock of Honiton Lace, Collars, Veils, Berthes, Mittens, Sleeves, Handkerchiefs, Scarfs, &c., with a variety of Sprigs and Edges of every pattern, SELLING OFF AT A GREAT REDUCTION.

The Stock and Business to be disposed of on advantageous terms, and the House and Shop to be Let.

This is a most advantageous business, well-adapted for an intelligent female of good address.

Left: Sophia Abbot ran a tea-dealer business from this house at 33 West Street, Hastings, in the 1830s.

Below: Ann Holt owned a seafront stationery business jointly with her younger brother.

HOLT'S
CIRCULATING LIBRARY,
STATIONERY,

SHELL WORK AND FANCY REPOSITORY,

23 and 24, White Rock Place, Hastings.

ESTABLISHED 1838.

A choice collection of Sea Weeds, Mosses, &c.

———

Books lent to read by the volume,—and the Times News-paper lent to read.

GREAT ATTRACTION !
MACHINE STITCHING FOR THE MILLION !

MRS. PHILLIPS begs to announce to the Ladies of Hastings and its vicinity, that the BOUDOIR SEWING MACHINE can be seen at work daily, at 7. CENTRAL ARCADE, MUSIC HALL, where a general assortment of Ladies' and Children's Underclothing is kept. A single garment at the wholesale price. Wedding Trousseaux and Outfits for all parts of the world are made on very reasonable terms.

Observe the Address—

MRS. J. PHILLIPS, 7, CENTRAL ARCADE, MUSIC HALL, HASTINGS.

Wholesale Depôt, 5, Aldermanbury Postern, London.

MRS. WELLS

RESPECTFULLY announces to the Nobility, Gentry, and Public, that her SHOW ROOMS are now open with an elegant variety of novelties in Millinery and Dress for the ensuing season; also an extensive assortment of Straws, Baby Linen, Patent wove, French, and English Stays. Her selection having been made from the first houses of fashion in the metropolis, the style and moderate charges she feels persuaded will be appreciated by those Ladies who have honoured her by their commands, to whom she returns her sincere thanks.—Mourning orders executed with the greatest attention.—For ready money.

168, High-street, Lewes, May 13th, 1837.

FISH, GAME, AND POULTRY.
(Established 50 years).

MRS. A. STACE (Successor to R. Baldock),
FISHMONGER AND POULTERER,
2, CASTLE STREET, HASTINGS,

Begs to return her sincere thanks to the Nobility, Clergy, Residents, and Visitors of Hastings, St. Leonards, and the surrounding country, for the very liberal support they have extended to her for some years past, and respectfully informs them that, having made very extensive arrangements in the counties of Sussex and Kent for regular supplies of game (from celebrated preserves), poultry, &c., she will be enabled to supply them with fish, game, and poultry, of the best quality, at such prices as cannot fail to give satisfaction.

Country orders punctually attended to, on the most moderate terms.

☞ BEST NATIVE OYSTERS, for barreling or table, always on hand.

M. MENCKE,

𝔐𝔲𝔰𝔦𝔠 𝔖𝔢𝔩𝔩𝔢𝔯 𝔞𝔫𝔡 𝔖𝔱𝔞𝔱𝔦𝔬𝔫𝔢𝔯,

No. 39, GREAT EAST STREET, BRIGHTON.

Broadwood's Piano Fortes for Sale and Hire.----Harps and Guitars Lent on Hire.----Musical Instruments of the first Manufacture.

PIANO FORTES ACCURATELY TUNED.

MUSIC NEATLY BOUND.——MUSIC AS SOON AS PUBLISHED.

Two adverts that do not mention that the proprietor is female.

Above: The M. before Mencke was Mary.

Below: Ann Walter could claim to be fruiterer and greengrocer 'to the Royal Family' because she had supplied either Princess Victoria and her mother the Duchess of Kent when they stayed at St Leonards in 1834 or the dowager Queen Adelaide in 1837.

THE FIRST ESTABLISHED AT ST. LEONARDS.

——o——

A. WALTER,

FRUITERER AND GREEN GROCER,
To the Royal Family,

No. 6, SOUTH COLONNADE,
ST. LEONARDS.

A GOOD SUPPLY OF FRESH BUTTER AND NEW LAID EGGS.
Vegetables supplied fresh from the Garden every day.

WINTER FASHIONS.--47, High Street, Lewes.

MRS. DRAKES respectfully informs the Nobility, Gentry, and Inhabtants of Lewes and its vicinity, that she is just returned from London with a very superior STOCK of rich and fashionable GOODS well selected for the season, and has opened her old-established SHOW ROOMS with an unusual display of MILLINERY and Fancy Goods in general. As this is the last season she will have the honor of soliciting those Ladies who have so liberally patronised her for 19 years, she is determined to sell every article at such prices as must command attention. The Stock she has to offer consists of very choice Goods suited to the season—such as Bonnets, Cloaks, Shawls, Mantillas, Pelerines, Velvets, Satins, Gros de Naples, French and English Merinos, Cashmeres, Saxony and Mousseline de laine Dresses, Ribbons, Gloves, and a great variety of other goods, which she is determined to sell at a great sacrifice, in order to dispose of the Stock this season, as she will retire from the business when it is over. Her Dress-Making will be carried on with the strictest attention, having provided herself with a Dressmaker from one of the first houses in London, and every order will be executed in the best style of fashion. The only alteration in that part of her business will be to make all Dresses at half the price she has been in the habit of charging, in order that she may part with the whole of her Stock by Lady-day next.

THE CHEAPEST
TOY, EMBROIDERY, & BASKET Repository
IN HASTINGS!

MRS. FUNNELL begs to inform the Residents and Visitors of Hastings and St. Leonards, that, owing to the increase of business, she has enlarged the Premises, and has just received a Large and well-selected Stock, which she now offers at London prices.

Mrs. F. begs to call the attention of Ladies to her Stock of EMBROIDERY, which consists of Infants' Robes, Children's Frocks, Capes, Sleeves, Borders, &c., &c.

Embroidery Cottons, and all kinds of Haberdashery.

Beads of every description.

A Large Assortment of English and Foreign Baskets, Bassinetts, Toys, &c., very Cheap!

Observe the Address—FUNNELL, 21, CASTLE STREET.

women sometimes owned several different businesses within one town. Some examples from the mid-century include Martha Noakes, a farmer with 210 acres, who also owned a butcher's shop in Lamberhurst; Sophia Crouch, who was both an innkeeper and a goods carrier at Withyham, and Rebecca Cleaver, a carpenter, wheelwright and smith at Bishopstone. At Pulborough, Mrs. Caroline Jarrett was a linendraper, grocer, hatter and postmistress; at Worthing, Nancy Carter was a bookseller and stationer who ran Carter's Library and Reading Room, sold pianofortes and owned a Berlin wool repository, as well as being an agent for the Globe Fire Insurance.

SHOP WORKERS

Few women were employed as shop assistants outside of their own families prior to the 1850s. From about this time, they began to work in bakery, confectionery, drapery and millinery shops. Thomas Brett, whose chronicles are cited often in this book, employed his daughter Augusta in his bookshop at 28 Norman Road West, St Leonards.

Although various employment legislation was passed in the mid-19th century, none of it applied to shopworkers, who generally worked excessive hours.* Most shops opened early and closed late, and on Saturdays many were open till midnight. A typical shop assistant was expected to stand all day, was allowed about 25 minutes for dinner and 20 minutes for tea, and worked 85-90 hours a week. A diary kept by a milliner's shop-girl in the 1860s shows that her typical working day began at 8 or 9am and ended between 7 and 10pm. Early closing day was Wednesday, when she finished at 5pm.†

A national early-closing movement was started about 1842 and by the 1850s it had spread to Sussex, in the form of a small campaign for provision shops to close early on Saturdays – at 9pm instead of the customary time of between 10 and midnight. This was born of concern that employees may be too tired for 'the religious duties of the Sabbath morning.'[13]

Despite all its drawbacks, shop work proved more popular than domestic service among unskilled working class girls. Shop workers enjoyed plenty of human contact with customers and work-mates, while servants were often terribly lonely. Working in a shop provided girls with

* Shop hours were not regulated by statute until 1886.
† The diary is held at Hastings Reference Library.

opportunities to meet potential husbands, and gave them more money and freedom to dress as they pleased (within limits) unlike servants, who had to wear a uniform as a visible sign of servility.

Assistants (and apprentices) usually 'lived in'. Employers could keep a watchful eye on their behaviour at all times, and could often doubly exploit their staff, for resident domestics could double as shop assistants and *vice versa*. Many shop girls were young teenagers, for whom it was not respectable to live independently and 'unprotected'. Their pay was, in any case, too low to afford lodgings. Living-in conditions above the shop or workshop were often wretched, with the barest minimum of space and facilities. Beds, which were generally shared, were often located in ill-ventilated rooms or dormitories. Personal privacy was impossible and bathrooms were rare. Petty rules were numerous and fines were frequent.[14]

A Brighton staymaker's assistant went on an excursion to the Foresters' Fete in 1857, got left behind by the return coach, and could not return until the following day. She was instantly dismissed. As her tardiness was accidental she sued her employer, Madame Dawney of Pool Valley, for a month's wages in lieu of notice. The judge found in favour of the employer, and issued a stern warning to other servants.

BATHS, BOOKS AND BILLIARDS

Many Sussex women were proprietors or managers of indoor baths. Among the earliest were Sarah Webb, proprietor of the Warm and Shower Baths in Eastbourne, recorded in a directory of 1828; Mrs. Neal, manager of the Hastings Old Baths in about 1830; and Ann Creak, Proprietor of Wood's Original Warm Baths, Pool Valley, Brighton, in the 1830s.

These establishments bore no relation to the public baths we know today; some were luxurious establishments. Pelham Baths, located just east of Pelham Crescent, Hastings, were clearly intended for the well-to-do visitor: a stone hall led into 'two handsome saloons, of an octagonal form and decorated with beautiful Chinese scenery'.[15] In these gorgeous surroundings customers were promised 'excellent plunging and shampooing' in the eleven warm baths, the two vapour-baths, two shower-baths and the plunging bath. The premises were opened in 1825, and the proprietor at mid-century was Martha Thatcher, who was succeeded on her death in 1857 by her daughter Ellen. In the 1870s Pelham Baths were in the hands of Jane Emary and her daughters.[*]

[*] The Emary family had owned the *Castle* and *Albion* hotels.

Women were employed in bathing establishments as bathers, and also in Turkish Baths as shampooers and rubbers (i.e. masseuses), to attend only lady clients.

As well as managing Pelham Baths, Martha and Ellen Thatcher let houses, and were (consecutively) proprietresses of a Theological Society and Library, which was located within the baths premises. Although library proprietress was considered to be a suitable and respectable business for a woman, few took up the profession, probably because of the large initial outlay involved in setting up. As early as 1779 Miss Widgett opened one at the Steine in Brighton and Evans' 1805 guide to Worthing mentioned that Mrs. Stafford ran the Marine Library but, fifty years later, only a handful of women had opened libraries in Sussex. The earliest in Hastings was run by Mrs. Austin at Marine Parade, in about 1820. She also let the five bedrooms above it to holidaymakers. Perhaps the longest-established in Sussex was Carter's Library, Warwick Street, Worthing, which was run by Nancy Carter for over 50 years.*

A few women owned billiard saloons, notably Mary Heatherley in Cuckfield, the Misses Binstead in Bognor, and the Misses Hopkins in Eastbourne. Ann Inkson, proprietress of the *Wheatsheaf* public house in Chichester, provided a billiard saloon for her customers.

PERSONAL AND MEDICAL SERVICES

Women were not permitted to train in the medical profession.† However, there were a great many unqualified nurses and midwives operating in Sussex, relying on experience and traditional remedies handed down from mothers and grandmothers. Any woman might act informally as nurse to a friend, neighbour or relative who was ill. Untrained nurses could also be hired: there were over 25,000 in Britain in 1851. Professional nurses started to qualify in the 1860s and by 1871 there were 40,000 enumerated in the English census.

Nurses were employed in workhouses. An advertisement‡ for one at Uckfield stated that applicants must be 'single, or widows without encumbrance [with no dependants] between 25 and 40 years of age'. The salary was £20 per annum 'with lodgings and the usual rations in the

* Nancy Carter (1788–1855) owned several businesses in Worthing. Worthing Museum holds a pastel portrait of her.
† The world's first qualified female physician, Elizabeth Blackwell, retired to Hastings in 1879.
‡ Published in 1873, slightly outside the period of this book.

Workhouse'. No medical or nursing qualifications or experience were required. The only stipulation was that 'No person can be appointed who is unable to read written directions upon medicines'.

A number of Sussex women offered various medical and personal services within the boundaries permitted for persons without a physician's degree. Some cured corns and bunions, and others advertised themselves as 'medical rubbers' (i.e., masseuses). One of them, Mrs. Linsted of Brighton, used and also retailed her patented 'Mother's Friend Ointment'. Another, Mrs. Boham of Hastings, was in business with her husband. Their advertisement included a doctor's testimonial, which read: 'Mr. and Mrs. Boham … are not mere rubbers, but understand their business manipulating exclusively the structures affected, and this with much skill and judgement'.

Hairdressing had been a female occupation until the 18th century, when it was taken over by men. By the middle of the 19th century, there were so few women in the profession that Mrs. Wigforth could claim in her advert to be the only female hairdresser in Hastings or St Leonards – and even she had inherited the business from her late husband.

Therapeutic hypnotherapy sounds like a modern-day treatment but it existed in Victorian England, under the name 'curative mesmerism'. A lady practitioner worked in Hastings in the 1860s, having been trained at the Mesmeric Infirmary in London. She advertised anonymously in the local press, and could be contacted only 'c/o Homoeopathic Chemist, Robertson Street.'

Female chiropodists were operating in Sussex as early as 1839. In 1851, three out of the four practising were women and, curiously, they were all in Brighton.

In 1839, Eastbourne, Cuckfield and Hailsham each had a female druggist or 'chymist' (one of whom doubled it up with a stationery business) while in Brighton, Harriet White ran a successful patent medicine warehouse in Castle Square.

Sussex boasted two female dentists: Margaret Worgan, 'surgeon dentist and chymist' was, in 1851, an unmarried woman aged 69, who had been born in Yorkshire but was conducting her profession in Hove. Mrs. Roper offered her services as a dentist at 161 Western Road, Brighton for 14 months in the 1840s before returning to London, where she had a surgery for 24 years. She had removed to Brighton temporarily for the sake of her health, no doubt believing, as many did, that the sea air would restore her. An 1845 newspaper reported that 'Mrs. Roper, the well-known "dentist"

Established upwards of 100 Years.

PATRONIZED BY THEIR LATE MAJESTIES,
GEORGE THE FOURTH, WILLIAM THE FOURTH, AND
THE ROYAL FAMILIES.

CREAK'S
ROYAL ORIGINAL BATHS,
POOL VALLEY,
STEINE, BRIGHTON.

A. Creak begs to return her sincere thanks to the Nobility, Gentry, and
Inhabitants of Brighton, and particularly to those whose favours have been
bestowed upon her for the last Forty Years, and trusts, as she always
superintends the business herself with experienced attendants, she will merit
a continuance of their hitherto liberal and esteemed support.

TERMS:

SEA-WATER BATHS.	£	s.	d.	FRESH-WATER BATHS.	£	s.	d.
One warm Bath	0	2	6	One warm Bath	0	3	6
Subscription for Ten ditto	1	0	0	Seven ditto	1	0	0
One Cold Bath	0	1	6	One Cold Bath	0	2	0
One Shower Bath	0	1	6	Eleven ditto	1	1	0
Sixteen ditto	1	0	0	Shower Bath	0	2	0
Hip Bath	0	1	6				

SHAMPOOING BATHS.

The Indian Vapour and Shampooing Baths 0 4 0
Six ditto 1 1 0

All Subscriptions to be paid on taking the first Bath.

Hot and Cold Sea Water, and Baths of every description, sent to any part of the Town
by pail or arrangement at per Week, Month, &c.

Mrs. Creak's advert and a drawing of her baths in Brighton.

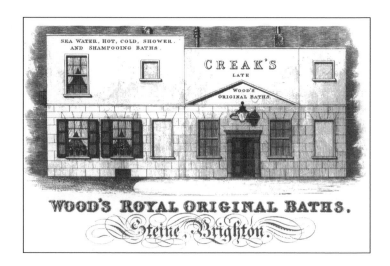

MRS. H. LINSTED,
PROPRIETRESS OF THE MOTHER'S FRIEND OINTMENT,
PROFESSIONAL RUBBER,
DELHI HOUSE, NORTH GARDENS, BRIGHTON.

Sold at her Establishment, and by the following Agents:—Mr. SANGER, Chemist and Druggist, Oxford Street, London; Mr. BURTLET HOOPER, Chemist, King William Street, London; Mr. HOLLWELL, Chemist, Edward Street, Grand Parade, Brighton; Mrs. SEARLE, 48, Queen Street, Brighton; Mr. MARTIN, Chemist, Cliffe, Lewes; Miss SCOTT, Montague Place, Worthing.

Mrs. L. attends on Patients afflicted with Spinal complaints, Rheumatism, and Weak Joints, &c., &c.

Corns Extracted without pain or inconvenience.

Mrs. L.'s Ointment is a speedy cure for all diseases of the eye, Scorbutic Affections, Scrofula in any parts of the body, and for the various ailments to which human nature is subject.

Testimonials &c., to be had on application.

6, CAMELFORD STREET, MARINE PARADE.

MADAME SANDERS, from Paris, respectfully informs the Public that she has a new Invention, an instantaneous and effectual Cure for Corns, Bunions, Callosities, Nails growing into the flesh, and every disorder incidental to the Feet, without cutting or causing the slightest pain.

Immediately after the extraction the tightest boot or shoe may be worn without the least inconvenience.

Madame Sanders can produce 2,000 Testimonials from France and England, and from several ladies in Brighton, none of which are inserted in public newspapers.

Residence, 6, Camelford-street, Marine-parade, Brighton. —At home, from ten to four, or will attend at private residences if required.

Madame S. cautions the public that there are several Chiropodists in this country who profess to find several roots in a corn. Madame S. totally denies the assertion: there are no roots in a corn such as they profess to take out, there is but one corn on a joint for which Madame S. charges as a corn.

MRS. WELLARD,

(LATE OF MANOR HOUSE, STREATHAM,)

Respectfully informs her Friends, the Nobility, Gentry, and Visitors, that she has resumed

READING TO INVALIDS,

And continues to let Plate, Linen, &c.

by the day, week, or month (as usual) on moderate terms.

For the accommodation of Families, in distant counties, a list of the best Houses kept correct, and any information respecting them answered by applying to

No. 20, WEST STREET, BRIGHTON.

N.B.--Silver corner Dishes and Covers, Ornamental Wine Coolers, &c. &c. for parties.

MESMERISM.

A LADY, formerly of the Mesmeric Infirmary, London, as curative Mesmeriser, is now residing in Hastings, and is open to engagements with patients. For cards apply to Mr. Snowdon, Homœpathic chemist, Robertson street, Hastings, or at the office of this paper.

50, ROBERTSON STREET, HASTINGS.
MRS. WIGFORTH,

THE ONLY LADIES' HAIR DRESSER IN HASTINGS OR ST. LEONARDS, (widow of the late J. T. Wigforth, formerly Court Hair Dresser, of Bond Street, London).

. Every article requisite for the Toilette in great variety.

Sole proprietress of the recipe for manufacturing the celebrated Vegetable Extract.

PATRONIZED BY THE FACULTY.

MRS. POTTER, OPERATOR ON CORNS, &c., 25, New Road, opposite the Post Office, Brighton. Corns, Bunions, and defective Nails speedily cured without pain or inconvenience.—Mrs. P, having had fourteen years' successful practice in Brighton, can give numerous and respectable references.

At home from Two till Four daily.

FEMALE DENTIST,

OF TWENTY-FOUR YEARS' PRACTICE IN LONDON, BRIGHTON, &c.

MRS. ROPER, Pupil of Charles Gresson, Edinburgh, 1816 No 161 Western Road, opposite Clarence Gardens, or a line addressed to Mrs R., at Mr Booty's Repository of Arts, No. 65, King's Road, corner of West Street, will meet immediate attention. Mrs R. has recently received from a lady of distinction, another striking testimonial of some operations, including twenty-two teeth, in two sittings, from one female, and in the aggregate, thirty-six in the same establishment. with other strong assertions of her acquisitions as a thorough Dentist in all its tendencies.

Mrs R. intends quitting Brighton for London as early as possible, having practised here fourteen months, being detained with dangerous illness during the last London season. Improved Mineral, Natural, and Artificial Teeth, from one to a complete set. Mrs R. extracting the roots previous to fixing them, as too many cases of failure arise from not attending to the diseased state of the teeth and gums, as numerous complaints have been made of this particular.

Tooth Tincture. 5s.; Tooth Powder. 2s. 6d. Antibilious and Aperient Pills, from the Recipe of an eminent Physician in Boxes, 2s 6d. each.—London address, at Mr Cocking's, Chemist, 19, Great Portland Street, Cavendish Square, during the season.

SERVANTS' FRIEND INSTITUTION,
29½, WEST STREET, BRIGHTON.

MISS WARREN begs to draw the attention of the Ladies of Brighton, and of the County of Sussex generally, to her

REGISTER FOR FEMALE SERVANTS,

which is acknowledged by all who have honoured her with their confidence to be a most advantageous medium for obtaining Servants of respectable character.

Servants of good character in any part of the County may obtain Situations at the above address; but no Servant need apply unless her character will bear investigation.

☞ Office hours from Ten till Five.

A waiting room for Servants.

PELICAN
Life Assurance Offices,
70, LOMBARD-STREET, & 67, CHARING-CROSS.

[Established 1797.]

AGENT FOR BRIGHTON:

MRS. SAWYER, MIDDLE STREET.

MRS. FRANCIS,
175, HIGH STREET, LEWES.

OFFICE FOR DOMESTICS,
BOTH MALE AND FEMALE, AND
REGISTRY FOR APARTMENTS.

Charge, 1s. upon Application, and 1s. 6d. more when Suited.

All Letters requiring an answer, a Stamped Envelope to be enclosed.

PENELOPE GANDER, BRIGHTON

AND LONDON RAILWAY CARRIER, DAILY, No. 6, REGENT STREET, and 28, NEW ROAD, BRIGHTON.

OFFICES IN LONDON.—George Grinslade's, the George Inn, Borough; and Castle and Falcon, Aldersgate street, City; Henry Gander's, Catherine Wheel Inn, Borough; and 20, Old Change, Cheapside, City.

Waggons and spring vans kept for the purpose of removing goods to any part of England. Goods warehoused by the week, month, or year.

P. GANDER, in returning her most grateful thanks to her friends for the liberal patronage bestowed upon her late husband during the last 30 years, begs to inform them and the public generally that she intends carrying on the business established by him with the assistance of her son James, and in soliciting a continuance of their favors would assure them that no exertions will be wanting on their part to merit their support.

28, New road, September 15th, 1854.

THE BANKRUPTCY ACT, 1861.

In the County Court of Sussex holden at Hastings·

IN the matter of MARY GLYDE, of No. 4, Hill-street, Hastings, in the County of Sussex, Fly Proprietress and Beerhouse-keeper, adjudged Bankrupt on the 26th day of July, 1866.

A Meeting of the Creditors of the said Bankrupt will be held before the Registrar at the County Court Office, Hastings, on the 18th day of December, 1866, at Eleven o'clock in the forenoon, for the purpose of declaring a dividend, and also whether any allowance shall be made to the bankrupt. Proofs of debts will be received, and Creditors who have not yet proved, and do not then prove, will be excluded the benefit of the dividend.

WILLIAM BLACKMAN YOUNG,
Registrar.

MRS. OSBORNE,

Letterpress, Copperplate, & Lithographic

PRINTER,

No. 55, GEORGE STREET, HASTINGS.

Osborne's FARMER'S ACCOUNT BOOK, price 7s. 6d.; an excellent method of keeping good Accounts with very little trouble. Also, Osborne's TEAM AND LABOUR ACCOUNT BOOK, price 5s. 6d.

4, GEORGE STREET, HASTINGS,

LATE GENERAL POST OFFICE.

(Established 1830).

A. WATERS (Widow of the late W. V. Waters),

PRACTICAL SILK FURNITURE, and CLOTH

DYER AND CLEANER,

CALENDERER, AND HOT PRESSER,

Merino Steam Finisher, British and Foreign Shawl and Scarf Cleaner, &c.,

4, GEORGE STREET, HASTINGS.

A. W. returns her sincere thanks to the nobility, clergy, and public generally, for the patronage she has received, and trusts, by strict attention and moderate charges, to merit a continuance of the same. An experienced London hand has recently been engaged. All orders will receive immediate attention and be returned with the least possible delay.

Faded Damask, Bed and Window Furniture Cleaned, Dyed, and Finished equal to New.

Feathers Cleaned, Dyed, and Curled, and made on the most Improved Style.

Mourning Dyed at a Day's Notice if required. Blacks Dyed so as not to come off.

Furs, Kid and other Gloves Cleaned. Gentlemens Apparel Cleaned and Renovated.

Orders from Hotels and Lodging Houses done with immediate despatch and at reduced charges.

was brought up this morning and fined 5s for being drunk. Defendant said she was subject to "hysterical fits"'. Although rare, female dentists were not unheard of; there were at least 17 others in England between 1797 and 1854.[16] From 1878 women were banned from practising. From then, dentists had to be trained at special dental hospitals, which were closed to female students until 1895.

OFFICE-BASED SERVICES

Most of the women working in offices were proprietresses of domestic servants' registration offices. These acted as introduction agencies for servants and householders. The servants would register and sit in a special waiting room while, in her office, the proprietress would discuss their merits with prospective employers, who were then introduced to their chosen servant. The agency would receive commission.

A handful of Sussex women were agents for insurance companies. Among them were Mary Spooner of Worthing, Kate Philps of Chichester (who arranged business for the Fire Guardian & Life) and Mrs. Sarah Sawyer of Brighton (Pelican & Phoenix). Female insurance agents were even rarer in rural areas and small towns. I found only one: Harriett Harwood, (County Fire & Life) based at Henfield in the late 1850s.

Only four female house-letting agents were recorded in directories between 1830 and 1870, all of them listed in Brighton in 1839.

Until the late-19th century, clerical work was seen as the domain of men. Few women could have worked in this area, in any case, because labouring women did not have sufficient literacy or numeracy skills and women with adequate education were generally middle class, and thus not expected to work for wages. The pioneer women in this area were bookkeepers. The 1861 Census shows a few women working in this role for various hotels and shops in Sussex.

POST OFFICES

Post Offices were run by a postmaster or mistress, who was a servant of the Crown. In addition, Post Office Receiving Houses were located at many inns and hotels, some of which were licensed to women. There were postmistresses in many small towns and villages in Sussex (the appendix contains a list of them). Some were engaged in running other businesses at the same time. For example, the postmistress at Pulborough was a linen-draper, grocer, and hatter; the one at Albourne was licensee of the *King's Head*, and at Midhurst the postmistress was also a printer.

A postmistress might employ a male or female assistant. Widow Sarah Randell, the incumbent at Hurstpierpoint in the 1850s, employed her son.

Where a postmaster was employed, he was often assisted by his wife or daughter. At Burwash, for example, the post office assistant was married to the postmaster. A similar arrangement existed in Hastings until 1824, when the postmaster, George West, was dismissed. Luckily for Mrs. West, she was retained by his replacement. She lost her job when a Mr. Bond took over in 1829, bringing with him his daughter Alicia as his assistant. When he was dismissed in 1831 Alicia became postmaster, receiving the same handsome salary as a man: £62 a year plus emoluments worth £81. She retained the job for two years.[17]

Other women worked in jobs related to the postal mail. There was a very small number of female stamp distributors in Sussex; the first was probably Elizabeth Bull of 9 Ship Street, Brighton, recorded in 1800. Elizabeth Poole of Cuckfield appears in the 1851 Census as a 'letter deliverer' and, around the same time, Miss Sarah Ray ran the 'Stamp Office' in Battle. Mrs. Martha Cresswell was in charge of the 'Office for Post-Horse Duty' at Worthing.

TRANSPORT

In the mid-19th century, road transport available to the public consisted of horses, sedan chairs, chaises (i.e., chairs) drawn by ponies or goats, small omnibuses, and flys.* This was an era in which no genteel person would carry his or her own shopping, parcels or luggage but would use one of the many commercial goods carriers that operated in every town.

Proprietors of all transport businesses had to be licensed by Town Commissioners. Among the earliest women to be licensed in 19th-century Sussex was Elizabeth Baker. In 1836 she was granted a licence by Hastings Commissioners to operate two sedan chairs. In Chichester, Charlotte Stones was a coach proprietor in the late 1830s, while Mary Attree, of 42 George St, Brighton, was licensed to let horses (and was also an undertaker).

Several female fly proprietors were in business in the 1850s, including Mrs. Hannah Taylor and Mrs. Ann Muzzell in Brighton, and Catherine Roser in Hove. In Hastings, Mrs. E Smith ran a fly business near the *Albert Shades* and Mary Glyde, a widow with three dependent daughters, inherited a fly business (and a beer-shop) on the death of her husband in the early 1860s. Unfortunately the business, based at 18 Hill Street, went bankrupt in

* Quick-travelling, one-horse, covered, lightweight carriages – taxi-cabs, in fact.

1867 but the 1871 Census shows that Mrs. Glyde managed to retain the beer-shop, which was at 4 Hill Street. In Worthing in 1858 Mrs. Sarah Teesdale let horses, flys, and pony and goat chaises, while Mrs. Stent was an Omnibus and Fly Proprietor, as well as running the Railway Office at 29 South Street. Bridget Barton owned the Town & Country Carriers, based at 7 East St, Hastings. She was born in 1799 and took over the business after her husband's death in about 1850. She was summonsed in 1853 because a driver she employed overloaded three horses. In 1856 Mrs. Barton complained to the authorities at being charged a shilling a load for the beach she carried out of the borough limits. Describing herself as a 'very old ratepayer', she suggested that 2d a load would be fairer. They decided instead to waive all charges during the summer.

The most prominent woman in the transport industry in Sussex was undoubtedly Mrs. Penelope Gander who, upon being widowed, took over the proprietorship of her late husband's goods-carrying business in 1854, when it had been operating for 30 years. She had one branch at 28 New Road, Brighton and two more in central London. The firm undertook the removal of goods to anywhere in Britain and also offered storage and warehousing. Gander's luggage truck was conveyed by railway every evening 'to all parts'.

MALE TRADES

As previously mentioned, there were certain trades that were not open to women because they were not admitted to the necessary apprenticeship. However, if a woman married a man in such a trade, and was later widowed, she would find herself the proprietor.

At Rottingdean, Elizabeth Boys was a bellhanger and Mrs. Bethal had a 'chemical factory and works'; while Brighton boasted a female carver and gilder, Mrs. Shelley, of 73 Western Rd. Crawley had a female wheelwright – Mrs. Sarah Bex – while Horsham and Cuckfield had female coopers. Women saddlers and harness-makers operated in Hurstpierpoint, Chichester, Brighton and Lewes in 1828. That year, four out of the nine saddlers and harness-makers in Chichester were female, while Sarah Stround was both a harness-maker and coachbuilder. At Hurstpierpoint, Barbara Norman was a very successful brick-maker and potter with 25 employees; Mary Osgood was a brick-maker at Woolbeding, and Elizabeth Colegate was a bricklayer at Guestling. Sarah Gaston was listed as a builder in Lewes in 1828, while Mary Martin of Arlington was recorded to be a 'lime-burner, farmer & owner of a lime-works'. In Brighton, Hannah

Buckman was a cutler; Mary Bennett, a lime burner; Mary Vine, a miller; and Jane Turner and Ann Cripps were (separately) coachbuilders. There were two female cabinetmakers in Brighton in the 1850s: Mrs. Buzzacott of 1 Dean Street and Mrs. Nye of 45 Market Street; and two female cutlers: Hannah Buckman of 162 North Street and Hannah Hurst of 11 Union Street. The 1859 and 1862 directories of Sussex listed women in the following trades: plumber, painter, glazier, housepainter, gas fitter, brazier, ironmonger, coach-builder, brass founder, stonemason, tinplate worker & brazier, sailmaker, wheelwright (six), and blacksmith (25).*

In Horsham in the 1820s Sarah Phillips was a letterpress printer, and in 1859 Mrs. Matilda Sicklemore was listed as a letterpress and copperplate printer. The 1870 directory includes six female printers in Sussex: three in Brighton and one each in Hastings, Midhurst and Chichester. In Brighton in 1851, Eliza Tickle – a married woman with three children – was listed as having a copperplate printing business at 151 Edward Street.

LAUNDRESSES

Laundering has been carried out by poor women for their own families for centuries, and taking in the dirty linen of others turned this domestic chore into paid work. With the steep rise in population† and incomes, by the mid-19th century an increasing number of families were putting their laundry out to be done by professional laundresses, and it soon became one of the most popular female trades. For example, in 1851, 236 Hastings women were enumerated as washerwomen, laundresses or mangle-keepers, making this the third most populous female occupation. Nationally there were 146,000 in 1851 and an additional 24,000 by 1871.

The work involved heavy and arduous physical labour, and fitness and strength were occupational requirements. Many of the newer, more affluent households in Sussex – especially in the fashionable seaside resorts – had cold water piped in, but most women had to collect it from a well. Some houses had built-in coal-fired copper boilers, such as were installed in the purpose-built washerwomen's houses known as Lavatoria – 'washing-places' – in the new town of St Leonards. Otherwise, linen was boiled in a cauldron hung over a fire and soaping was done in large sinks. There were few labour-saving devices except a wooden 'dolly' with which to work the clothes about and a washboard for scrubbing. The only detergents were

* A list of female blacksmiths in Sussex appears on page 231.
† The population of England increased as follows: 1750: 11 million. 1800: 16 million; 1850: 27 million; 1900: 42 million.

soap and 'elbow grease'. Washed items were passed, as appropriate, to manglers, ironers and clear-starchers.

In the 1840s, as part of the trend towards tidying up the seaside towns, the authorities made washerwomen's work a little more difficult by forbidding laundry to be aired in public places, although items could be spread on certain parts of the beaches to dry.

As the population grew, commercial laundries opened, employing women to wash, iron and mangle, and men to collect and deliver with a horse and cart. One of the first in Hastings was owned by Mrs. Ann Tapp, who was in business for at least 20 years until her death in 1854. I could not establish how many women Mrs. Tapp employed, but in Hove, laundress Margaret Weir hired four washerwomen while in Brighton, Sophia Offen engaged nine at her laundry at 38 Apollo Terrace. Elizabeth Watts was the mistress of a far larger establishment in Brighton, engaging a staff of 45.

While commercial laundries provided running water and more sophisticated equipment, the volume of work was much greater than women had been accustomed to in their homes.

A commercial laundry in Hastings was the site of the first strike involving women workers in Sussex. In April 1860 there was a brief walkout of washerwomen in one Old Town establishment, possibly Mrs. Mary Aldridge's, at 87 High Street, over the bad-tempered attitude of a male supervisor. The local paper took a frivolous view of the proceedings:

Strike among the Washerwomen

[T]he hands engaged in a well-known laundry establishment (which has a place and a name not much over one hundred yards from the town clock),* and the business of which is visibly – so far as folks out–of-doors know anything about – conducted by one of the sterner sex, who, by-the-bye, is the 'don' among the laundry fraternity, as well as the beau ideal of cooks, nursemaids, and other fair damsels who own 'the soft impeachment,' and whose natty 'turn out,' well-kept 'Jerusalem', and polished harness; certainly does credit to this 'antient port,' – suddenly 'struck work' one day last week.

According to 'our own correspondent' this 'nice young laundry-man,' in addition to being rather 'gay,' has also

* The clock was – and still is – on the Old Town Hall building, now a museum.

a penchant for John Barleycorn.* From one or other cause the 'good lady' of our hero, on the day in question, had a dispute with her liege lord, and the poor 'scrubbers and rubbers' fell in for a share of the bad humour of 'my lord'.

The women could not appreciate these whims, and so with becoming 'spirit' down went soap and soap-suds, soda, blue, and 'stuff' and away went the matrons who generally 'stand at the tub,' and matters – that means the dirty clothes, – and the semi-clean linen remained in status quo (freely translated 'dirty water and wash tub') at the time our informant inspected the 'scene of the disaster.' Whether there was a truce, an importation of 'new hands,' or a satisfactory settlement between master and washerwomen, we know not; but as the glazed hat and blue ribbon, and the quadruped with its necessary 'fixings' were both seen (not the hat, but the owner) doing their usual six miles an hour on Saturday, it is hoped that the clean linen department was attended to with its accustomed regularity.[18]

Clearly, the reporter was treating the matter as entertainment. The inflated reporting style accentuates the lowly calling of the washerwomen, mocking them and their concerns. Perhaps ridicule was a way of avoiding having to admit that the genteel classes of Hastings were dependent – sartorially, at least – on a group of uneducated women of the labouring classes.

Six months later, prompted by men's campaigns for shorter hours and early-closing days in their own industries, forty to fifty laundresses and ironers of St Leonards – dubbed 'the fair dames of frothy waters and the smoothers of crinoline' – demanded a reduction in hours or further recompense. Their gruelling shifts began at 6am and finished at 9pm. They wanted to finish at 7pm instead, or to get 6d a day added to their 2s 6d daily wage, but their employers – most of whom were women – refused. On Monday 3rd October the town crier was despatched to let all the town know that the women would work only till Friday, and if their employers did not agree to their demands, they would walk out. 'This caused quite a commotion throughout the town. Bands of resolute females of all ages hurried from house to house, repeating their demand', recalled Brett, a local journalist, while the *Hastings & St Leonards News* reported:

* Beer.

> Our township has been the scene of a commotion since the issue of the last impression of the News and it has been a moot point whether clean linen would not be at a premium. The washers and ironers, it appears, have not yet realized any benefit from the laudable movements which have of late years been gaining ground, for early closing, and shortening the hours of labour of the masculine portion of the labouring population. 'From six in the morning till nine at night' has been 'no fiction' with this hard-worked class. The spirit of disaffection has at length gained the upper hand, and the soap-sudonians, having unsuccessfully demanded 'less work or more pay' – to the extent of two hours' daily abridgement of their toil, or 6d a day more money – struck work on Friday. Many of the employers were necessitated to yield to the demands of the toilers, whereat great rejoicing took place.[19]

The triumphant women got drunk and, carrying banners, marched through the Old Town behind a hired band:

> On Monday evening (having previously primed themselves by potations at the public-houses which they had made their head quarters), they sallied forth through the streets of the district headed by some drums and fifes, and a flag inscribed 'Less hours or we won't work – Britons never shall be slaves.' The scene has been summarised, by those who were on the spot, in the one epithet 'disgraceful.' Under the circumstances perhaps they may be forgiven. It is our sincere desire that these useful personages, having 'won the day,' may make good and beneficial use of the time placed at their disposal.[20]

Brett opined that it was 'generous sympathy which prompted the employers to yield to the demand so readily and so honourably'. He hoped that the women would put the two hours they gained to good use, and suggested the women do 'all in their power to prove by increased interest or activity that the loss to employers it less than they imagine' – in other words, to perform as much work in 13 hours as they had in 15.

One correspondent to the local press was disappointed that women worked at all:

> I was amused to find, from my wife, that considerable embarrassment had arisen from a strike amongst the washerwomen. Now, I dare say that their hours of labour are long and their wages low, but I would ask the question – Where are the husbands? I am told that many of them earn good wages, as bricklayers, carpenters, &c., who spend their wages (which are now very good), with some few and honourable exceptions, in the public-house. If their wages were applied as they should be, most of these women would be found at home, caring for the house and children. [21]

Unfortunately, he failed to suggest who would deal with the town's dirty laundry!

THE ARTS

Although mid-19th-century Sussex boasted many female poets, authors, painters and musicians, these were middle class accomplishments and not paid occupations. Hastings resident Bessie Rayner Parkes, for example, was a published author and poet, yet the 1851 Census shows her as 'unoccupied'. The painters Marianne North and Barbara Bodichon also lived in Hastings in the 1850s and, in the 1870s, it was home to painter Joanna Samworth, novelist Mary Pulloyne, and Mary Howard, a writer on theology and topography. There were several female artists in Brighton; one, Eliza Green of 11 West St, was a portrait painter in the late 1830s.

PHOTOGRAPHERS

From the 1860s the new field of photography created more jobs for women. In 1861 spinster Sarah Parkes of Robertson Street became the first woman in Hastings to be enumerated in the census as an 'artist & photographist'. Later, women were employed as colourists, assistant photographists and photographic artists. Lucy Godbold of 8 Grand Parade, St Leonards, was a 'photographic painter'. Her father was a well-known studio photographer and she had probably been his apprentice. Miss Gillard's advertisement announced that she coloured photographs at her own residence, 1, Magdalen Road, St Leonards.[*]

[*] The 1861 Census showed 204 female photographers nation-wide, or 8% of the profession.

ACTRESSES

Brighton was home to actress Mary Elizabeth Braddon from 1857 to 1860. During this time she took lodgings at 26, and later at 34, New Road. She appeared at the Theatre Royal under the name Mary Seyton and also worked as a journalist for the *Brighton Herald*. In 1860 she gave up acting and began to write sensational fiction. In 1862 her book *Lady Audley's Secret* was a phenomenal success and eventually sold over a million copies.* This enabled her to support her mother (whose husband had abandoned them both). Miss Braddon eventually wrote 80 novels and five plays and was one of the most popular writers of her generation.

Actress Ellen Elizabeth Nye Chart arrived in Brighton in 1865 and married the owner of the Theatre Royal. She carried on working after marriage and even after the birth of her son. When she was widowed in 1876 she took over as manager, greatly enhancing the theatre's success; indeed, Musgrave wrote that 'during her almost legendary reign the theatre achieved a reputation of remarkable brilliance'.[22] Amy Sedgewick, who lived in Hove, also appeared at the Theatre Royal. She gave up her acting career upon marrying in 1858 but five years later was widowed and returned to the stage. She remarried in 1873 and again gave up work; indeed, a silk programme is still exhibited on the wall of the stalls foyer announcing 'Miss Amy Sedgewick for six special performances ... Being her farewell appearances in Brighton prior to her retirement from the stage'. Two years later she was widowed and again she returned to work. After her third marriage she retired permanently from the theatre.

MUSICIANS

Most middle class girls were trained to play an instrument – usually the piano – but only the great virtuosi, most of them foreign, performed professionally. It was not considered appropriate or in keeping with feminine modesty for women to be paid, let alone to seek fame, in any area of music. The only acceptable venue for a public performance was in church, and there were a number of lady organists in Sussex. It is likely that they received no payment; any woman sufficiently educated to play a pipe-organ would probably have come from a middle class family. Among them were Mrs. Munday, organist at a chapel of ease in Worthing, who retired in 1853 after 'long and highly efficient discharge of her duties', and Miss Hurlock, the organist of St Pancras Church, Chichester, in the 1840s and

* It is still in print and was recently made into a television programme.

'50s. Emma Hume was organist at St Mary Magdalen Church, St Leonards, from its opening in 1859 until her marriage in 1864. Miss Hume was the rector's daughter, and she was clearly very talented, for she trained a choir and gave concerts – one performance attracted an audience of 300. She also played at society weddings, including that of an MP's daughter in 1862. The church had functioned with a second-hand organ and, in her honour, a fund was opened on her wedding day to purchase a new one.[23]

Brett mentioned that two blind girl organists, Ellen (13) and Emily (17) and their brother Tommy (11)* had given a recital at St Mary-in-the-Castle, Hastings, in 1856. He reported that 'Their performance, separately, of five pieces each astonished and delighted all the large number of persons present'.[24]

BED AND BOARD

Offering accommodation in their own homes was an ancient and traditional occupation of women. During the late-18th century, many Sussex seaside towns gained favour among the fashionable and wealthy as watering places, and the small handful of coaching inns was soon unable to cope with the growing number of visitors. Women with a spare room or two – especially on the seafront – saw an opportunity to make money, and the seaside landlady was born. Offering accommodation was an ideal business for women: it was socially acceptable, it utilised their domestic knowledge and made them learn business skills and bookkeeping. By 1851, running a lodging- or boarding-house was among the most populous occupational categories of women in Sussex.

Brighton was able to offer seaside lodgings from the middle of the 18th century. By 1824, 16% (27 of 163) of the town's lodgings were run by women; by 1851 the figure had risen to 41% (of 461) and, by 1869, women were in the majority, managing 57% of the town's lodging houses.

As early as 1817 *Powell's Guide to Hastings* listed over 80 women offering all types of accommodation, from a single bedroom to a seven-room beach house. Some let rooms in addition to following a trade or business of their own. For example, milliner Mrs. Henbury let seven bedrooms in her High Street home. For others it was their only source of income: Miss Dutton ran a ten-bedroom boarding-house with three reception rooms. In the

* Brett omitted to give their surname.

Priory Valley, Miss Browning opened a boarding house at 2, York Buildings, near to the newly built *Castle Hotel*, while Mrs. Boomer and Mrs. Gallop offered rooms near the Rope Walk on the America Ground. Trade must have been good, for most of the 80 appeared in successive issues of the guide. In 1822, all nine lodging houses located at the one- to five-bedroomed Ebenezer Cottages were in the hands of females. However, in The Croft, a prestigious road filled with tall, elegant houses, many of which had 12 bedrooms, all of the lodging house keepers were men. In 1851 there were 126 female lodging house keepers listed in Hastings and many more unlisted. They attained a near-monopoly on the seafront.

The establishment of St Leonards in 1828 brought women further opportunities and, as early as 1830, several were offering seafront accommodation; one was Ann Thorp of 20 Grand Parade.[25] Her contemporary, Miss Woodgate, came to St Leonards in 1829 as a lady's maid. After the death of her employer, she leased 19 and 20 Marina and ran them as lodging houses for 45 years. Mrs. Thompson's, at Marina, was said to offer 'all the comforts of a private residence with the additional advantage of select society and an excellent table'.[26]

A list of Eastbourne lodging houses compiled between 1840 and 1860 shows that of 128 named keepers, 111 were wives or widows, 13 were single women and only four were men.

Few women could have afforded to purchase a lodging or boarding house and those who did own the premises most probably inherited it from their parents.

A boarding house was like a hotel, with bedrooms and communal reception rooms, whereas in lodging-houses serviced apartments were let. Some proprietors employed women (and sometimes men) to manage the premises, on a commission basis or for a weekly wage. Others leased and managed a house themselves.

Seaside landladies were often characterised in published literature, and many more were mentioned in diaries or written accounts of holidays. In 1826 an anonymous holidaymaker wrote in a letter:

> My bedroom is about 7ft square … my sitting room is an elegant cube of 8ft … my landlady is about 5ft high, and 5ft in circumference, her face is a finer bit of colour than any Titian you ever saw.[27]

COMFORTABLE LODGINGS

'This is Your Bed, Sir.'

A RESPECTABLE MARRIED WOMAN,

WITHOUT ENCUMBRANCE, wishes for the care of a Lodging-House, in Hastings or St. Leonards, or elsewhere. She is a good Cook, and can give good references. Address, J.R., 1, Sussex place, St. Leonards-on-Sea.

The job required organisational skills; it involved shopping, laundry, cooking and cleaning and also heavy lifting – every day, buckets of coal and jugs of hot water had to be carried up many stairs, in seafront houses that were up to six storeys high. Keepers of the larger houses employed servant girls to perform these tasks and, as Jessie Boucherett described, their day was unremittingly busy:

> The hardest worked class of women are domestic servants, especially in schools, hotels, and lodging-houses. It was a few years ago, no uncommon thing for a lodging-house maid to be at work from six in the morning till eleven at night, getting no rest except at meal times, and even to have these short intervals broken into by the lodger's bell. No one who has habits of observation and has been often in lodgings, can have failed to remark the ceaseless activity of the unfortunate maids, and their worn and weary appearance. Some improvement in the condition of these poor wretches is now beginning to be made. Last summer the mistress of a lodging-house complained to me that it was now necessary for lodging-house keepers to allow their maids to go to bed at ten o'clock every night, and to give them an afternoon out every other Sunday, or no servant would stay.[28]

While in 1820 demand for lodgings had outstripped supply, by the 1860s the reverse was true. Landladies had to lower their charges, and some even went out of business. Angela Hanson of 88 Marina, St Leonards, went bankrupt in 1863, owing £320 to 33 tradesmen. Most were local shopkeepers with whom she had accumulated large accounts, in accordance with the custom of the day. For example, she owed £45 to her grocer – about 45 times a working woman's weekly wage. However, the only debt the court ordered her to settle was the £7 10s owed to her manservant. She did not own the house, and selling all her furniture raised a mere £57. Angela Hanson's debts were small compared with those of Ann Ward, who owed over £2,000 when her lodging-house at Robertson Terrace, Hastings, failed in 1866. For others, business was thriving: in the same town, in the same year, Elizabeth Cox was simultaneously running five seafront lodging houses.

Lodging-house keepers were the mainstays of the tourist and visitor trade and their excellence contributed greatly to the commercial success of the Sussex seaside towns. They were so highly regarded that in 1884 R. E. Smith MP argued that they deserved the vote. He must have been referring

to the top end of the market because the title 'lodging-house' included every class of establishment from the sublime to the squalid. The former included the 13 elegant residences in Pelham Crescent, Hastings. Twelve were lodging houses, of which nine were run by women. There must have been a lot of work involved, because the proprietresses always employed staff or called upon their families for assistance. Elizabeth Ellis, landlady at no. 10 in the 1860s, engaged her three daughters to help manage the house. These sumptuously furnished residences were let by the year, season or month to professional men such as doctors, clergymen, JPs and MPs.

At the other end of the scale, tramp lodging-houses catered for the near-destitute, and for hawkers and travellers, who took rooms by the night. This description of some in Brighton was written in 1839:

> In Nottingham Street there are eight or nine lodging-houses. Lodging keepers have commonly three or four houses, for each of which they pay 2s. 6d. per week. The following is a description of one of them. One room, common to the whole of the inmates, who amounted to 30, including the children, served both as kitchen and sitting-room. The room was crowded when I visited it in company with the chief police-officer, Mr. Solomon,* with not less than 17 people covered with filth and rags. In the largest of the sleeping rooms, 16 feet by 10 feet, by 7 feet high, there were six beds, five on bedsteads and one on the floor, to accommodate twelve people of both sexes, besides children. Each person paid 3d. per night. [29]

In Hastings, all the tramp lodging houses were located in the Old Town. Most were tucked away behind public houses, or were reached only through narrow passages known as twittens. Landladies either rented the house, paid the expenses and kept the income, or managed the house on behalf of the owner, with whom they shared the income fifty-fifty. Many landladies undertook to provide meals and wash linen. There were several premises in East Hill Passage including Ellen Lester's, which was above her beer-shop (the *Fisherman's Home*), and Esther Brooker's, which accommodated 26 guests on census night, 1851, most of whom were travellers. Sarah Fuller's, at 12 Wellington Court, was a squalid place just behind the *King's Head*. Another two were located behind the *Crown Inn*.

* Henry Solomon, Chief Constable of Brighton Police. He has the dubious fame of having been murdered in his own office, in 1844.

One of these (the *Merry Christmas*) was managed by Eliza Paris, who rented the premises for 7s a week, plus taxes, and let 24 beds at 2s a week each. (The behaviour of her clientele can be judged from the fact that she employed a man specifically to deal with rough customers.) Another house, with 12 beds, was run by Mrs. Huggett, who paid the landlord half of the income. She charged 2s per week from which she 'found' (i.e. paid for) all the coals and candles. *Fisher's* had 16 beds and the Principal, Mrs. Emily Brockwell, paid 7s 6d a week rent for it. She later opened one in Gibbon Square, behind the *King's Head*. Ann Holt rented a tramp lodging house behind the *Cinque Port Arms* in All Saints' St. She charged the inmates 2s a week for bed, washing and cooking, and hired a keeper to perform all the work. There were two dormitories, each accommodating eight persons. When full the house brought an income of 32s a week, from which the proprietor, Miss Holt, paid 12s rent and paid the keeper's wage of about 10s.

Miss Holt was a respectable businesswoman with a thriving stationer's shop on the seafront but, sometimes, common lodging house keepers were more disreputable than the inmates. Mary Griffin of Waterloo Place, Hastings, was charged with begging in 1860 and was sent to Lewes Gaol for seven days; a year later she was fined 5s for being drunk and disorderly. Mrs. Fisher was summonsed for overcrowding her lodging-house in East Bourne Street and her servant, Sarah Hart, was fined 5s for being drunk and incapable.

One interesting character was Bridget Flannagan, who was married to a railway navvy. Both were Irish, and their migration can be tracked from the birthplaces of their three children: Bristol, Tunbridge Wells, and Ore. Bridget was an enterprising woman who saw a profitable opportunity in the slums of the Old Town when her husband's job brought them to Hastings in 1850: he was employed in building the railway extension from St Leonards to Hastings. Mrs. Flannagan clearly had little respect for the law. After being fined for running an unlicensed common lodging house at the Fishmarket (called the *Baker's Arms*), she opened a legitimate one in Waterloo Passage but was later fined 1s for allowing more persons to sleep in one room than the law permitted, 1s for letting persons of opposite sexes sleep in the same room, and £1 for failing to whitewash the house.

THE LIQUOR TRADE

Women have been involved in the beer trade for centuries before licensing began in 1610. Stephen Inwood notes that women had a 'strong position in the victualling and alehouse trades since the sixteenth century' from which they were gradually pushed out.[30] Although depleted, they were still very much in evidence in 1851, when over 10,000 British women held liquor licences for beer-shops, while 9,000 more were innkeepers.

Records from the 1820s show that aspiring publicans needed money, friends and a good social standing to obtain a liquor licence. They had to enter into recognizances with sureties of £30 from themselves and £10 each from two respectable persons, generally tradespeople. An aspiring licensee would collect signatures on petitions approving the proposed location of the premises. This was often countered by a petition presented by a nearby publican anxious to block a potential competitor or by local residents or by property-owners worried about the effect on the neighbourhood. For example, Ann Tolhurst of Ore was refused a licence because of complaints that her apple shop was an unsuitable premises from which to sell beer. Lastly, the approval of justices was needed. The applicant was required to prove him or herself a fit and proper person to conduct a public house with all its attendant responsibilities.

By extrapolating from various statistics, it seems that women comprised about a quarter of the licensees in Sussex seaside towns in the early 19th century. Evans' 1805 guide to Worthing mentioned a Mrs. Hogsflesh at the *Sea Hotel* and Mrs. Bacon at the *New Inn*. It was recorded in 1828 that three of the 17 pubs and two of the four hotels in Hastings were licensed to women and, in 1839, women held the licences of two of Arundel's nine pubs. By the 1860s about half of Sussex beer-shops and about one in 10 public houses were licensed to women, and most of the rest were jointly run by married couples but licensed in the man's name. A couple of exceptions were the *Duke of Cornwall*, Post Office Passage, Hastings, where widow Mrs. Wenham held the licence jointly with her son, and the *Colonnade Hotel*, Queen's Road, Brighton, whose landlady – Jane Baker – was an employee and not the wife of the landlord.

LANDLADIES-BY-MARRIAGE

Licences were issued to men, spinsters and widows, but not to married women. A licensee's wife was, however, universally known as the landlady and usually served behind the bar, whenever household and childcare duties allowed. If accommodation was let, the wife managed the rooms, meals and laundry. When external catering was provided, it was she who was praised for the excellence of the victuals. If a landlord was charged with breaching licensing laws it was, as often as not, his wife who appeared in court and paid the fine. It is impossible to discover how many landladies-by-marriage there were in Victorian Sussex because only their husbands' names appear in directories and advertisements.

Ann Yates, for example, was a hotel and pub landlady from 1832 to 1864. She and her husband ran the *Hare & Hounds* at Ore (a small stone-built alehouse with a theatre attached to it) before moving to the *Royal Oak*, a busy hotel in central Hastings. Mrs. Yates bore 13 children, of whom six died in infancy. When of age, two of her daughters worked as barmaids. Although three out of the four family members running the pub were female, only William Yates's name is recorded as licensee. It was not until she was widowed, in 1864, that Ann's name appeared in official records.

It was also common for a wife to take sole charge of a beer-shop or pub while her husband followed his own career. Sarah Nabbs ran the *Pilot Inn*, Stone Street, Hastings, while her husband worked as a sailmaker.*

FEMALE LICENSEES

The only women who could hold the licence of a hotel, pub or beer-shop were spinsters and widows, and so the remainder of this section is about them. In mid-century Sussex, women were licensees of all types of premises, including one-room beer-shops, busy town-centre taverns and spacious, detached country inns. A female licensee might be found in any size town or village, but the greatest number was found in Brighton and Hastings, followed by Chichester, Lewes and Rye.

HOTELIERS

The 1823 *Pigot's Directory* was the first to list a female hotel keeper in Sussex. It showed that one of Hastings' three hotels, the *Crown*, in Courthouse Street, was licensed to a widow called Sarah Smith. It was a coaching inn, and its stabling (for 28 horses and 12 carriages) extended all the way up

* In the 1840s they moved to the *Swan Shades*.

Crown Lane to Tackleway. Mrs. Smith and her husband had run it since 1794. *Powell's Guide* of 1811 said that Mrs. Smith, then a wife-landlady, had 'fitted it up in the best style of domestic comfort.' The death of her husband in 1814 left her with seven children to support, and so she applied for the licence and continued to run the business herself until 1832. She was, therefore, landlady for a total of 38 years. She also owned and ran two lodging houses in East Hill Terrace. *Powell's Guide* of about 1831 was very complimentary, remarking that:

> Mrs. Smith deserves particular commendation and support, as being the first... to add to the accommodation of Visitors by every species of comfort, neatness, and domestic attention.[31]

In a directory of 1839, Mary Ann Eastey was shown as licensee and proprietor of the *Albion Hotel*, 1 Old Steyne, Brighton while her townswoman Sarah Pollard was in the same role at the *New Ship Hotel* in Ship Street. In 1846 seven of Brighton's 106 hotels had female licensees. The *Gloucester Hotel*, near St Peter's Church, was run by Sarah Brierley. It had 30 bedrooms (in which it could sleep 38 persons), and boasted eight sitting and tavern rooms, a grand coffee room, stables with 22 stalls, 11 coach houses, a tap,* and seven cottages.

Worthing's *Marine Hotel* and Seaford's *New Inn Hotel* had female proprietors at the time of the 1851 Census, as did Brighton's *Harmon's Hotel*. The latter's licensee, Isabella Boyster, was a 45-year-old widow with two children aged six and eight. She was clearly prospering, for she employed a number of staff. As well as day workers, living in the hotel were a nursemaid for the Boyster children, a housekeeper, two waiters, a chambermaid, a page, a porter, a cook, two kitchenmaids, a still room maid and two housemaids.

The Conqueror Hotel,† one of the earliest in St Leonards, was managed by Mrs. Collins in the 1830s. Robert Hollond MP chose to stay there on many occasions, and Mrs. Collins was contracted to provide the catering for a huge political banquet in 1841, held in a series of marquees on Priory Meadows. Later the licence was transferred to Mrs. Sarah Johnson, who was also held in high regard.

Each of the four most prestigious hotels of 19th-century Hastings – the

* A tap was a room attached to a hotel or large pub, in which beer could be bought for consumption on or off the premises.
† Located at what is now the east end of Marine Court.

Royal Oak, the *Swan*, the *Castle* and the *Albion* – had female proprietors at some point.[*] The *Royal Oak* at Castle Street was licensed to Ann Sargent between 1825 and 1829 (she had been landlady of the *Hastings Arms,* 1821-2). In 1864, Ann Yates took over the licence of the *Royal Oak* from her late husband but by the end of the year she had retired and moved to London. She retained proprietorship of the pub, leasing it to a series of licensees. One of then, Alice Darke, appears in the 1871 Census as its licensee at the surprisingly young age of 22.

The *Swan Hotel* had for centuries been Hastings' foremost coaching inn, public house and hotel, enjoying a prominent position in the High Street. Every important social and civic function was held there, including sumptuous dinners, fascinating lectures and glittering musical entertainments. Among its licensees were at least six women, including Mrs. Hay (1642), Mercy Grove (1726-29), Widow Gurr (1751) and Henrietta Collier (c. 1836-1841).

The heyday of the *Swan* was the mid-19th century. Its finest hour came when it was chosen as the venue for a famous banquet in 1850 in honour of the Lord Mayor of London, a native of Hastings. Incidentally, according to written accounts, no women were present, and a sketch in the *Illustrated London News* confirms this. Secondary sources cite only William Carswell in connection with the *Swan* at this time, yet his wife Elizabeth was landlady for over 30 years while her husband was landlord for only 17 years. After his death in 1858 Mr. Carswell's estate passed to his wife, and she obtained a transfer of licence for the *Swan*. Under her management, it maintained its high reputation and in 1859 was chosen as the venue for a magnificent banquet in honour of the Bishop of Chichester and 80 other dignitaries. In 1871 Mrs. Carswell received a special presentation from prominent townspeople on the occasion of her 30th anniversary as landlady. The following year she applied to magistrates for a permit to remain open till midnight for the forthcoming Mayor's Banquet. The Mayor himself heard the application and, oddly enough, declined it!

The *Swan Tap*, a beer-shop with accommodation that adjoined the *Swan*, was run in the 1860s by Miss Mary Rosina Willett. It was known to attract undesirables, and the landlady was criticised by magistrates for allowing four people, two of each sex, to share a room for a fortnight. Although Mrs. Carswell had no control over the *Swan Tap*, it operated under the licence she held for the *Swan*, rendering her legally responsible for

[*] The first *Royal Oak* was at Oak Hill, at the southern end of the High Street. It later became the Dispensary.

its conduct, a situation criticised by some as unfair to the licensee.

Owing to ill health, Mrs. Carswell retired in 1873 and died a year later at her home, 9 High Street, leaving her estate to her sister and nieces. The vacant tenancy was advertised in the local newspaper and was taken by Mrs. Collins, a lady with a great liking for strong liquor. When drunk she enjoyed a bout of fisticuffs and in 1875 was summonsed for assaulting her husband.[*]

The first serious rival to the *Swan* opened in 1817 as *Emary's Castle Inn Family Hotel*. Situated on the corner of Wellington Place, facing the foot of the West Hill, it was the first major hotel to open in Hastings 'new town'. It boasted Assembly Rooms for fashionable gatherings and public meetings, a prototype tourist information facility, coach-houses, stables and its own well. Coaches for London and Brighton left from its doorstep. In 1854, 1855 and 1858 Frances Emary was listed as the proprietor, at which time it was called the *Castle Hotel & Posting House*. In 1871 it was recorded that Maria E. Lock, a widow aged 47, was the manager, and on census night she had eight guests and 13 live-in staff in her charge.[†]

Hastings' fourth important hotel, the *Albion*, was also owned by the Emarys until 1867, when the licence was transferred to Harriet Bowles. The subsequent landlord, Mr. Ellis, was a habitual drunkard and Miss Bowles returned, this time as manager. When she left in 1869 the licence was transferred to Mr. Ellis's mother. By the 1880s the *Albion* was back in the hands of the Emarys, with James's widow Susan as licensee. One of her advertisements is reproduced in Rex Marchant's book, *Hastings Past*.[‡]

The *Duke of York* was a low-class hotel in Union Street, a crowded working class area of St Leonards. The licensee, Mary Fairhall, her sister, her daughter and her two sons also worked on the premises. The only guests when the 1871 Census was taken were ten musicians – presumably, a visiting band.[§]

BEER-SHOPS AND PUBLIC HOUSES

Until the late-19th century, there were few 'soft' drinks available and water was mainly unfit to drink, so it was customary for beer to be taken freely at any time of the day, by both sexes, and especially by those of the labouring classes. To meet this demand, a huge number of beer-shops and pubs

[*] The *Swan* was destroyed by a bomb during the Second World War.
[†] The *Castle* was demolished in the 1960s
[‡] The *Albion* is still trading on Hastings seafront.
[§] The former *Duke of* York is now a private residence.

opened all over Sussex. By the third quarter of the 19th century there were many more establishments of that category in Brighton and Hastings than there are today.*

The sale of small-beer did not require a licence. Mrs. Towner was the first woman to sell it in the new town of St Leonards. From 1829 she supplied the workmen employed by the town's founder, James Burton.

Until 1830, if a person wanted to sell only ale or beer, a limited licence – that is, one that excluded spirits – was given by justices. The Beer Act of 1830 changed this; from then, any male householder, or any spinster or widow assessed to the poor rate, could obtain a licence from an Excise Officer for a fee of two guineas, which allowed the sale of beer from private houses, for consumption on or off the premises. This opened the floodgates: it was noted that 100 people were licensed in Brighton in the first week. By 1837 there were 45,000 beer shops in England, licensed to sell ale, beer, cider and perry. About 30-40% of licensees were women. Most comprised a room in a private house in a low-class residential area. Those near the seafront might open as early as 3.30am to cater for fishermen. Some offered music and dancing, and they could get rowdy at times, with drunken quarrelling and fist-fights spilling out into the streets – much to the annoyance of neighbours.

The most disreputable beer-shops were frequented by prostitutes, who often lodged with the landlady above the shop. In 1833, the Poor Law Commissioners for Sussex described beer-shops as 'most mischievous' because they 'allow of secret meetings' and were run by 'the lowest class of persons'. The Commissioners called them 'receiving houses for stolen goods, and frequently brothels'.[32] Twenty-nine years later, a Hastings newspaper editor described them as 'a greater source of public evil than the public-houses' and suggested their abolition.[33] The 1869 Wine and Beerhouse Act meant that a justice's approval was once again required to obtain a license.

In 1860 a writer explained why beer-shops in Brighton were so popular among the working classes:

> The houses of the poor in Brighton, which are situated in
> narrow streets and courts, are for the most part ill-ventilated,
> and badly drained, if at all. The numbers which are huddled

* In *The Encyclopaedia of Brighton* (1990) Timothy Carder noted that in 1889 there were reported to be 774 public houses in Brighton, or one per 130 inhabitants, and in 1990 there were only 235, one per 600 inhabitants.

together in them render decency and decorum next to impossible. Many of them being built with inferior bricks and mortar made of sea-sand are wretchedly damp so that even the walls are covered with lichens, and the miserable tenants, unable to endure the depression of spirits which is the necessary result, try to drown their uneasy sensations in the neighbouring beer shops. [34]

Detailed and lengthy research into the public house licences held by women in every town and village of Sussex was outside the scope of this book, but research carried out for an earlier project[35] uncovered the following information concerning those in Hastings. In 1823, *Pigot's Directory* shows that women held the licences for two of the six taverns in Hastings. The licence of a busy town-centre pub, *The Hastings Arms,* George Street, was held by at least three women in the 19th century: Ann Thwaites, 1800-4; Ann Sargent, 1821-4 and Mary Ann Ray, 1870-1. Mrs. Thwaites was later landlady of the *Anchor Inn,* a few doors away, while Mrs. Sargent moved to the *Royal Oak. The Angel,* St Mary's Terrace, licensed to Miss Barbara Ticehurst in 1852, was patronised by the artist Whistler, who painted the world-famous portrait of his mother in her house, no. 43. The pub was built above St Clement's Caves, which once housed its cellars. An old coaching inn, the *Bull* at Bulverhythe, between St Leonards and Bexhill, was licensed in 1827 to Hannah Davis, widow of the previous landlord, in 1833 to Elizabeth Wilkinson and from 1851-2 to Miss Sheather.

A document in Hastings Museum lists 20 female freeholders of licensed premises. Some were also the licensee while others let the premises to others.

In 1861 twelve of Brighton's 338 public houses had female licensees. *The New Inn,* North Street, had been licensed to a succession of women since the century began, including Miss Heather in 1813 and Mrs. Gilburd in 1818.

A female publican was mentioned in the Sussex press in 1857 for her popularity. Mrs. Fielder, landlady of the *Dolphin Inn*, Emsworth, retired after 32 years. A five-month campaign conducted by her regular customers persuaded her to return.

Lists of women involved in the liquor trade are included in the appendix.

VICTUALLERS

In mid-19th century Sussex, fewer women ran catering establishments than ran pubs. Although three out of eight coffee houses in Brighton in 1839 had female proprietors, they appear in few other towns, mainly Rye, St Leonards and Hastings. One of Hastings' foremost licensed victuallers was Miss Ann Lock. She expanded her high-class confectionery shop at 50½ George Street into a refreshment room and obtained an alcohol licence in order to serve brandy. Miss Lock's was 'frequented by a higher class, and at higher prices'[36] than other, similar premises, and her clientele included members of the local nobility and gentry. In 1864 she was commissioned to make a wedding cake for Catherine, daughter of Frederick North MP. The following year Miss Lock provided the refreshments for the town's Grand Christmas Society Ball in the Assembly Rooms at St Leonards, and in 1866 she was chosen to supply a sumptuous wedding breakfast for the marriage of Mr. North's niece. The 1871 Census showed that she employed three men and that her mother, the widow of a tailor, lived with her.

Premises that had female licensees in the mid-19th century.
The Cinque Port Arms, Rye.

WHITE HART FAMILY HOTEL, LEWES.

Mrs. ELLEN STENNING

(Widow of the late JOHN STENNING),

PROPRIETOR.

This Hotel is replete with every comfort and convenience for Tourists and Families; within Two Minutes' walk of the Railway, and directly opposite the County Hall.

Three very different premises, all of which had female licensees in the mid-19th century.

The White Lion, Brighton; *The Jolly Sailor*, Rye; *The Grenadier*, Hailsham.

St. Leonards on the Sea.
Brunswick House & Undercliff.

Above: The Conqueror Hotel (the detached building, centre left.) By the time this etching was created in 1849, its name had been changed to Brunswick House. Marine Court now occupies the site.

MRS. BROWN,
MARINE HOTEL,
FOR FAMILIES AND GENTLEMEN,
REPLETE WITH EVERY COMFORT & ACCOMMODATION,
WORTHING.

MRS. STEWART'S
COFFEE HOUSE & DINING ROOMS,
29, GEORGE STREET,
HASTINGS.

HOT JOINTS DAILY FROM 12 TILL 2 O'CLOCK.
GOOD BEDS.
DAILY & LOCAL PAPERS TAKEN.

Left: 29 George Street, Hastings.

Premises with female licensees in the mid-19th century.

Clockwise, from above left: The George, 120 All Saints' Street, Hastings (now a private house); *The Old Bell Inn,* Rye; *The Union Inn,* Rye, and *The Stag,* Hastings.

BEAR INN

AND

COMMERCIAL HOTEL,

(Adjoining the River Ouse, so esteemed by Anglers,)

LEWES.

ELIZABETH GARNHAM, PROPRIETOR.

**This Hotel is replete with every comfort for Tourists
and Private Families.**

WINES & SPIRITS OF THE FIRST QUALITY.

FLYS TO MEET ALL TRAINS.

THE SUN HOTEL & COMMERCIAL INN,

EAST STREET, BRIGHTON.

MRS. PERFETT,

WINE & SPIRIT MERCHANT

The House affords superior Accommodation, and commands
A FINE VIEW OF THE SEA.

The choicest Wines and Spirits.

AN ORDINARY EVERY DAY.

*Coaches and Railway Omnibuses call at the Hotel for
every Train.*

EXCELLENT STABLING.

Premises with female licensees in the mid-19th century.

Above: The Bull at Bulverhythe, an old coaching inn, was licensed in 1827 to Hannah Davis, in 1833 to Elizabeth Wilkinson and in 1852 to Miss Sheather.

Below: The Royal Albion Hotel, Brighton. In the late 1830s, Mary Ann Eastey was listed as its licensee and proprietor.

BREWERS

Sussex has been brewing ales for centuries. One of the first female brewers in Victorian Sussex was Elizabeth Jones of 16 Western St, Brighton, who was also a coal merchant. She was recorded as being in business in 1839. The 1841 Census lists Jane Dabbs as a brewer at Edinburgh Square, Chichester, and Mrs. Elizabeth Golden as a maltster and brewer at Northlands, Ashburnham (where she was also sub-post office mistress).

At least three women owned or co-owned commercial breweries in mid-century Hastings. In the 1850s Mrs. Ellen Ruth Amoore took over the Eagle Brewery,* presumably after her husband's death.† The Phoenix Brewery in Courthouse Street, owned by father and son James and Charles Burfield, passed in the late 1860s to their widows, Kate and Frances. Data from 1872 shows that the women also owned eleven public houses and three beer-shops.[37] The rental from these, together with the brewery, must have brought a considerable income. According to the 1871 Census, Kate employed 15 men in the Phoenix Brewery, where her two sons and daughter Harriet were managers. They lived at 1, George Street. An advertisement for their beer is reproduced opposite.

The Phoenix Brewery provides an example of how women in business are omitted from history. In his 2001 publication, *Sussex Breweries,* Graham Holter states in his entry for the Phoenix that James Breeds 'Left the business to his son-in-law and grandson, James and Charles Burfield. It traded under the Burfield name ... until 1908.'[38]

EMPLOYEES

In hotels, eating houses, coffee shops and pubs, girls and women worked as waitresses, cooks, barmaids‡ and chambermaids. A few women were employed as managers. Prior research carried out in Hastings and St Leonards provides these examples: Mrs. Raven was cook and manager at the *Horse & Groom,* Mercatoria, in the 1830s. Miss Bowles was manager of the *Albion Hotel* in the late 1860s and in the 1870s Emma Gribble was shop manager of a cook and confectionery business at 5 Marina Colonnade. The 1871 Census shows that Sarah Ellis, a lady from Cambridge, was assistant manager of the prestigious *Seaside Hotel,* Stratford Place.

* The Eagle Brewery was destroyed by fire in 1868.
† W. Amoore Junior was shown as the owner in *Diplock's* 1846 guide.
‡ The mid-century censuses list barmaids as young as 15.

J. & C. Burfield & Co.,

BREWERS

1, GEORGE ST., & 21, WELLINGTON PLACE,

HASTINGS

HASTINGS PALE ALE
ONE SHILLING PER GALLON

Above: Following the deaths of James and Charles Burfield, their brewery and associated retail businesses came into the hands of their widows Kate and Frances, who ran them for many years without changing the name of the company from J & C Burfield. This obscured the fact that this advertisement was for a business owned and run by women. The 1871 Census entry for 1, George Street, Hastings, shows Kate Burfield, a widow of 62 as 'Head of Household', and her occupation was given as 'Brewer employing 15 men'.

EAGLE BREWERY.

ELLEN R. AMOORE,
COURT HOUSE STREET,
HASTINGS.

Superior Tonic Ale, London Porter, and Stout.

MANUFACTURING

The clothing industry was the second largest employer of women (the largest being domestic service). It encompassed a wide range of different workers, including dressmakers, shirt-makers, makers of underclothing, milliners, hatters, glovers, hosiers, straw bonnet makers, collar-makers, tailors, patten-makers and shoe- and boot-makers. Women also made accessories; among them were lapidaries,* embroiderers, lace-makers and lace-joiners, gaiter-makers, furriers, curriers,† and feather-workers. There were just under a million British women working in the clothing trades in 1871. The greatest number was concentrated in dressmaking and millinery, which occupied 267,000 women in 1851 and 300,00 in 1871.

In the mid-19th century, clothing manufacture was still entirely in the hands of small traders. Milliners and dressmakers occupied the higher end of female 'needle-employment' and at least one operated in every village, while towns abounded with them. Needlework was seen as a natural profession for women because it was sedentary and was traditionally performed for the care and maintenance of the family. Within this industry, a woman might be an employee, an apprentice, a sole proprietress or an employer. A sole proprietress would perform the work in her own home. If she prospered, assistants would be engaged and, at some point, depending on the size of her house, she might move out to a workshop or have one built on to the house. She might also engage one or more apprentices.

Girls had been apprentices for hundreds of years, but the practise was in decline. There were fewer apprenticeships for girls in all trades in the 19th century than there had been in the 18th, partly owing to the separation of work and home, and also because of the increased costs of establishing a business.[39] Nevertheless, some girls managed to secure apprenticeships in small workshops. Millinery required an apprenticeship of up to seven years, during which time a girl received no wages; in fact, fees were charged. It was, therefore, a father's decision whether to pay for his daughter to be apprenticed. An apprenticeship offered a sense of belonging to a trade, and gave women the opportunity to earn a reasonable living and the skills to work for themselves in the future.

* Jewellery-makers.
† Leather dressers.

MRS. WM. BARNES,

CONFECTIONER & LOZENGE MANUFACTURER,

121, EDWARD STREET, BRIGHTON.

FIRST-CLASS CONFECTIONERY.

Pastiles, Jujubes, Lozenges, Sherbets, Jams, and Jellies, all warranted genuine.

MRS. KING,

(From the Establishment of Vouillon and Laure—late Maradan, Carson' and Co.—Prince's Street, Hanover Square, London),

DRESS AND CORSET MAKER,

No. 11, BLACK LION STREET, KING'S ROAD,

Facing the Western Entrance to the Market,

BRIGHTON.

MRS BRAYNE,

STAY AND CORSET MAKER,

132, ST. JAMES'S STREET, BRIGHTON,

(late of No. 2, Colonnade.)

MRS. BRAYNE having now opened at the above Residence with an entire New Stock of the first Parisian Patterns, most earnestly solicits a continuance of that Patronage and support which she has been honored with for many years.

Observe!—Corner of Old Steine, opposite Lewis, Allenby, and Bedford's.

N.B. Agent to Dr Kingdon's Patent Spine Correctors.

MADAME VICTORINE,

(FROM PARIS,)

Milliner & Dress Maker,

4, STRATFORD PLACE,

HASTINGS.

MISS TOOTH

BEGS to announce that she has just returned from Paris, with all the novelties of the season, in Millinery, Mantles, and Dressmaking.

Her Show Rooms will open THIS DAY, Friday, the 8th instant, when she hopes for an early visit from all who have hitherto so kindly patronized her.

14, German Place, Brighton.

JANE PANNET, late of No. 55, Middle Street, Brighton, Dress-Maker, in returning thanks to the Nobility and Gentry, for the patronage she has received these last fourteen years, begs respectfully to inform them that she has succeeded to the Business, and also to the House and Show-Rooms of Elizabeth O'Connor, late Thwaites and Rossiter, of No. 14, German-place, Brighton, which has been established thirty-five years.

J. P. trusts that, by attention, and also by continuing the same moderate scale of prices which she has hitherto been in the habit of charging, she will secure the support of the Nobility and Gentry of Brighton and its vicinity.

Jane Pannett has made arrangements to have the earliest change of Parisian and other Fashions, which will be constantly on view, and which she will be glad to submit to those Ladies who will do her the honour to inspect them.

A. SPRATLEY,

Strong Home-made

BOOT AND SHOE MAKER,

No. 62, NORTH STREET,

BRIGHTON,

Respectfully informs the Friends and Customers of her deceased husband, that she still continues to carry on the above Business for the support of her Family, and trusts, by using materials of the best quality, and employing able hands, to ensure a continuance of that support her husband enjoyed for the last fifteen years.

———— oo ————

Repairing and Bespoke Work strongly executed, at the lowest ready money prices.

In the clothing trades, employment for journeywomen (day-workers) was not lucrative. The problem was that every girl was taught to sew, and needlework thus became the first resort of any woman who had no special skills but needed to earn money. It was also the kind of work that a middle class woman down on her luck might easily take up. Because of the availability of labour, the hours were excessively long and the pay pitifully low. In 1862 a lady journalist warned, 'All who are wise will avoid this profession, because such numbers crowd into it, that the competition drives the payment down to a point below that at which life can be sustained.'[40]

Thanks to the large number of well-to-do lady visitors and residents of Sussex there was plenty of skilled dressmaking work available, particularly in the summer months. Upper class ladies dressed to impress and kept their dressmakers very busy creating, ornamenting, mending and altering garments. Upper-crust lady milliners took business trips to Paris and, on their return, placed newspaper advertisements to advise customers that they were fully apprised of the very latest French fashions, then considered the height of elegance.

As it was unthinkable to venture outdoors without a hat or bonnet, manufacturers of headgear also did a roaring trade, selling ready-made items as well as designing and making them to order. Even the relatively small town of Hastings had 249 adult female milliners in 1851. As well as hats and bonnets, milliners made caps, cloaks, mantles, gloves, scarves, muffs, tippets,* handkerchiefs, petticoats, hoods and capes. With so much work available, especially in Brighton with its numerous wealthy lady visitors, it is intriguing that milliner Lucy Coats of that town was declared bankrupt in 1868 with debts of £110 18s 6d and assets, nil. It seems likely that she was beset by illness or other bad luck, for other milliners were doing extremely well.

During 1834 there was a tailors' strike and local needlewomen quickly turned their hands to this traditional male skill. When the men returned to work, some of the women failed to revert to their former, ill-paid specialities; indeed, some married tailors and worked alongside them. Making stays and upholstery were two more male preserves which women were entering by the 1850s. Staymaking required considerable physical strength and women in this line of business may have employed male labour to assist with the heavier work.

* A fur shoulder cape with hanging ends, often consisting of the fur of a fox.

Nationally, the skilled millinery and dressmaking trades were damaged by the growing demand for cheap, ready-made clothing. From the 1840s some garments began to be cut in quantities on a band-saw and then given to needlewomen to finish off at home at very low piece-rates. These 'slop-workers' became a cause célèbre after an 1843 report in the satirical magazine *Punch* shocked the public with stories of their cruel exploitation, and of how they lived, worked and died in miserable conditions, often resorting to the pawn shop, prostitution, and even theft to keep themselves from starving. Indeed, cases were brought before Sussex magistrates in which a milliner or dressmaker had pawned the material given by a client.

In the 1870s, the sewing machine began to come into use in Sussex as elsewhere; a small handful of machinists appears in the 1871 Census, working for dressmakers and tailors.

Women have traditionally laboured in family workshops, manufacturing a wide range of domestic wares, and a number of Sussex women were engaged in these crafts. The 1855, 1862 and 1870 Sussex directories listed women in the following trades: cabinetmaker, chairmaker, chair caner, chair-bottomer, cupper, surgical bandage manufacturer, pianoforte maker, manufacturer of small items made of sea-shells, sail-maker, account book manufacturer, basket-and-sieve maker, birdcage-maker, umbrella-maker (there were just three: a widow and her two daughters), brush and broom manufacturer, watch or clock maker, and artificial florist (who made French paper flowers or wax flowers). Maria Moon of Lewes was an ostrich-and-fancy-feather manufacturer in the late 1820s, and Mrs. Wood, also of Lewes, manufactured guns, rifles and pistols in the 1830s (see her advert on page 53), while Eliza Stone of Brighton was a black borderer in the 1850s. Women also worked in the flourishing tobacco-pipe trade, as pipemakers, turners and trimmers.

A small number of women headed family businesses. In Petworth, Mrs. Frances Elliott & Son were maltsters, hop merchants and corn factors. The Lewes firm of Grace Cheale & Sons, located in Southover High Street, manufactured agricultural machinery. Mrs. Cheale employed eight workers, one of whom was her son, who worked as a machinist. Mary Goldsmith of Sussex Street, Brighton, owned a tobacco pipe manufactory employing seven men. She inherited the business from her late husband, whose death had left her with five children to support, the youngest being under five.

Food manufacture was undertaken by female bakers, confectioners and pastrycooks. These were generally one- or two-person businesses and items for sale would normally be manufactured in the back room of the shop. As

well as producing goods, bakers often cooked meat and pies brought in by customers with no oven at home.

An article on Victorian dressmakers can be found in the appendix on page 240.

TOLL-COLLECTORS AND CARETAKERS

Many Sussex women were employed by commercial firms and private individuals as caretakers in establishments or services open to the public. The majority worked at turnpike gates, as toll-collectors. Thomas Brett mentions that in early-19th century St Leonards, 'There presided in the Tower toll-gate a venerable old dame and doctress* of the name of Dabney ... much respected by all who knew her'.[41] Most of them were widows, but married women were sometimes found working at tollgates; one, Ann Sturt, collected tolls from users of the turnpike road at Hailsham. She was aged 40 and raising six children. On quiet roads the duties of a tollgate collector were not enough to keep her busy and the income was insufficient for subsistence. In such cases, some ran another business; at Chichester, for example, toll-collector Mary Wallis also kept a beer-house.

Some women were employed in more unusual areas. In 1839 Isabella Shopland was recorded to be, jointly with her husband, a Collector of Tolls at Brighton Market.

A small number of women were employed as gatekeepers at large houses. Mary Beany, a widow with three young children, attended the gate at Baldslow House, and elderly spinster Elizabeth Whybourne was employed at Bohemia Lodge, Hastings. The 1871 Census shows that she still held the job at the age of 96. The Earl of Chichester employed a woman as Keeper of Old Hastings Castle in the 1850s. Widow Sarah Whyborne, a lady in her sixties, was assisted by her son David, who later succeeded her. She kept a resident house-servant, so presumably the Earl paid a reasonable wage.† Very few women held janitorial posts at public buildings. One of them was Mrs. Sarah Payne, Hall Keeper at Brighton Town Hall in the 1860s.

* By 'doctress' Brett perhaps meant that she was a wise-woman who knew how to use herbal remedies.

† The Whybornes' gravestones are visible at old Halton churchyard, Priory Road.

During the 1850s, fruiterer Ann Golding was listed in Hastings' directories and advertisements as 'Keeper of St Clement's Caves and Cosmorama'. The ancient caves had been rediscovered in 1825 and Mrs. Golding's husband had obtained permission to open them as a tourist attraction two years later. When Mrs. Golding died, her daughters took over the fruit shop and the caves.

MATRONS AND SUPERINTENDENTS

It is worth making a brief incursion into the 18th century because during that period, women were sometimes employed as heads of public institutions, a practice that ceased as the prison population grew and as small parish poorhouses were abolished to be replaced by larger workhouses.

Ivy Pinchbeck noted that certain parishes in 18th-century Hertfordshire recognised the right of a widow to succeed her late husband as a gaol-keeper.[42] Whether this was widespread in Sussex is unknown, but examples exist for Horsham, Hastings and Petworth. Horsham Gaol was noted in 1773 as being managed by a widow, who was paid £10 a year.* From 1753 Mr. and Mrs. Lovekin were appointed Master and Matron of St Clement's Poorhouse (known as the *Pilchard*) in George Street, Hastings.† When Mr. Lovekin died in 1760 his wife, Sally, became Governor pro. tem., assisted by her daughter. A public meeting voted by 34 votes to six that she should continue, and she held the post for five years.[43] Fifty years later, another Hastings widow headed a public institution, for nine years. Hannah Goodwin was born in 1798 and, by the age of 24, was a destitute widow with three children, the youngest just 12 months old. After working as a monthly nurse, she took charge of St Mary-in-the-Castle Poorhouse in 1828. This was located at what is now 12-16 Wellington Place, and housed 20 inmates. When it closed in 1837 – the workhouse took over its role – she lost her job. The next time she appears in records is in 1848, when she was working as a pew-opener at St Clement's Church and, with her dressmaker

* The gaol at Horsham in 1773 was described by John Howard as follows:– 'Only one room about 10.5 feet by 6.5 feet, 6.5 feet high. In it the prisoners are always locked up. Allowance, 3d. worth of bread a day. No employment. Keeper a widow whose husband died of gaol fever. Salary £10. Fees 3/4. No table'.

† All Saints' Poorhouse was in Old London Road and that of St Leonards was a thatched cottage in Tivoli.

daughter, had moved to Church Passage, where they occupied a cottage adjoining a graveyard, comprising three rooms and a wash-house. Owing to failing vision she became unable to work, and she died a pauper in 1854.

In 1932 writer Wray Hunt considered the duties of a female gaolkeeper. The object of his musings was Ann Smart, who took over the governorship of Petworth House of Correction in the late 18th century:

> The keeper of the House of Correction received a small salary, but had to keep the prisoners out of her own pocket, being reimbursed each quarter sessions… One wonders what Ann Smart did about certain of her duties. It was the task of the keeper of the House of Correction to administer the discipline of the house to vagrants and petty rogues, and Ann Smart had plenty of such, of both sexes, in her charge. It would also be her duty to whip convicts through the streets when that very common sentence was passed upon them. One wonders whether the redoubtable Anne did this herself or by deputy? If the latter she would have to pay for the service, the regulation fee being half a crown for a whipping administered in the gaol, five shillings for whipping at the cart's tail, plus the hire of horse and cart…
>
> It must have been a strange life for a woman, controlling a prison full of ruffians of both sexes, with no separate cells, except a few black punishment holes where the prisoners were chained by the necks to the walls, or, if one bill is to be trusted, confined in thumbscrews, presumably not the mediaeval torture implements, but an arrangement like the finger pillory that caught and held the thumbs of refractory prisoners so that struggling and resistance gave intense agony.
>
> Ann Smart's days cannot have been dull. She must have known that every time she passed through the common room of the prison she was in peril of assault, if not worse… I wonder if she had in her charge the last woman to be burned in Sussex… a certain Anne Cruttenden…[44]

By the 1830s, matrons were no longer placed in charge of gaols or poorhouses, except in the master's temporary absence. They had specific responsibilities of their own, mostly relating to the supervision of female inmates and the domestic arrangements. (The duties of a workhouse matron are listed on page 242.) According to the 1841 Census, 1,598 British women were 'Keeper, or Head of a Public Institution'.[45] These would have been heads of hospitals and asylums, which will be discussed later.

The 1861 Census abstracts revealed that 3,272 Sussex women were employed in 'Public Service'. This included all public institutions that housed female inmates, prisoners or patients, such as gaols, lockups, houses of correction, workhouses, hospitals, lunatic asylums, and charitable institutions for the poor, the sick and the disabled. The employment of some was guaranteed by law: a statute enacted during the reign of George III stated that 'a matron shall be appointed to every prison in which female prisoners shall be confined'.[46]

All of the above-mentioned institutions employed women as nurses, attendants, cooks and housekeepers. The large workhouse in Brighton also employed a woman as superintendent of female labour and another as 'Assistant of Imbeciles'. Workhouses also employed schoolmistresses, of whom details are included in the section on teaching.

Seldom was a woman placed in any but the lowest ranks of power or influence and never was she permitted to wield authority over men, other than servants and inmates. The best a woman could aspire to was to obtain a post as matron and, once there, she usually remained until old age or infirmity forced her resignation. Owing to the lack of career opportunities for women, they tried to retain good situations for as long as possible. In Brighton, for example, the first matron of the workhouse, Mrs. Sattin, remained in her post (with her husband as governor) for 32 years from 1859. *

To be considered for this type of work, an applicant had to be respectable, pious and of unblemished reputation. Perhaps as a result of reading Dickens' *Oliver Twist*, modern day writers often have a poor opinion of those who ran workhouses. For example, Peter King wrote:

> The job would appeal to a homeless couple, the husband perhaps a bully, with a shrewish wife, delighted to command the unlimited supply of free servants. Generally speaking though, workhouse matrons were slightly less unkind than their husbands. [47]

In fact, workhouse and prison matrons were usually well respected. Mrs. Jones, matron of Lewes House of Correction, ceased work when age and infirmity prevented her from carrying out her duties. The authorities recommended that, as her conduct was in every respect good, she be granted a pension, a very rare thing for a woman to obtain at that time. The

* Mrs. Sattin's daughter Elizabeth was, at some time, the assistant matron.

chaplain spoke of her kindness and the governor added that 'a more humane and attentive person there could not be'.*

A gaol or workhouse matron was usually the wife of the governor or master because, in most cases, living quarters were shared. This was also the case where other staff were employed. The wives of deputy masters, porters and schoolmasters became assistant matrons, nurses and schoolmistresses. There were several exceptions to this. At Lewes† and Petworth gaols, the accommodation for governor and matron was separate and each job was advertised independently. An announcement in an 1852 newspaper invited applications from 'a person not less than 30, nor more than 45 years' to fill the matron's post at Petworth. The salary was £50 per annum, 'with coals and candles in addition, but no rations'. At Ticehurst Workhouse in the early 1850s the (23-year-old) governor was married to a teenager of just 18 and so Charlotte Elliott – a well-respected local widow with the maturity of 57 years – was appointed matron instead.

Women working in social institutions witnessed many unpleasant sights because their work put them in close contact with the most desperate and degraded members of their sex. In 1868 the Medical Officer for Brighton Workhouse at Race Hill reported that the maternity wards housed:

> A large preponderance of single women, mostly servant girls, some of the town [i.e., prostitutes], a few with syphilis, and many married women who had been deserted by their husbands. [48]

As there were no female police officers, wives of police officers or gaolers were employed when necessary to search female prisoners. A small gratuity was probably given to them by the sergeant for this occasional task.

With regard to remuneration, the joint wage offered at Chailey for a married couple as master and matron of the workhouse was £52, plus 'board, lodging, fuel etc', while East Grinstead offered £60. The latter stipulated that the master must be able to keep accounts, and that both must be of the Established Church. An advertisement for a vacancy as assistant matron at Lewes Workhouse in 1865 offered £26 plus 'board at

* In the prison at that time were 44 males and 10 females convicted, and 80 males and nine females awaiting trial.
† Its full title was the County Gaol and House of Correction for the Eastern Division of Sussex.

LEWES HOUSE OF CORRECTION.

WANTED, a FEMALE TURNKEY. All persons desirous of the appointment are requested to send to me, in writing, (free of expense), on or before Wednesday, the tenth day of November next, a statement of their names, age, and place of residence, with testimonials of qualification and character. The wages will be 12s. weekly for the first two years ; 13s. 6d. weekly above two years and under five ; 15s. weekly above five years and under ten ; and 16s. weekly above ten years. Further particulars of the duties of the office may be known on application (free of expense) at my office, or at the said House of Correction The candidates will be required to attend personally at the House of Correction, on Thursday, the 11th day of November next, at 11 o'clock in the forenoon precisely.

WM. POLHILL KELL,
Clerk to the Visiting Justices.

Lewes, 28th October, 1841.

BATTLE UNION: WANTED IMMEDIATELY

A man and his wife as Governor and Matron of the New Central Workhouse. Salary £100 with three rations of such provisions as the House affords, and no allowance or payment to be made for any extras whatsoever. The parties chosen will not be allowed to bring more than two children into the House with them and if any are brought, their maintenance to be deducted from the aforesaid salary.

Below: Wyckham Terrace, Brighton. Built in 1850 in the Gothic style (unusual for Brighton) it served for many years as a home for 'Female Penitents' (reformed prostitutes) under the watchful eye of Arthur Wagner.

Hastings Infirmary, workplace of numerous women including a matron. A lithograph, from the 1860s. The White Rock Theatre now occupies the site.

the Governor's table', washing and lodging for a woman aged between 25-40 'without incumbrance'. Workhouse schoolmistresses usually earned about £10 per annum, while a nurse was paid £16 per annum plus her board and lodging.

While women were no longer placed in charge of a gaol or workhouse, they could head private institutions. In the 1850s Ann Ivory, a 50-year-old widow, was governor and proprietress of Ringmer House Lunatic Asylum. She employed three nurses and two domestic servants. In the 1870s Mrs. Foreman was head of Church Hill House Asylum, Brighton, and Mary Pank, a widow, was 'Superintendent of the Insane' at a private asylum at 76 Marina, St Leonards, where she employed two male attendants and a housemaid. In her charge were four male 'lunatics', two of whom were peers of the realm.

Women were superintendents and matrons at a wide range of charitable institutions, including Ladies' Homes, Industrial Kitchens, Servants' Homes, Mendicity Houses and Convalescent Homes. Among them were, in Brighton, the Asylum for Poor Female Orphans and the Asylum for the Blind and, in Chichester, the Pupil Diocesan Institution, which trained young females to be domestic servants. The first matron of White Rock

Infirmary, Hastings, a 22-bed institution that opened in 1841, was Mrs. Crouch. Her initial weekly wage of 8s was soon raised to 12s, plus free accommodation, coals and wood. She was succeeded in 1862 by Miss Griffen, former housekeeper at the Foundling Hospital,[*] London, who was selected from 22 applicants. Frances Hartley soon replaced her and remained as matron for 20 years, retiring only because of her defective vision. Similar longevity was demonstrated by Maria Marshall, who was Matron of Hastings' West Hill Industrial School for 22 years.

Women were treasurers, secretaries, and collectors for various charities. For example, Mrs. E. Chatfield was assistant secretary and collector for Brighton Dispensary.

THE CHURCH

Within the church, a woman could be a deaconess, a nun or an Anglican sister. The 1851 Census abstracts for Hastings show two women 'church officers'; these may have been caretakers, or pew-openers, a traditional women's job in the church. Among the former was Lucy Smith, chapel-keeper at the Congregational Church at Robertson Street, Hastings, in 1861.

Pew-openers were mainly widows; they spent much of Saturday polishing the pews, seated the congregation two or three times on Sunday, and attended on weekdays for weddings and funerals as required. Coins received from the congregation amounted to about 30s per annum, making the 'salary' about one-seventh of the average woman's wage. Despite that, 'A Cambridge Graduate' complained in a letter to the local press about having to give a penny to the pew-opener at St. Clement's Church, Hastings.

It has been claimed that the idea of convalescence by the sea was virtually invented by the Reverend Mother Harriet Brownlow Byron (1818-1887). After recovering in Eastbourne from a very serious illness, she founded All Saints' Convalescent Home in Meads, a district of Eastbourne, in 1867. The foundation stone was laid by Lady Fanny Howard and it became operational from 1869. It was named All Saints after the Anglican community she had founded in London in 1851. The original building still stands and is now All Saints' Hospital.

Religious women also founded and worked in educational establishments, as described in the next section.

[*] A foundling was a child, usually illegitimate, that had been found abandoned.

TEACHING

As there was no state education system until the late-19th century, schooling was provided by privately owned seminaries, by endowed and charity schools, and by churches. Government first took an interest in education in 1833, when the Education Bill awarded grants to support some schools.*
This interest culminated in the 1870 Education Act, which was the first step towards the provision of free and compulsory education for all children.

Teaching was highly respectable but poorly paid. Because all other professions were closed to them, for intelligent women teaching was the nearest they could get to an academic career. The term 'academic' aggrandises what was in fact a lowly qualified job performed mostly by people with a meagre education.

Women teachers in mid-19th century Sussex taught in four circumstances: as proprietresses of private day and boarding schools; as tutors of single subjects at an hourly fee; as governesses teaching children in their homes; and as employees of institutions, including Sunday Schools, endowed schools, British Schools, National Schools, Ragged Schools, gaols, workhouses, schools of industry and private seminaries.

PROPRIETRESSES

There were hundreds of private schools in Sussex, both day and boarding. The earliest appeared in the late-18th century in Brighton, Hastings, Lewes and Chichester, and by the mid-19th century they were found throughout the county. As the years progressed these 'seminaries', as they were usually called, became increasingly numerous and the censuses show that children were sent from all over the world to be educated in Sussex.

One school for young ladies, owned by the Twiddy sisters, was at 81 High Street, Hastings. They offered 'full board and instruction in English, French, geography and history', and assured parents that 'references of the highest respectability can be given.' The charges were: 25 guineas per annum for fulltime boarders, 18 guineas for weekly boarders, and eight guineas for those who attended by the day.†

* The first grant, in 1833, was £20,000; by 1870 state support had increased to £800,000.
† A guinea was £1 and 1s.

'PROFESSORS'

Women with a suitable education in a single arts subject offered private tuition in their own homes. They habitually advertised themselves as professors (of music, singing, dancing, drawing or a language) but, since women could not attend university or obtain any formal qualifications, this title had no academic substantiation. Their skills were mainly those learned as ladylike accomplishments, although Mrs. Begbie of St Leonards, who in the early 1870s advertised herself as 'late Professor of singing at the Royal Academy of Music' was, presumably, properly trained.

CHURCH SCHOOLS

Sunday schools are thought to date from the 16th century and rose in popularity until, by 1787, about 250,000 pupils attended in England. The growth of Sunday schools in the early-19th century was phenomenal. They were popular because both the children and the teachers – who were untrained volunteers – had Sundays free from work. In 1801 nearly 14% of working class children in Britain went to Sunday school; by 1831, the proportion had increased to almost 50% (1.25 million) and in 1851 three-quarters of all working class children aged between five and 15 were regular or irregular attenders.

Most large Sussex towns had thriving Sunday schools before 1820. The first to open in the new town of St Leonards was founded by a group of ladies headed by the founder's wife, Mrs. Elizabeth Burton, at 36 Marina, between 1828 and 1830.[49]

The National Society for the Education of the Poor in the Principles of the Established Church was founded in 1811. Its aim was to open a Church of England school – known as a National School – in every parish of the land in order to teach the Scriptures and basic literacy, and to bestow a moral education. By 1851 it had opened 17,000 schools nation-wide. Among them was the Parochial Boys', Girls' and Infants', founded by Rev. W. Wallinger, minister of St Mary-in-the-Castle, Hastings, in 1830. In 1848 it was given a proper schoolroom at Portland Place by Mrs. Vores, the mother of his successor.

The non-conformist churches opened British Schools under the auspices of the British and Foreign Schools Society. They were introduced in 1810 and the first in Sussex was probably the one opened in Eastern Road, Brighton, in 1828. By 1851 there were nearly 1500 in Britain.

The first British girls' school in Hastings was opened under the patronage of the Duchess of Kent at a Wesleyan Chapel in Waterloo Place in 1835. It had places for 100 girls.* St Clement's and All Saints' National Schools also opened in 1835 with fees of a penny a week per child. The girls' section, 200-strong, moved to 99-100 All Saints' Street in 1853. One of the early head monitors, Mary Ann Pickerden, became a fully qualified and certificated teacher, whereupon she left to work in Birmingham. In 1863 Maria Caldwell became the seventh mistress from the school to compete for a scholarship and to be elected a Queen's Scholar of the First Class. Her prize was one year's instruction with board, lodging, laundry, medical attendance and £3 spending money. (Male winners of the same prize received £4.)

St Leonards Sunday school grew and was moved into a corner of the Assembly Rooms, then to St Clement's Place, East Ascent, with Mr. & Mrs. Tebay in charge. It later merged with the St Leonards National and Parochial School that opened in Mercatoria in 1847.† The first master and mistress of this school were a married couple from the north of England. It is interesting that Mrs. Gibson was employed as the school's mistress while raising a family. Mr. Gibson was paid £60 a year while his wife received £45. Their house was provided rent-free. Other schoolmistresses earned less. The one at nearby Christ Church infants', for example, earned £30 per annum in 1865. The mistress of Wadhurst National School in 1833 earned £10 – while the master enjoyed £20 – to which was added the penny a week paid by each child.

As National and British Schools were opened across Sussex, they created thousands of jobs for women.‡ Women could teach only infants and girls, because they were insufficiently qualified to teach the boys' curriculum, since they were denied entry to universities. Some schools used a 'monitorial' system, in which a teacher taught monitors, who in turn taught the younger children. (This meant that some very young girls were enumerated in the census as pupil teachers; the youngest found during this research was 13.) This developed into the pupil-teacher system, in which children were apprenticed to a teacher, after which they could take an exam for college. After training college they could get a certificate permitting them to teach.

* The boys' school was opened under the Baptist Church in Wellington Square.
† It is now a mosque.
‡ By 1841, there were over 29,000 schoolmistresses in Britain.

All church schools were dependent on voluntary contributions. However, the National Society had the advantage of benefiting from the existing Anglican diocesan and parochial system. In addition, people favoured the Church of England when making donations and bequests.

The churches trained their own teachers. In Chichester there was a Diocesan Training College for Schoolmistresses at Rose Hill.

A parish schoolmistress had a tough job, for poor children usually had no prior education and the classes were overcrowded. In 1846 the *Infant Teachers' Assistant* said of staffing:

> We are bold to affirm that few females, if any, are competent to the charge and instruction of more than sixty or eighty children. Above that number will require a master and mistress.[50]

In 1869 the Rector of Burwash wrote of a pupil teacher at his local school:

> Polly Thompson needs more systematic help in teaching: the numbers are too great & the initial ignorance of the children to give her a fair chance. She works hard & conscientiously, tho' she lacks all enthusiasm. Still she is a good mistress.[51]

Many spinsters dedicated their whole lives to teaching. One, Miss Watson, was mistress and headmistress of Wadhurst National School for 42 years from 1866. Originally from Burwash, where she was a pupil-teacher for five years, she had served as an assistant teacher at Framfield and studied at the Normal Training College at Brighton. Another, Eliza Wood, worked at Burwash School for 36 years, first as principal and later as an assistant mistress after the school came under the auspices of government regulation. She was a much-loved figure, and was teaching until a few hours before her death at the age of 62, in 1870. The rector said that 'a more faithful consistent God fearing teacher it would be hard to find.'[52]

One of the most outstanding teachers of this era was Miss Charlotte Page. During her 40-year career she was head of Wadhurst's Cousel Hill School, where she gave instruction, amongst many other subjects, in:

> Form, including the triangle, pentagon and rhombus; general subjects such as the manufacture of paper and its properties; rice and its cultivation and growth; water, the island, trains; natural life, with the wolf, mole, bat, ostrich, birds and their beaks, together with daffodils, roots and edible roots; colour,

including shades of red, and, too, the 'general uses of the map'.[53]

She even played the organ to accompany hymns. Miss Page had been a pupil teacher in London for five years and had trained for two years at Brighton College before going to Wadhurst, at the age of 21, in 1868. During the first school inspection in 1869, it was recorded that she 'is conducting it with much tact and judgement. The general condition of the school does her much credit.'[54] In her next school, Wadhurst Infants', she was highly praised for her confident manner, and for the good discipline and 'happy tone' of the school.*

The convent at St Leonards had opened in 1834 as a nunnery for the Daughters of the Holy Heart of Mary and, in 1848, was taken over by the Society of the Holy Child Jesus, headed by the society's founder, Mother Superior Cornelia Connelly of Philadelphia, USA.† By the 1860s, there were three schools on the site. One was a surprisingly cosmopolitan, fee-paying boarding school for young ladies; another was St Michael's Middle School and the third was the Gate School, for the poor. The boarding school was a fine seat of learning that boasted an impressive array of 20 female teachers from Lancashire, Devon, Ireland, Switzerland and Italy. They were all specialists in their subjects, which included music, singing, painting, literature, Latin, French, German, grammar, drawing and needlework. The boarders came from all over the UK, and also from Belgium, Spain, India, St Lucia and Australia. An inspector's report said:

> It is impossible to witness without admiration the results obtained in this very interesting school in which consummate skill in the art of teaching, unwearied patience and the most persuasive personal influence have combined to accomplish all the rarest fruits of Christian instruction. The school is now probably one of the most perfect institutions of its class in Europe.[55]

The schools had 35 live-in servants, of whom 32 were female, including a doorkeeper, a dairymaid and a baker. The youngest servant was aged eight: she was the 'second-under-kitchen-maid-in-training'. She may

* Many more details of Miss Page's time at Wadhurst are given in Kenneth Anscott's excellent book *The Education of Wadhurst*.
† The Venerable Mother Connelly died at St Leonards on 18 April 1879 and was buried at Mayfield. A short biography can be found on page 241.

have been one of the orphans that Mother Superior Cormelia Connelly would take in and instruct in domestic service.[56]

ENDOWED AND CHARITY SCHOOLS

Philanthropists founded a number of schools for the children of the poor. Some were endowed by one person while others were supported by public subscription. Although most were for boys, some for girls existed, and among the earliest was the Union Charity School for Girls in Middle Street, Brighton. Later, Mr. Swan Downer bequeathed £7,100 to found a charity school for girls in Brighton. He intended to clothe and educate 20, but the Trustees managed to eke it out so that 50 girls benefited. At Bognor, Princess Charlotte founded the Jubilee School, for 50 girls, and Mrs. Smith endowed a school to clothe and educate a further 20. When James Saunders died in 1708, he left sufficient money to open schools in Hastings – one for boys and two for mixed infants, each taking 30 children. These opened in 1809 and were supported by public subscription. The infants' classes were run by 'school-dames', who were paid £10 a year – equivalent to a housemaid's wage – compared to £40 paid to the boys' masters. As there was so little employment for educated middle class women there was no shortage of applicants, even at such a low salary. An advert in 1811 drew six candidates. Later the remuneration was raised to £25 but from this the 'dame' had to pay for the rent and coals of the schoolroom.

The first day school in Hastings was Cavendish Place Infants', established in 1829 by the Infant School Society and funded chiefly by Countess Waldegrave, although parents still had to pay a nominal fee. Mistresses Martha and Amelia Andrew worked from 8 until 6 in the summer and until 4 in the winter. They collected twopenny fees from each child on Monday mornings.

The Ragged School Union, founded in 1844, opened schools for children whose 'ragged' clothing was not acceptable to the church schools. They charged no fees. Two of the earliest in Sussex opened in 1855: one in Carlton Street, Brighton; the other in Stone Street, Hastings. Miss Margaret Paton opened another in a former church hall at 39a Tackleway, Hastings. This was in a very poor area of town and by 1862 the number of children grew so large that a fundraising bazaar was held, at which £500 was raised for new premises.

HORSHAM UNION.

WANTED, A SCHOOLMISTRESS for the Central Workhouse at Horsham. Salary Fifteen Pounds, with Board and Lodging in the house.

Candidates are requested to apply at the meeting of the Board, at the Board-room, Central Workhouse, on Wednesday, the 13th day of March next, at 12 o'clock at noon.—Testimonials of character and ability will be required.

Horsham, 28th February, 1844.

Hastings Union.—SCHOOLMISTRESS WANTED

NOTICE IS HEREBY GIVEN, that the Board of Guardians of the Hastings Union will, at their meeting, which will be held at the Board Room of the Hastings Workhouse, on Thursday, the 20th of October instant, proceed to elect a single person, not exceeding forty years of age, to fill the situation of Schoolmistress to the Hastings Workhouse. Salary £20 per annum, with board and residence in the house.

The person to be appointed must be accustomed to the National School system of education, and she will be required to instruct the children in knitting, sewing, mending clothes, &c., and to enter upon the duties of the office on the 27th day of October instant.

Written applications, accompanied by testimonials, are to be forwarded, free of expense, to the Hastings Workhouse, on or before Wednesday, the 19th day of October instant, addressed "To the Chairman of the Board of Guardians of the Hastings Union," and the Board would prefer the personal attendance of the respective applicants at their meeting on the next day (Thursday), at two o'clock in the afternoon.

By order of the Guardians,

Hastings, October 6, 1853. F. C. INSKIPP, Clerk.

PUBLIC INSTITUTIONS

Under the 1834 Workhouse Act, children in workhouses had to be given three hours' daily instruction in 'reading, writing, arithmetic, and the principles of the Christian Religion, and such other instruction as may fit them for service, and train them to habits of usefulness, industry and virtue'. Some schooling was also provided in the larger gaols. Adverts reveal that Lewes House of Correction paid schoolmistresses £20 per annum, while Horsham and Steyning workhouses offered them £15 plus free board and lodging, and Cuckfield paid £25 plus board. Least attractive was East Preston, near Littlehampton, which offered only £10 plus board, lodging and washing. Uckfield Workhouse paid £20 to its schoolmistress (and £30 to its schoolmaster). While the former taught reading and sewing to girls, the latter taught reading, writing and arithmetic to boys. At Ticehurst, the post of master and mistress was a joint one, at a joint salary of £40 'plus double rations'.*

In 1847, the mistress at Hastings Workhouse, Elizabeth Tebay, was suspended and later dismissed for being drunk while taking some children outdoors for exercise. The governor's daughter, Emily Harman, took charge of the children temporarily and although the vacancy was advertised in the local paper, she was appointed. In 1851 she was highly praised by the Government Inspector of Schools and was presented with a gift. She must have left by 1853, since the position was re-advertised. In 1867 Miss Sarah Pusey was mistress, at a salary of £50 per annum plus board.

Mrs. Simmonds, schoolmistress at Petworth gaol, resigned from her post in 1866 in order to spend more time on her home duties. However, as soon as she saw her job advertised in the newspaper at £40 per annum instead of the £30 paid to her, she reapplied and was accepted. This provoked an argument between various senior officers, but it was eventually agreed that, as her services were 'very valuable', and it was 'unlikely that they could get anybody more efficient', she would be allowed to withdraw her notice and continue at the higher rate of pay.

EMPLOYEES

Educational expectations for girls were so low that anyone with a modicum of basic education could become a governess in a private house. This led to the job being overcrowded, which in turn kept down wages. Governesses were socially isolated and low paid. They were too high-class to mix with the lower domestic servants, but too low-class to be friends with their

* Ticehurst Workhouse was built in 1837 to house 200 inmates.

employers. Bessie Rayner Parkes said in 1859 that 'no class of men can compete with the governess in wretchedness' because they were ill paid and ill used, and could never earn enough to put anything aside for their old age. Specialist charities could not cope with the huge number of distressed, even destitute, former governesses.

Those employed in schools exhibited a broad array of capabilities, and salaries ranged widely. One at the Brighton Proprietary Female Day School, teaching English, French, music and drawing, earned £100 without board, while a native of France or Switzerland was offered £80 to teach French, music and fancy needlework. A teaching assistant, in any subject, was paid £30.

The majority of educated schoolmistresses teaching in the better Sussex schools and seminaries were not born here; they came from London and beyond. One, Charlotte Mason (1842-1923), was born in Bangor but moved to Worthing, where she became the first headmistress of Davison School in 1863. She was later Vice-Principal of Bishop Otter College, Chichester, and became well known as a reformer of educational practice and founder of the Parents' National Education Union.

TEACHING AND WOMEN'S EMANCIPATION

Once women became entrenched in the national education system, the need for them to be properly qualified was a very persuasive factor in the campaign to open universities to women.

Many mid-Victorian feminists also saw education as the key to women's emancipation. Educating girls fitted them to become teachers, thus providing careers for thousands of spinsters and widows. Female teachers would be role models of independent career women for the younger generation. They would be living proof that women had the intellect to enter the professions and would confirm that they were fit to have the vote. It was hoped that educated women would become more conscious of the subordinate position of their sex and join the feminist cause.

Indeed, in some areas teaching was a hotbed of feminism and it comes as no surprise that the first women's suffrage society in Hastings was founded by the proprietor of a ladies' seminary in the 1880s.

PREPARATORY BOARDING SCHOOL,
SOUTHOVER, LEWES.

THE MISSES SWAYSLAND

Continue to receive a limited number of young Ladies and Gentlemen, and they beg to express their grateful thanks to those Friends who have been kind enough to honour them with their support, and hope, by attention, to merit a continuance of their favours.

Young Ladies instructed in English History, Geography, with Plain and Ornamental Needlework ; also, Writing and Arithmetic on Moderate Terms.

French, Music, and Dancing, by Approved Masters.

Young Ladies' Establishment,
PROSPECT HOUSE, FAIRLIGHT.

MISS ADES.

Terms per Quarter.

	£	s.	d.
Boarders, upwards of ten years of age	4	10	0
Ditto, under ten	4	0	0
Day Pupils	0	8	0
Writing and Arithmetic	0	5	0
Laundress	0	10	0

French and Music, by Masters, on the usual terms.
Young Gentlemen admitted under Eight Years of age.

Each Boarder is requested to bring a Knife, Fork, Spoon, and Six Towels, to be returned on leaving the School.

The strictest attention paid to the religious, moral, and physical interests of the Pupils.

Above: The National and Langton School was built in Marley Lane, Battle, in 1845. This early print shows the building's fanciful gothic facade. Initially the school comprised two large rooms with the head teacher's living quarters in between. It later became Battle primary school.

Below: The Swan Downer School in Brighton, latterly a disco.

FARMING

Until the mid-19th century most of the population of England lived in rural areas and farming was Britain's largest industry, with almost 1.5 million people involved in 1851, but this was declining and twenty years later only 980,000 were so engaged.

Women's part in farming and agriculture was also in decline. In 1851, for example, the census revealed that only 131 Hastings women were engaged in 'possessing or working the Land, and engaged in growing Grain, Fruits, Grasses, Animals and other Products' compared with 717 men. This amounts to just under 2% of all women over 20, but Hastings was mainly an urban area. The 1861 Census for all of Sussex shows 4.6% of women over 20 so engaged.* These figures include both owners and employees.

Dozens of women in Sussex owned farms. Elizabeth Collyer, a farmer and grazier, had 200 acres at Rye and employed 30 workers while, at the other end of the scale, two sisters with a small market garden and a dairy herd might carry out all of the labour themselves. It was common for farmers to run another business as well. At Lamberhurst, Martha Noakes, a farmer of 210 acres, had a butcher's shop in the High Street and Mary Eastland, a farmer of 150 acres, was licensee of the *Chequers Inn*. Lydia Hooker of Frant, a farmer of 30 acres, was also a victualler.

Of all farm employment, dairy work was considered to be the most suitable for women, although some were engaged in making cider and perry, and looking after bees. Sussex had a large dairy industry in the mid-19th century. Only eleven women were listed as owning dairy herds in 1862, but many hundreds more worked as dairymaids. The work involved caring for, feeding, and milking a herd of cows and manufacturing milk products such as butter and cheese. While modern-day readers may imagine a rosy-cheeked girl doing a little light milking while basking in the Sussex sunshine, according to Harriet Martineau† the work was harder 'and more injurious to health than hoeing turnips or digging potatoes.' Dairymaids often lived in near-poverty and had 'no end of work' to perform. 'On a dairy-farm', wrote Miss Martineau, 'the whole set of labours has to be gone through twice a day, nearly the whole year round' and dairymaids frequently suffered from 'maladies arising from over-fatigue and insufficient rest'.[57]

* Numerically, 4,338 women.
† Harriet Martineau (1802-1876) social commentator, journalist and feminist.

Ellen Carpenter appeared to be a typical Sussex dairymaid, working in Eastbourne in the first half of the 19th century. When she retired aged 70, she begged to be allowed to keep her perquisites, in the form of the cast-off flannel and coarse towelling used in cleaning the dairy. These, and any other old rags she could acquire, were turned into underclothing and stockings and she wore a pair of old kid gloves on her feet. One day in 1857 Miss Carpenter was found dead in the dairy and, to the astonishment of all, when her house was cleared it was discovered that she had accumulated over £700 in gold. Further investigation revealed that she had £878 in the Lewes Savings Bank and 'a considerable sum' in the Bank of England. No will was found, but 17 cousins emerged as from nowhere to stake their claim. Where the money came from was never established. She certainly could not have saved it from her earnings: a dairymaid was paid about £10-12 a year.

A list of female farmers appears on page 232.

RAILWAYS

From the 1840s the first railways were being constructed in Sussex, and work continued throughout the period covered by this book. The permanent way – that is, the strip of land along which the track is laid – was cut and dug by hand by men of legendary strength and stamina known as 'navvies'. Intriguingly, the 1851 Census lists three women 'railway labourers' working on the construction of the South Eastern Railway between Tunbridge Wells and Robertsbridge: Mary Smith, 40; Elizabeth Taylor, 20; and Elizabeth Waters, 21. They were all unmarried and living in lodgings (one, at least, above a beer-shop) which suggests that, like the men, they were itinerant. Two married women were also noted in the census as working on the railway: Frances Gadd of Wadhurst, whose husband was an agricultural labourer and Hannah Hamilton, a Scot aged 32, who lived in the railway hut at Bexhill with her Irish husband and their three children. It is impossible to establish what these women's duties were. Navvies did employ female housekeepers but these would have been enumerated as domestics and not as 'railway labourers'.

Some women found permanent employment operating the gates at level crossings, especially in rural areas. Most were residential and a lineside cottage came as part of the wage. Among the earliest was Elizabeth Peddleston of Bexhill, noted in the Census of 1851. She lived in a tied cottage by the side of the line with her husband, a railway labourer. The job

was not without its dangers and, sadly, reference to Mrs. Peddleston's being killed by a train 'some years ago' was made in a Hastings newspaper in the late 1870s.

The London, Brighton & South Coast Railway employed a small number of stationmistresses at small, rural stations in Sussex. One of them, Miss Robinson, took over Woodgate on her father's death in 1862 until her marriage the following year.

By 1870 women were employed at the larger stations all over Sussex as ladies' waiting room attendants and refreshment room staff, and as charwomen in railway offices. In the carriage and wagon workshops (at Brighton and Lancing) women were employed as French polishers, in painting small objects such as crests, gauges and nameplates, in knitting the overhead string luggage racks, in blindmaking and dyeing, and in embroidering the company crest onto anti-macassars and various items of napery for the hotels and restaurant cars. They also staffed the railway hotels and laundries, and the staff hostels and canteens.[58]

Sea and Beach Occupations

In many towns along the Sussex coast, including Hastings, Newhaven, Seaford, Brighton and Worthing, women worked in the fishing industry. Brighton's ancient fleet was in decline. By 1862 it had only 150 boats. Hastings' fishery was still central to the economy of the town in the mid-19th century, when 500 families were engaged in it. In 1850 there were 88 boats and by 1861 this had increased to 150.

Women's involvement is hardly ever mentioned and is difficult to establish. Although the 1841 Census abstracts list 306 'fisherwomen' in Britain, none of them was in Sussex. However, some women, for example Charlotte Clarke of Hastings, owned a fishing boat, and hundreds of women and girls worked in the industry helping their husbands, fathers or sons. They mended nets, and cleaned and gutted fish to prepare them for sale. Despite this, census enumerators listed those married to fishermen as non-working 'housewives' unless the woman herself ran a fishmonger business completely independent of her husband's employment.

Women fishmongers operated in every Sussex fishing town. When, for example, Hastings' new fishmarket opened in 1870, the 12 stallholders

comprised four women, six men, and two whose gender is not recorded. Women also hawked fish and shrimps from barrows and baskets in streets and public houses – except on Sundays. In 1841 a young girl was arrested for 'crying shrimps' on a Sunday: the Lord's day of rest.

Fishermen's families lived, as they had for centuries, in circumstances of chronic insolvency but they constituted a cohesive community of many interconnected and extended families. Although it seemed chaotic, life in the fishery was structured by 'rhythms of poverty' caused by the weekly and seasonal fluctuations in income. The mid-1800s were, overall, prosperous years for fishermen, but there were many dips in their fortunes and it fell to their wives to ensure that the rent was paid and that their families did not starve. Most had a means of earning money when they needed to, performing laundry, sewing, charring and baby minding. Steve Peak relates how, in 1858, some Hastings gentlemen put forth a plan to set up a local net-making business, to give employment to women, elderly fishermen and boys. However, the scheme was abandoned because they would not accept the low wages necessary to make them competitive, and so the nets continued to be made at Bridport. Mr. Peak remarks that Hastings women could make more money by charring or taking in washing.[59] Countess Waldegrave inadvertently helped Hastings' fishwives in these moneymaking activities when she paid £2,000 to build public washhouses in Bourne Street in 1865, with the intention of improving the level of cleanliness and hygiene of the poor – 'the great unwashed'. For a small fee, the women used the laundry facilities to carry out their usual work of washing, drying and ironing other people's clothes. The Countess may not have approved of this but the income it generated helped to alleviate some of the poverty.

An aspect of life that allied fishermen's wives was the danger their husbands faced every day. In 1850, eleven Worthing fishermen drowned while attempting to rescue the Lalla Rookh, an East Indiaman foundering three miles off the town in a storm. The tragedy caused eight women to become widows – one of whom was struck dumb by the news – and left 36 children fatherless. During the 1860s, twenty-four Hastings fishermen were lost at sea. One of the widows had seven children to support and one more on the way. A subscription fund was opened, to which the Mayor, the Countess Waldegrave, Frederick North MP and other dignitaries contributed. The total collected for the widows was £1257.[60]

Fish were not the only saleable items to be harvested from the sea. Shells might be collected, for use in making souvenirs (though mostly they

were imported) and in 1824 John Shearsmith wrote of women who collected agates on the beach at Worthing:

> It is no uncommon sight to see a fair bevy of the gentle sex, hammer in hand, roaming along the beach, and peering with curious eye among the boulders and shingle in search of these; ever and anon, by a brisk application of the hammer to some promising specimen, affording practical evidence of the invigorating quality of the air, which can brace muscles so tender to such a Herculean task.[61]

SEA BATHING

Several women were proprietors of outdoor bathing machines. These were not in fact machines, but tall, wooden boxes on wheels. The trade entailed keeping a horse, which drew the machine onto the beach and then reversed it into the water. Customers boarded the machine and, after climbing out of the other end in their bathing dresses, were physically 'dipped' by the proprietor, or by an employed bathing attendant, always of their own sex.

Among the proprietresses was Ann Cobby, one of the great 'characters' of Hastings beach. Records of her presence at her 'patch' opposite Breed's Place span 17 years around the middle of the century. She and her family were a rough lot, by all accounts, and were often involved in arguments and brawls – usually with each other – which frequently landed them in the magistrates' court.* Resentments simmered between rival bathing machines, and sporadic outbreaks of violence were reported in the local press.

In 1854, Mrs. Cobby's bathing machine was accidentally blocked in on the beach by workmen employed by the authorities. She complained to Hastings Commissioners, who paid her £5 to cover her expenses for 'breaking the rocks off the Parade to get the machine out'. In 1865, following a complaint by a gentleman, Mrs. Cobby was summonsed to court for 'cruelly torturing her horse by causing it to be worked in an unfit state'. She vehemently denied the charge, asserting that she had owned horses for many years and always looked after them well. After being fined 2s 6d and made to pay 13s costs, Mrs. Cobby left the court enraged: 'It won't stop there', she said. 'I don't see why my character should be taken

* Her son, to give him his due, saved at least five people from drowning during his long career on the machines.

136

away by a gentleman like him.'[62] What retaliatory action – if any – she or her family took has unfortunately not been traced.

In Brighton, some of the female members of the fishing families took advantage of the town's newly developed tourist industry and became 'dippers' – they grasped their clients and dipped them vigorously into the sea. The most famous Brighton dipper was Martha Gunn (1776-1815), who was notoriously large and strong. The *Brighton Herald* explained that they:

> ...are considered to be the descendants of the aborigines [of Brighton] who, as supposed, were originally Flemings; but it is quite as probable they were Normans...The fishermen and bathers are a kindred tribe, speaking, singing, and acting in the same sort of fashion and an odd fashion it is generally considered... they mix little with the other inhabitants, and preserve many of their old customs and traditions. They are a noisy but good-natured, manageable race.[63]

The women wore 'blue bathing dresses with bright red or yellow kerchiefs spread over the shoulders and a rosette of the same colours pinned on the bosom', plus straw bonnets or hats. They called their faces 'mahogany' and 'indeed are burnt by the sun and by the reflections of it in the water, as red as mahogany or a brick.' Several, said the reporter, had never been further than the four miles to Rottingdean in their lives.

The indoor seawater baths that appeared in Brighton from the 1770s took customers away from the dippers and bathers, eventually putting them out of work. Clifford Musgrave, historian of Brighton, observed:

> The final disappearance of the women dippers and men bathers was heralded by the ceremonial attendance of a party of them, about 120 strong, at the Great Exhibition of 1851 in Hyde Park under the escort of Mr. Lewis Slight, Clerk to the Town Commissioners, and two other officials. The women were dressed in new dark-blue dresses and bonnets, while the men wore blue guernseys and straw hats. Many of them had never set foot out of Brighton before, nor had travelled in a railway carriage. [64]

They were a rough-and-ready bunch: after a visit to Brighton the painter John Constable wrote of 'the old bathing women, whose language, both in oaths and in voice, resembles men.'[65]

DOMESTIC SERVANTS

While nation-wide 40% of all employed women worked in domestic service in 1851, in Sussex the figure was well above the national average, at 53%. The overwhelming majority of working class girls entered domestic service, which was the largest category of occupation for women throughout the 19th century.

A related job was that of charwoman, a cleaner employed on a daily basis in domestic, commercial or industrial premises. This was generally the province of older women, particularly widows, who had only domestic skills to offer an employer. Charring was a booming occupation: there were 49,000 working in Britain in 1851 and by 1871 this had grown to 74,000.

Many women were employed as housekeepers, particularly in rural areas in homes where the housewife was in poor health, or had died, leaving her husband to raise children alone while running a farm or other business. Alternatively, one might be employed in a farmhouse in which a wife with a young family could not be expected to cope with also looking after the household and the farm-workers.

All domestic work in the countryside was heavy and involved long hours. As well as domestic tasks there was always some care of livestock. Duties assigned to females included feeding pigs, plucking poultry and milking cows. One unnamed domestic servant, whose words were recorded by the rector of Burwash, said:

> I'd be churning twice a week and cheesing twice a week and brewing twice, besides washing and baking; and six cows to milk every night and morning, and a sometimes a dozen pigs to feed. There were four men lived in the house and I'd do all the boilin' [of linen] to do - besides the beds to make ... I was twelve years a servant at 1s 6d a week, and then I got married; and when my husband died I went into service again, and for all I'd been a married woman, I only got 1s 6d. After a while I got 2s a week, and then a man who'd been a soldier wanted somebody as could keep house for him, and he gave me 2s 6d a week.[66]

Domestic service seemed to be the answer to everybody's needs. People wanted servants, and women needed work. As a bonus, the work fitted girls to become housewives. The only fly in the ointment was that

most girls would have preferred to be doing just about anything else. Eliza Lynn Linton described a housemaid's life thus:

> In no other trade or profession is there such a want of personal freedom, such continuous command, such arbitrary denial as in this. Take the list of what is denied in an ordinary well-conducted house. No followers, no friends in the kitchen, no laughing to be heard above stairs ... no cessation of work save at meal-times, no getting out for half an hour into the bright sunshine, save 'on the sly,' or after the not always pleasant process of asking leave; and above all, education for the fancy or the intellect beyond a dull magazine for Sunday reading, which is held quite sufficient recreation for lonely Betty moping in the dreary kitchen on the afternoon of her Sunday in ... with the world seen only through the gratings of the area window as the holiday folks flock to and fro – this is English domestic service. [67]

Shop and factory workers had Royal Commissions, parliamentary committees, social investigators and trades unions to take up their cause, often leading to reduced working hours and improved health and safety and welfare provisions; servants had no one to plead their cause. Trades unions found it impossible to enrol them, and it is debatable how keen the middle class members of committees and commissions were to improve the lot of servants, since they employed them in their own houses. As a result, servants worked longer hours than any other employees. It was calculated in 1873 that a housemaid's day extended from 6am to 10pm, less two-and-a-half hours for meals. Her 13½ hour day was 3½ hours longer than that of a factory or shop worker. And at weekends, while others had a shorter Saturday and a Sunday free from work, the servant often worked even longer than on weekdays. Female lower* servants earned about 2s a week plus their board and lodging. Their few personal possessions were stored in a small trunk known as their 'box'. They usually had to share a room, sometimes even a bed, with another servant and those in single-servant households were often desperately lonely and homesick.

Young girls were sent out into service from the age of about ten, sometimes younger. Signs of protest or discontent were met with stern warnings and, eventually, dismissal. In 1864, 16-year-old Fanny Beaton made her feelings known rather spectacularly, by twice setting fire to her

* Such as kitchen maids, scullery-maids, housemaids, and maids-of-all-work.

bed, which was fully enclosed behind wooden shutters in the basement kitchen. In court Miss Beaton admitted that her mistress, Mary Akehurst of 12 Marine Parade, Hastings, was kind to her; she had simply wanted to go home. She was sent to prison for one month.[68]

In a small middle class or prosperous working class household, one maid-of-all-work was engaged to carry out the most menial chores, often as an assistant to the housewife. As the family's income rose, so did the number of servants, and this served as an outward sign of prosperity. In a medium-sized house, a parlourmaid and cook would be engaged as well. Only the largest, grandest households employed higher servants such as a lady's maid, butler or footman.

Servants were traditionally engaged at hiring fairs, but by the 19th century the rise of bureaucracy and town living led to the introduction of special agencies to introduce servants to potential employers. One of the first was run by Mr. J. Tanner, who opened a room in his house at 30 All Saints' Street, Hastings, as a registry office, so that girls who had newly arrived in town could obtain places as servants as soon as possible, 'that the evils of idleness might be avoided.' He charged nothing but, later, commercial agencies were opened – the forerunners of today's employment agencies.

The austere life of servants was thrown into sharp contrast by their wealthy employers' array of beautiful clothes and accessories. A servant could never afford to buy such things for herself. Pilfering from employers was common; many girls were prosecuted and custodial sentences were the norm. Honest girls, who purchased cheap imitations – paste jewellery, pretty hair-slides, a bit of lace or perhaps a gay straw hat – were roundly criticised for having a 'love of finery'. It was even described as a 'social evil' by a local newspaper editor, who condemned servant girls for buying 'tawdry finery', while blaming their 'ignorant mothers' for fostering in them a 'love of "showing off" beyond their station.' He believed that 'a lady is perfectly justified in forbidding her domestic to dress in a style which is plainly beyond her honest means' and advised that she should 'refuse to allow her to appear in public in the guise of a poppet or with the airs of a fool'. He suggested that the reason these 'silly girls' dressed up was 'to get the power of dazzling butcher's boys', which was a sure sign that they were 'graduating for a life of sin or a home of misery.' In conclusion, he reminded readers that there was 'Christian work' for 'kindhearted' women in saving these 'poor creatures' from the 'ruinous consequences of a giddy

love of dress which too surely await so many of these victims of bad taste and ignorance.'[69]

The fabulously wealthy Countess Waldegrave echoed these sentiments in 1867 when she gave a stern lecture to schoolgirls on the merits of saving up their surplus pennies to purchase warm clothes for winter, instead of indulging their 'love of finery'. She warned that when (not if) they became servants, their mistresses would disapprove of their attempts to get above their station in life. God was cited in support: He, in His wisdom, had allotted to each her correct place in society. To contradict His plan was blasphemous.

SITUATIONS WANTED.

TWO YOUNG PERSONS want situations. One is desirous of obtaining a place as PREPARATORY GOVERNESS or COMPANION; the other as BARMAID at an Hotel, or as HOUSEKEEPER. They are both highly respectable, and very engaging in their appearance.

Apply at No. 13, Castle-street, Hastings.

TO NURSES.

WANTED IMMEDIATELY, in a respectable Family, an experienced UPPER, and an UNDER NURSE. The former must be competent to take a baby from the month, and to bring it up by hand. Both will be required to work well at the needle, and to produce satisfactory references as to character and capabilities.

Apply by letter, prepaid, to X. Y. Z., Ransom's Printing Office, Hastings.

WANTED A SITUATION AS WET NURSE.

A YOUNG WOMAN, of respectable connection, 21 years of age, is desirous of obtaining a Situation as WET NURSE. Further particulars may be had on application to the Proprietor of this paper.

A YOUNG WOMAN, the daughter of a respectable farmer, who has been accustomed to the Dairy, is desirous of obtaining a situation. She would have no objection to wait upon a lady and make herself generally useful in the house, or to accept of a Housekeeper's place. The most unexceptionable reference can be given as to character, ability, &c.

All letters to be forwarded (post paid) to A. B., Sussex Express Office, Lewes.

WALKING THE STREETS

> [Women who are] a step from starvation ... 'must try the streets,' as they will describe it. If they are young and reckless, they become prostitutes; if in more advanced years, or with good principles, they turn street-sellers; but this is only when destitution presses sharply.
>
> HENRY MAYHEW[70]

Mayhew's observation about London was true of Sussex: the lowest and most desperate occupations in town took place on the streets.

STREET-SELLERS

Hawking was the lowest form of retailing. It required little capital and no premises. Hawkers walked the streets or knocked door-to-door, selling cheap items such as wool-work, bead-work, crochet-work, shell-work, stay-laces, baskets, flowers, cottons, combs, toys, lace, buttons, matches and food; some even sold wood. In Brighton in 1851 Mary Ledger, aged 18, was a wood-hawker and Martha Deuch, who was just nine, sold firewood.

The life was extremely hard. As Mrs. Lee of Burwash, a hawker with five children under 12, put it: 'Ours isn't a living, it's only a being'.[71] Hawkers often lived with one foot in the workhouse or gaol. Many resided in common lodging-houses, while the more prosperous might rent a room for a few months. Some slept in damp cellars or even in sheds. Many were Irish, fleeing the potato famine; others were gypsies, among them Elizabeth Oag, of Netherfield Road, Battle, a hawker of tin wares, who lived with her parents in a caravan.

Hawkers were often brash and colourful characters. As no one employed them they did not need to maintain a genteel or humble demeanour but would brazenly call out their wares. During their arduous day they frequented beer shops for much-needed refreshment and were often the worse for drink. One, Fanny Dunstall, was prosecuted for 'being drunk and furiously driving her horse and cart to the danger of foot passengers' in Robertson Street, Hastings, in 1862. She was fined 10s plus 4s 4d costs.

In Hastings all kinds of food were hawked until 1832, when Town Commissioners passed a Local Act that allowed only fish to be sold freely in the streets but which levied market tolls on all other foodstuffs, ranging from 1s 6d a day for meats down to a 1d for butter. This made it more difficult for women to afford to run a stall and criminalised anyone hawking without a licence.

Policemen and magistrates saw hawking merely as a front for begging. They wanted the county 'tidied up' of these uncontrolled persons because they pestered genteel visitors, which put the tourist industry in jeopardy. In addition, shop-owning tradesmen campaigned against hawkers. In 1860, 40 of those in Hastings signed a petition complaining about the increase in street selling. The magistrates' solution was to raise the price of a hawker's licence tenfold. This placed it beyond the means of the poorest and those who operated without a licence could be prosecuted, fined and even imprisoned. It was a cruel blow against women who had hit rock bottom but who were still trying to support themselves instead of entering the workhouse, or selling themselves.

PROSTITUTES

Prostitution was extremely common in Victorian towns. Indeed, historian Susannah Fullerton has gone so far as to assert: 'Prostitution, as an employer of female labour, was second only to domestic service.'[72] In 1850 the *Westminster Review* estimated that there were 50,000 prostitutes in England and Scotland.

The cream of the trade lived an outwardly genteel life in fine apartments, and were discreetly kept by 'gentleman friends', but there was nothing glamorous about working class prostitution, which took place in semi-concealed public areas or in squalid rented rooms. Most of them ended up in a terribly degraded condition, plying a trade of the most sordid description up against the walls of the dismal back yards and alleyways at 6d to 1s a time.

The two main routes by which working women became prostitutes were seduction and starvation. Most were victims of a patriarchal system which prevented them from earning enough to support themselves and which placed such a high value on female chastity that a girl who was seduced perceived herself to be ruined and unmarriageable. A poorly paid girl would resort to it out of sheer desperation to supplement her wages, which were often insufficient even for the most basic subsistence. It was well known that needlewomen were obliged to turn to occasional,

clandestine prostitution when business was slow; they later married or the work picked up and, with luck, no one found out.

Others were not so fortunate. A girl who was illiterate, abandoned, alcoholic, orphaned, or too weak for domestic service, might find refuge as the 'unmarried wife' of a man prepared, initially, to support her. Before long something usually went awry: the 'husband' put her on the streets, or the relationship ended, leaving the woman destitute and with a 'past'. Other women lost their reputations by having illegitimate children. These women, in the parlance of the day, were 'ruined' – that is, no longer virgins. Having nothing left to lose, they became prostitutes.

A correspondent to *The Times* wrote in 1858 that it was 'a monstrous falsehood' to label thousands of 'poor hardworking sewing girls' as prostitutes. She continued:

> It is a cruel calumny to call them in mass prostitutes; and, as for their virtue, they lose it as one loses his watch who is robbed by the highway thief. Their virtue is the watch, and society is the thief. These poor women toiling on starvation wages, while penury, misery, and famine clutch them by the throat and say, 'Render up your body or die'... Would it not be truer and more charitable to call these poor souls 'victims'?[73]

Sometimes the road to ruin began when a man seduced a servant girl and then paid for her silence, thus demonstrating how much more could be earned this way than by any amount of domestic drudgery. What Joan Perkin[*] wrote about London held good for anywhere: she pointed out that a working class prostitute 'could earn in ten minutes up against a wall as much as a dock labourer could earn in five hours of back-breaking work.'[74]

In Brighton the trade was both endemic and entrenched:

> In 1796 the sixth edition of *The New Brighton Guide* could advertise the seaside town as a place 'where the sinews of morality are so happily relaxed, that a bawd and a baroness may snore in the same tenement'. ... Prostitutes numbered 300 there, exclusive of those at the army camp ...[75]

The first prostitutes recorded in 19th-century Hastings were Lucy Ballard in 1820 and Sarah Mitchell in 1826, who were arrested for 'wandering in the streets'. By mid-century there were dozens operating in

[*] Lecturer in Women's History at North Western University, Illinois.

the town and the same women appeared in front of magistrates time and time again. Among them were Portsmouth Poll, Dover Lizzy, Mary Ann Wratten, Elizabeth Watts, and the notorious Mary Keene, who was reputed to have been cautioned by every policeman in the local force.

A range of euphemisms was used to describe them: 'members of the frail sisterhood', 'frail and fair ones', 'girls of the town', 'nymphs of the pavé', 'our incorrigibles', 'ladies of certain lax morals' or, most commonly, 'unfortunates'. In 1871 one magistrate labelled Sarah Eldridge a 'social pest.' The term 'prostitute' is not normally found in the census's occupational column, but in 1851 whoever filled in the return for Brighton Workhouse used the word to describe two female inmates. [76]

Many prostitutes were former domestic servants who, after being seduced by men belonging to their employers' family or circle of friends, were sacked without a reference upon becoming pregnant. William Acton, a London doctor, remarked in 1857 that 'seduction of girls is a sport and a habit with vast numbers of men'. Professor J.F.C. Harrison described this kind of seduction as 'a mixture of brutality and exploitation on the one side and deference and the temptations that stem from poverty on the other.' [77]

A prostitute advertised her trade by her demeanour and her costume. Her attitude was brazen, and she usually held her head high and looked people straight in the eye, in stark contrast to other working class women, who had been taught to look meekly downwards and never to stare. She would dress much more showily and gaudily than other women. Indeed one newspaper report on Louisa Ogburn (one of Chichester's finest) remarked that 'her dress and appearance [bore] unmistakable witness to her profession.'

Although brothels were likely to have existed in several Sussex towns, particularly Chichester and Newhaven (because of the garrison and the port), evidence was found only in relation to Hastings and Brighton. In 1845 the *Brighton Gazette* revealed that,

> Several of the streets leading from Edward Street to the Downs are crowded with brothels, where scenes of the greatest depravity are enacted, and it is deplorable to observe the number of girls, mere children, from 12 to 18 years of age, who are nurtured in these hot beds of immorality and who infest our streets in the evening…

In his *Encyclopaedia of Brighton* Timothy Carder notes that 'an official survey taken in 1860 recorded 97 brothels and 300 prostitutes with, no doubt,

many others unrecorded'.[78] Evidence given in magistrates' courts reveals that they would loiter on or near the seafront after midnight – especially the beach in front of King's Road and on the Level – meet their clients and either go home with them, take them back to their lodgings, or rent a room for a few hours. It seems that a room could be hired at any time of day or night: Elizabeth Jarrett and her client turned up on a Brighton landlady's doorstep at ten past one in the morning and were able to secure a room immediately.

Prostitutes also congregated in the county's numerous disreputable public houses and beer shops; indeed, any flashy single woman swilling alcohol at the bar of such a place was sure to be a 'fallen one'. At first, alcohol numbed the shame and overcame the inhibitions of girls new to the trade but, all too swiftly, drunkenness became a way of life and many drank themselves into oblivion every day. After being 'treated' to a few penny shots of gin, they would totter along the gas-lit streets describing to passing men, in terms of the basest vulgarity, what was on offer. If a policeman heard them, or a man complained, they were charged with 'being drunk and using obscene language'. This was possibly to avoid a charge of soliciting, which would require the accosted gentlemen to attend court.

Prostitutes increased publicans' profits and many a blind eye was turned as they solicited for trade on the premises. However, it was an offence for a licensee to 'allow persons of notorious bad character to assemble'. Such was the oft-repeated charge against many Sussex licensees, most often in Brighton and Hastings and, to a lesser extent, in Chichester, Rye and Lewes.

In Hastings the cases were many. Richard Wood, landlord of the *Privateer Inn* in Cross Street,* was reported by Sergeant Brazier for allowing 'fiddling and dancing' in his pub after midnight, and for permitting two known prostitutes, 'Dover Lizzy' and 'Sally Bates', and two other girls to carouse with young men. Mr. Wood, as a repeat offender, was fined 10s plus 15s 5d costs.[79] John Drayton, landlord of the *Hole in the Wall* beer-house, behind Bohemia Road, was summonsed in 1866 for 'unlawfully allowing persons of bad character to assemble.' The police stated that, on one occasion, six prostitutes were found drinking there and on another, ten. He was fined 5s. William Huggett was summonsed for 'allowing prostitutes and persons of notorious bad character to assemble' at his pub, the *Ship*, Bourne Street. One night Inspector Battersby found about a dozen men with four prostitutes in a back room. Two days later he found a man in the

* Now Elford Street.

pub's backyard 'in a very indecent position with a drunken prostitute.' He halted their congress, but later returned to find 'the same pair engaged in the same act in the same place.' He remarked to magistrates, 'I consider it to be a worse place than a common brothel'. Mr. Huggett was fined 10s and 19s 6d costs.[80]

The landlord of the *Queen's Head* (a fishermen's pub in Hastings) was luckier. While considering the renewal of his licence, magistrates heard that he habitually harboured prostitutes but, as he had never been convicted, the renewal was granted. The landlord of the *Duke of York,* Union Road, St Leonards, was not so fortunate; he lost his home and his livelihood. At midnight one Monday in August 1864, a policeman's attention was drawn to the pub by the sound of music and singing. Inside he found 13 men 'carousing' with six women, five of whom he recognised as known prostitutes. He kept watch and saw the girls leave at dawn. In court, for 'keeping a disorderly house' the landlord was fined £1 plus 12s costs, and when his licence became due for renewal it was declined. This led to his being evicted by the pub's owner. One of the prostitutes involved, 17-year-old Susan Lee, later subjected the constable concerned to a torrent of verbal abuse, for which she received seven days' imprisonment.[81]

Magistrates in Chichester evidently did not think that allowing streetwalkers to congregate in pubs was a very serious offence. The landlords of the *Ship & Lighter* and the *Coach & Horses* were both allowed to keep their licences despite being caught with prostitutes on the premises. A beer-shop keeper was fined just 4s for 'harbouring prostitutes' but 40s for allowing drunkenness on the premises.

Prostitutes frequently cohabited with a man-friend or, more likely, a series of them, for quarrels and break-ups were frequent. Some men lived on their partner's immoral earnings. Women who lived alone often resided in squalid common lodging-houses or in rooms above beer-shops at 4d a night, some of which were described by police as 'low brothels' or 'dens of infamy'. Such was the label given to 19 Bourne Street, Hastings and 2 Albion St, Ore. The latter, in its four small rooms, housed ten persons. One of them, 19-year-old Bertha Hewitt, was 'a woman of dissipated and wretched appearance' who had abandoned her unwanted, illegitimate child in Battle Workhouse. The other occupants were the landlady (or madam) Mrs. Dunk,* her son and two daughters, two other women, almost certainly prostitutes, and three young children.

* Mary Dunk, b. 1805, the mother of at least seven children.

In contrast to the high public profile of, and the official records relating to prostitutes, their clients – who must have outnumbered them quite considerably – are almost invisible. No derogatory labels were attached to them, nor were they prosecuted. Their rare court appearances were solely as plaintiffs, complaining of being robbed by a girl they had hired. From court records it is known that the clientele included printers, sailors, plasterers, wheelwrights and boat-builders.

In Brighton, a Home for Female Penitents was opened in 1853, founded by Mrs. Murray Vicars and the Reverend George Wagner. Its sole purpose was to rescue prostitutes and train them for other, less remunerative, occupations such as domestic service. The women were also instructed in scripture and literacy and, where possible, their mothers were encouraged to visit. At first the home was opposite the Level but it soon moved to Lewes Road and, in 1855, to two locations: 1-6 and 10-11 Queen's Square and Wykeham Terrace. When the Revd Wagner died in 1857 the Community of the Virgin Mary took over the penitentiary and renamed it St Mary's Home. The nuns began to take in all kinds of needy persons and by 1866 they were unable to accommodate any more. Some inmates were moved to 17 Egremont Place in 1867, and the penitent prostitutes gained a new building of their own in 1868, known as the Brighton Home for Female Penitents, on the eastern side of Finsbury Road, known locally as the Albion Hill Home.[82] It lasted until 1917 when it became a home for girls, run by the Salvation Army.

As the population of Britain increased, prostitution flourished and by the 1870s the newspapers of both Brighton and Hastings were replete with court reports mentioning streetwalkers. It is interesting to note, however, that prostitution declined dramatically after the First World War, for several reasons. Hundreds of thousands of potential customers had perished on the battlefields; from the 1920s the unemployed could receive benefits; and women had more job opportunities. They had won the battle for the right to vote and had gained a new self-respect as a consequence of their war work.

A short piece by William Acton on the causes of prostitution can be found in the appendix, on page 239.

THE OCCUPATION OF LADIES

I have often heard it regretted that ladies have no stated employment, no profession. It is a mistake: charity is the calling of a lady; the care of the poor is her profession ... Women of fortune have abundant leisure which can no way be so properly or pleasantly filled up.

HANNAH MORE
COELEBS IN SEARCH OF A WIFE

Several seaside towns in Sussex – mainly Brighton, Hove, Hastings, St Leonards, Worthing and Bognor – attracted a large number of women of private means. The 1851 Census for Hastings and St Leonards, for example, showed that women comprised 79% of those enumerated as 'Persons of Rank or Property', and 11.6% of the town's females (compared with just 5.8% of its males) enjoyed an unearned income derived from investments.

In Brighton, the 1861 Census showed that 1,864, or 5% of all women aged over 20, were 'Persons of Rank or Property' while, in Hastings, the figure was 706, or 6.5%. Some of them derived income from investments in business, by lending mortgages, or by letting ground or buildings; others owned shares in the railways. Ninety-two Hastings women were house or land proprietors in 1851 and, in 1861, three-quarters of the town's residents who derived income from property rentals were female. Some women owned dozens of expensive properties in fashionable areas; a larger number had just a couple of lodging-houses, or three or four modest houses or shops let to tenants. In Brighton, Mrs. Jane Haas owned the *Albermarle Hotel* and employed Mrs. Rachel Lewson to manage it for her.

Many more women were supported by wealthy fathers or husbands. They had a superior education, plenty of free time and a desire to be engaged in a fulfilling occupation. However, they could not seek careers because that would bring shame and disgrace upon their families. In any case, the professions were closed to them and humble jobs were beneath them.

MANAGING THE POOR

In the 19th century the only state welfare was through a parish-based poor-rate, which supported the workhouses and gave destitute but deserving individuals outdoor relief. In Brighton, for example, 2,800 people a week were receiving such payments in February 1869, while 750 were living in the workhouse and a further 120 were in the county lunatic asylum at Hayward's Heath. All other assistance to the poor and needy came from voluntary donations made by wealthier people. The collection and dispersal of these donations became the occupation of ladies.

Managing the poor was a thoroughly respectable public channel for ladies' energy and ingenuity and the only way their organisational and financial skills could receive public recognition. Only by performing charitable or philanthropic work could a respectable lady play an active and prominent role in public life, hold offices such as organiser, treasurer and secretary, and have her name and address listed in directories and other public documents. Charity work was the only socially acceptable reason for ladies to attend public meetings, serve on committees, and take an active interest in current affairs and matters of interest to society.

Moreover, working for charitable organisations afforded ladies a great deal of social kudos and gave them the opportunity to rub shoulders with local dignitaries and titled personages. For some, it amounted to a career: for example, Charlotte Menella Lutwidge of 2 Wellington Square, Hastings, spent her whole life devoted to charity work. Her death in 1857 was said to be 'deeply regretted by both the pick and the poor'.

The overriding characteristic of these charitable activities was one of morality, driven by religious evangelism. In middle class eyes the poor lived irregular, irreligious lives. They wasted money on drink, tobacco and gambling while their children were dirty and undisciplined. The poor had to be taught to be thrifty and hygienic, and to forsake their bad ways. Charity workers saw themselves as missionaries to another culture, fighting the evils of poverty, disease, and 'the demon drink'. Their moral superiority was often resented by the poor, who might welcome some financial assistance but found the attached strings rather harder to accept. The poor were labelled either 'deserving' or 'undeserving' and the allocation of persons to each category was informed by the charity workers' middle class beliefs. For example, they provided aid to impoverished mothers and infants in order to improve their mortality rates, but they barred the most needy – unmarried mothers and their illegitimate children – from their benevolence.

There was gender division in charity work. Causes connected with

maternity, children, religion, health and education were seen as the province of ladies; but when fishermen were lost at sea it was usually gentlemen who launched relief funds for the widows and children. However, they still left the donkeywork, such as the day-to-day fundraising, to the ladies.

In the Sussex towns there was plenty of charity and temperance work to occupy them, owing to the grinding poverty in the poorer areas. Ladies founded, organised and managed a wide range and a large number of institutions and societies across the county. Among them were sanitary societies, shoe clubs, coal clubs, maternity and lying-in institutions, temperance, missionary and Sunday school societies, female benevolent institutions, and organisations for the care of widows, orphans, the sick and the infirm.

Among the earliest missions run by women in Sussex was the Maternal Society, founded in Brighton in 1813 to provide poor women with child-bed linen, clothing and suitable nourishment during the period of their confinement. To qualify, a woman had to be married, as the society could not be seen to condone immorality. Supported by 12 female subscribers, it helped 200 women a year. In 1839 some ladies of Hastings held a three-day bazaar in the Pelham Arcade in aid of an infirmary. They secured the patronage of the Dowager Queen Adelaide* and the stalls were manned by girls of the best families, including the MP's daughter, Marianne North. They raised £538. When the Ragged School in Hastings Old Town became overcrowded, and £500 was needed to build new premises, another group of ladies raised £390 in just three days by holding a bazaar, at which 175 well-heeled customers spent an average of 5s each – half a week's wages for a labouring woman. Among Hastings ladies' other successes were a Home for Invalid Gentlewomen, opened in 1855, and a Young Women's Christian Association, opened in Norman Road East in 1866, with bible classes given by the Countess of Aberdeen.

Sussex ladies founded many institutions for turning uneducated young women into servants. Among those in Brighton were the Industrial Home, the Diocesan Institution for Training Servants, and Eltham House Reformatory Institution for Training Female Servants. There were also servants' homes, where women could stay in between residential jobs or through a spell of illness. Hastings had a School of Industry at Albion House, West Hill, which had been established by a local heiress, Miss Sayer, in 1847, and was subsequently supported by public subscription. Seventeen

* Widow of the recently deceased King William VI.

poor girls were admitted, fed, clothed and instructed in 'the duties and employments of domestic servants', and also in reading, writing, arithmetic and plain needlework.

Women were also involved in temperance societies, prompted by the desire to relieve the suffering of poor wives and children at the hands of drunken men. It was estimated in 1850 that more was spent by the working classes on drink than on rent.* Drunkenness led to idleness, a working class vice that the middle classes could not tolerate. One temperance mission, the St Mary Magdalen Improvement & Recreation Society, based at St Leonards, tried to show the working man that fun could be had without alcohol. The middle class organisers provided the amusements themselves. In 1861 at St Mary Magdalen National School, a musical treat was presented to 350 of the working class by a concert-party of a dozen ladies and gentlemen. When the performance was repeated for a middle class audience, it was held at the St Leonards Assembly rooms – a much more prestigious venue.

Some charitable organisations preferred to give work rather than handouts to the poor. One, the Eastbourne Society for Promoting Female Industry, supplied sewing work in winter to women whose income dropped at that time. It was founded in 1861 and, in its first three years, it supplied 43 women in its first winter, 76 in its second and 137 in its third. In the third year 1,450 parcels of work were issued and 2,779 articles were made, of which 2,670 were sold, bringing the women a total income of £76, or just over 10s each. The 1864 annual report commented that 'the poor have expressed deep gratitude for the opportunity of earning a few shillings.'

Middle class ladies ventured out to those that they perceived to be in need of their assistance. They treated the slums as a foreign country, and employed the same language used in connection with missions to darkest Africa. Entering slum areas to inspect the homes and neighbourhoods of the poor provided excitement – even a little danger – to women who had until then been enveloped in a cosy and safe domestic environment, for they knew they were entering the domain of thieves, prostitutes, drunks and pickpockets.

Among the dozens of societies in Brighton was the Sanitary Association. Its objects were to bring public opinion to bear on the subject of the laws of health, and to aid all classes, more especially the poor, to

* In 1870 it was calculated that the average consumption per person per year was ten pints of spirits, four pints of wine and 275 pints of beer.

improve their sanitary condition. These objects were accomplished by the distribution of tracts and pamphlets, by lectures, and by the employment of female 'missionaries', as they were called. Their duties were to visit the poor and, in the association's own words, to 'inculcate the importance of sanitary matters'. Once they had their foot in the door they compelled the 'poor, ignorant masses' to borrow domestic equipment and to accept limes and disinfectants with which to cleanse their homes. The association awarded prizes to the tenants of the cleanest and best ordered cottages. A 'very superior' missionary was employed to act as superintendent of the others. Part of her delightful duty was to visit poor neighbourhoods and examine the state of cesspools, drains, ventilation, the water supply, and other matters related to sanitation. In 1867, one of the two female visitors inspected 57 of Brighton's back-streets, and lent or gave 115 papers and 782 tracts. Under her orders 52 houses were whitewashed, 190 brooms and brushes and 180 window syringes were loaned. The *Eastbourne Gazette* described the activities of the Sanitary Association as 'Nice amusement for our wives and daughters.'

Another important part of missionary work was to take religion to the working classes. An excellent way of gaining entry to the homes of poor families was to employ a working class bible-woman to visit the slum areas. As a woman of their own class, she was more likely to be welcomed inside than someone whose clothing and demeanour revealed her to be of a superior class. Once admitted, the bible-woman would read aloud from the bible or other religious tract (most labouring people were illiterate) and distribute free copies. The census for Hastings shows a bible-woman in 1861 (Elizabeth Mackie of 15 Stone Street), and a 'Missionary for Hastings' in 1871 (Ann McCarthur, born in Gibraltar and living at 2 Pelham Street.)

Rich women's missions to the poor were an extension of the female role of service and self-sacrifice, but charity workers eventually came to realise that they had little power to change the society that created so much poverty, misery and injustice to women. They felt that, if women were permitted to vote, and to take part in policy-making, government and positions of authority, many social problems could be solved. Most of the 'shakers and movers' of the women's rights movement had a background of charity or social work.

PHILANTHROPY

A considerable number of ladies gave money to charitable ventures without ever getting directly involved with the work. It was customary for ladies to donate to those causes related to women and children, and to missions and campaigns promoting temperance and health.

Mrs. Ann Thwaytes, who had formerly bestowed her generosity upon Herne Bay, moved to Charmandean House* in Worthing around 1840. There she continued to support many good causes: she contributed to a new infirmary, paid for the publication of a book (*The Geology of Sussex* by Dixon) and donated money for the restoration of Broadwater Church. She was described as an eccentric whose unbalanced behaviour caused her will to be contested after she died in 1866.

Mary Ann Gilbert, widow of a Lord of the Manor, pioneered the allotment movement in Eastbourne in the 1830s, a time when her parish lay under a cloud of unemployment, poverty and misery. Her aim in life was to teach people to make use of their opportunities, and on her garden gate this motto was engraved: 'Waste not time, and you will want not food'. She took a keen interest in her tenants and encouraged them to engage in spade culture. To show how the work should be done, she took up residence at one of her farms at Birling, which she caused to be cultivated by hand. It was largely through her endeavours that a meeting of the parish was held at the *King's Arms Inn*, Seaside, in 1827 to consider the question of cultivating a portion of the land lately occupied as a barrack ground with a view to giving employment to the poor of the town. It was then resolved 'by way of experiment' that 'one or two paupers of the parish who happen to be unemployed' would be given the work.

Later Mrs. Gilbert devised a plan to convert a portion of shingle on the seashore into productive land by covering it with a layer of clay soil, which enabled barleycorn and potatoes to be grown. Mrs. Gilbert's Willingdon allotments were also a huge success: it was shown that a Mr. and Mrs. Dumbrell would have been forced to enter the workhouse if it were not for the three acres of land they were given and had cultivated.

It was said of Mrs. Gilbert that she had 'indomitable energy' and that 'her courage and cheerfulness never failed her'. She was reported to have personally superintended 'any work she might have in hand, even to the

* Built in 1810 and extensively enlarged by Mrs. Thwaytes in the 1850s, it was demolished in 1963.

building of a cottage for her tenants'. It was also said that 'nothing was beneath her notice, nothing of indifference to her'.[83]

Sarah, Countess Waldegrave, wielded more influence upon mid-century Hastings than any other woman. Born in 1787, she was twice married and widowed gaining a large amount of wealth from the first husband and a title from her second. She is best remembered for laying the foundation stones of at least ten churches, which she also endowed. The first was at Halton in 1838, for which she donated the church and parsonage, the site and even the building stone. She founded schools for St Clement's and All Saints' parishes and gave both land and funds to build Halton School. She donated £500 for an infants' school and a house for the mistress. She financed numerous Sunday schools, poor-schools and institutions, and provided wash houses and public baths for the poor in Bourne Street. She paid for a Fishermen's Institute and was involved in the Hastings Literary and Scientific Institution. She bought uniforms and a rifle range at Ecclesbourne for the Volunteer Rifle Corps, and built a Mission House in All Saints' School yard. She helped negotiate for, and donated £100 to secure, a Public Recreation Ground at Priory Meadow. She was a major donor to every appeal for funds for the victims of accidents, and for widows of fishermen lost at sea; indeed, her name was almost always among the top five contributors. Organisers knew that once her patronage was secured, that of others would follow.

The Countess was a great benefactor, but she manipulated people and usually attached strict conditions to her gifts. When she endowed All Saints' School with £100 in 1835, it was on condition that there must be separate girls' and boys' entrances. She allowed public access to Ecclesbourne Glen and the Lovers' Seat only if no alcoholic beverage was sold there, because:

> Numbers of ladies stroll about these heights and frequently without an escort, and it would not do for these gentle creatures to be liable on their return home to the rudeness and swilled insolence of late wassailers on the lonely downs or in the blind mazes of the tangled woods.

Although evidently interested in women's welfare, the Countess was strongly opposed to women's rights, including votes for women.

Over a 40-year period the Countess assisted in treats and outings for thousands of children. In 1856, 118 pupils, 'being anxious to testify their gratitude', spent many weeks collecting subscriptions amongst themselves

to present her with the gift of a cottage tea urn. Four years later £200 was collected from the townspeople, including pennies from children educated at the various schools she had endowed, to erect a drinking fountain in her honour. It still stands, on the corner of Robertson Street and Trinity Street.

The Countess was disliked and feared, but respected by local clergymen, councillors and other officials with whom she dealt. They seem to have cowered in deference during their dealings with her; her title, wealth and their obligation to show gratitude on behalf of the poor and the Church of England made it impossible for them to behave in any other way.

Many other women donated money towards new churches. One, Dowager Lady Webster, widow of Sir Godfrey, paid entirely for Netherfield Church, Battle, in 1854; another, Lady St John, contributed liberally to the founding of Holy Trinity, Hastings in 1857 before building, entirely at her own expense, the first Christ Church, St Leonards, in 1859. She added a crèche in 1872, which was soon accommodating a daily average of 40 babies of working mothers.

CHARITABLE INSTITUTIONS.

LYING-IN INSTITUTION & DISPENSARY.

For the Diseases of Women and Children,

No. 69, HIGH STREET.

PATRONESSES,

Her Royal Highness the Princess Augusta
Her Royal Highness the Duchess of Gloucester.

Treasurer.—Sir Thomas W. Blomefield, Bart.
Physician Accoucheur.—Dr. Lyons.
Consulting Surgeons.—W. Attree, Esq.—J. Lawrence, Esq.
Surgeons Accoucheur.—T. R. Simonds, Esq.—W. Wilton, Esq.
A. Plummer, Esq.
Honorary Secretary.—Mr. T. A. Brew. *Collector.*—R. Mackenzie.

During the last year 450 Females were registered for Delivery, making a total of 2,189 since the commencement of the Institution in 1831. Females and Children admitted to the Dispensary 3,157.

This medical centre for women and children was based in Lewes.

SUSSEX AND BRIGHTON LADIES' SANITARY ASSOCIATION.

IN CONNECTION WITH THE

LADIES' NATIONAL SANITARY ASSOCIATION.

Committee.

Miss ALGER.	Mrs. F. MERRIFIELD.
Miss BOVILLE.	Miss MORRITT.
Mrs. BOYS.	Mrs. W. E. C. NOURSE.
Mrs. CONINGHAM.	Mrs. OLDING.
Miss MACAULAY.	Mrs. STRANG.
Mrs. MERRIFIELD.	Mrs. WILLIAM WILLETT.

Hon. Treasurer—Mrs. NOURSE.

Hon. Secretaries—Mrs. MERRIFIELD ; Miss ALGER.

Bankers—Messrs. HALL & Co. Union Bank, North street.

Depôt—Mr. BONNER, Bookseller, King's road.

It is an acknowledged fact, that by far the greater part of the debility, disease, and premature mortality in this country is the result of preventible causes; but it is an equally evident fact that very few preventive measures bearing upon the personal habits of the people have yet been adopted.

The promoters of this Association believe that, in a majority of cases, the principal cause of a low physical condition is ignorance of the laws of health ; and they have therefore combined to propagate this important branch of knowledge.

Subscriptions, Donations, Books for the Library, &c., will be gratefully received by Mrs. NOURSE ; the Ladies of the Committee; and at the Union Bank.

BRIGHTON FEMALE ORPHAN ASYLUM,
GLOUCESTER PLACE.

PATRONESS—*Her Most Gracious Majesty the Queen Dowager*

Treasurer.—John Mills, Esq. *Physician.*—Charles Price, Esq.
Surgeons.—Messrs. Blaker and Vallance.
Honorary Secretaries.—Rev. H. M. Wagner.—Rev, Thomas Cooke.
Collector.—Mr. Williams

The number of poor friendless Children at present in this excellent Institution is 25, who are from six to ten years of age; and it is intended to increase that number in the event of the Funds proving adequate to the wishes of the Committee.

ALBERT HOUSE INSTITUTION.

Invalid and Industrial Kitchen and Ladies' Home.

11, CROSS STREET, LONDON ROAD, ST. LEONARDS.

This Institution was originally established in connection with the St. Mary Magdalen Schools, in the year 1856, and then comprised the first two objects only. It was removed to its present site in 1863, by the late F. Montgomerie, Esq., the Founder, who built the house at his own cost, and bestowed it as a gift, placing the property in Trust for the purposes of the Charity.

A limited number of genteel ladies fallen on hard times lived at Albert House, where they were waited upon by trainee servants, to the benefit of both. A newspaper announcement for Albert House read:

> The building called "Albert House Institution" comprises a kitchen with usual offices and small Laundry, Apartments for the Superintendent, Dormitories for the Kitchen Girls, and Apartments for Ladies of limited means, for which they pay a moderate rent, including Kitchen fire and attendance. Each lady has two small but lofty rooms and is quite independent of the other inmates.

The Institution also offered meals for the poor, paid for by nine-penny or six-penny meal-tickets. These tickets could be purchased by people desirous of giving something to the poor but wary of giving cash for fear that it would be spent on beer.

> Tickets at Nine pence each will procure Roast or Boiled meat (chiefly roast legs of mutton), Broth with the meat in it, and strong Beef-tea. Tickets at Sixpence each will procure Puddings of Rice, Sago, Tapioca, &c., and Arrowroot ; when ordered by the Medical Attendant, Calf's-feet or other Jellies may be had, but for Jellies *two* Sixpenny Tickets are required.

References

[1] Jameson, A., 'Condition of the Women and the Female Children'. *Athenaeum*, March 1843.

[2] Foster, D., *Albion's sisters: A study of trades directories and female economic participation in the mid-nineteenth century.* Unpublished PhD thesis, Exeter University, 2002.

[3] Beswick, M., (1993) *Brickmaking in Sussex.* Middleton Press, p82-3.

[4] Parkes, B.R., Statistics as to the Employment of the Female Population of Great Britain. *The Englishwoman's Journal,* 1860.

[5] Brett, T. B., *Historico-Biographies,* Volume I, p100.

[6] *Hastings & St Leonards Chronicle,* 8 June 1864.

[7] Taylor, H., et al, *The Ladies' Petition. Petition presented to the House of Commons by Mr. J. Stuart Mill, June 17th, 1866.* Privately published pamphlet.

[8] A photograph of gravedigger, Mrs. Edward Steere, performing her duties appears in Brent, C., and Rector, W., *Victorian Lewes,* Phillimore, 1980. Illustration 73.

[9] According to Brett, T. B., in his *Histories,* Volume 1.

[10] Perkin, H., (1972) *The Origins of Modern English Society 1780-1880.* Routledge, p159.

[11] Perkin, J., (1993) *Victorian Women,* John Murray, p200.

[12] Brett, T. B., *Historico-Biographies,* Volume 2, p167.

[13] *Hastings & St Leonards News* 22 February 1856.

[14] I am indebted to Anthony Camp for this information on shop assistants.

[15] Manwaring Baines, J. (1955) *Historic Hastings.* Parsons, Hastings. p305.

[16] Hillam, C., *Brass Plate and Brazen Impudence,* Liverpool University Press, 1991, p159.

[17] The Bonds' residence was at 4 George Street, which later became the Post Office under a later postmaster. Manwaring Baines (1955) *Historic Hastings,* Parsons, 1955, p297-8.

[18] *Hastings & St Leonards News,* 20 April 1860.

[19] *Hastings & St Leonards News,* 12 October 1860.

[20] *Ibid.*

[21] *Hastings & St Leonards News,* 19 October, 1860.

[22] Musgrave, C., (1981) *Life in Brighton,* John Hallewell, p307.

[23] NADFAS Church Recording Group, (1983) *St. Mary Magdalen Church 1852-1982.* In 1866, a new organ was built by Holdich.

[24] Brett. T. B., *Historico-Biographies,* Volume 6, p60.

[25] Brett, T. B., *Histories,* Volume 2.

[26] *Ibid,* Volume 5. p37.

[27] Anon., (1826) *Picture of Hastings: A series of Letters from a Cosmolite to a Valetudinarian.* p6.

[28] Boucherett, J., 'Legislative Restrictions on Woman's Labour', *Englishwoman's Review,* 1873.

[29] Jenks, G.S., (1839) *Report on the Sanitary Condition of Brighton.*

[30] Inwood, S., (1998) *A History of London,* Papermac, p276.

[31] Quoted in Manwaring Baines, J., (1955) *Historic Hastings.* Parsons, p362.

[32] Extracts from the 1833 Poor Law Commissioners Report.

[33] *Hastings & St Leonards News,* 23 July 1862.

[34] Bishop, J.G., (1860) *Brighton As It Is.*

[35] Wojtczak, H., (2002) *Women of Victorian Hastings.* The Hastings Press.

[36] *Hastings & St Leonards Observer,* 27 August 1867.

[37] Manwaring Baines, J., list of licensees, Hastings Museum collection.

[38] Holter, G., (2001) *Sussex Breweries,* SB Publications, p68.

[39] Alexander, Sally, 'Women's Work in Nineteenth Century London' in Mitchell, J., and Oakley, A., (1976) *The Rights and Wrongs of Women* and Ivy Pinchbeck (1930). *Women workers and the Industrial Revolution.*

[40] Boucherett, J., (1862) *On the Choice of a Business.*

[41] Brett, T. B., *Histories,* Volume 1.

[42] Pinchbeck, I., (1930) *Women Workers and the Industrial Revolution.* Virago reprint 1981, p285.

[43] Manwaring Baines, J., (1955) *Historic Hastings.* Parsons, Hastings. p136-9.

[44] From www.yeoldesussexpages.co.uk.

[45] In London a Lady Superintendent had sole charge of the Female Prison and 600 inmates, assisted by a deputy and forty matrons. Parkes, B.R. (1859) *What Can Educated Women Do?*

[46] The 2nd rule of the 10th section of the 4th Geo, 4, c64.

[47] From www. winksworth.org.uk.

[48] Quoted in Gooch, J., (1980) *The History of Brighton General Hospital.* Phillimore, p8.

[49] *Hastings & St Leonards Observer*, 13 February 1937.

[50] Quoted in Ascott, K., (1998) *The Education of Wadhurst.* The Book Guild, p24.

[51] *Ibid,* p87.

[52] Wells, R., (ed.) (1992) *Victorian Village*, Alan Sutton, p105.

[53] Ascott, K.,(1998) *The Education of Wadhurst.* The Book Guild, p40.

[54] *Ibid.* p48.

[55] Quoted in Searle, S., (1995) *Sussex Women* JAK Books, p21.

[56] Thanks to Sister Helen Forshaw of the Society of the Holy Child Jesus.

[57] Martineau, H., 'Female Industry', in the *Edinburgh Review,* April 1859.

[58] Wojtczak, H., (2004) *Railwaywomen.* The Hastings Press.

[59] Peak, S., (1985) *Fishermen of Hastings.* p30.

[60] *Ibid.* p.30-31.

[61] Shearsmith, J., (1824) *A Topographical Description of Worthing* quoted in White, Sally, (2000) *Worthing Past* . Phillimore, p33.

[62] *Hastings & St Leonards News*, 8 September 1865.

[63] *Brighton Herald*, 27 April 1851.

[64] Musgrave, C., (1981) *Life in Brighton,* John Hallewell, p201.

[65] Quoted in Musgrave, C., (1981) *Life in Brighton,* John Hallewell, p256.

[66] Quoted in Johnson, W.H., (1993) *Victorian Alfriston.* Downsway Books, p23.

[67] Linton, E. L., (1874). *On the Side of the Maids.* Linton also wrote a rebuttal, from the employers' point of view.

[68] *Hastings & St Leonards News*, 15 August 1864.

[69] *Hastings & St Leonards News*, 27 June 1862.

[70] Mayhew, H., (1861) *London Labour and the London Poor*, Volume 1.

[71] Wells, R., (ed.) (1992) *Victorian Village*, Alan Sutton, p88.

[72] Ms Fullerton is President of the Jane Austen Society of Australia Inc.

[73] *The Times*, 24 February 1858, under the heading 'The Great Social Evil'.

[74] Perkin, J., (1993) *Victorian Women.* John Murray, p220.

[75] From 'Prostitution' by Susannah Fullerton, first published in the *Newsletter of the Jane Austen Society of Australia.* No.20, June, 2001. Quoted by permission.

[76] In Shrewsbury in 1861, one enumerator boldly listed prostitutes on the census return. See Butt, J., 'Red Lights in Roushill', in Barrie Trinder (ed) (1984) *Victorian Shrewsbury*, Shropshire Libraries.

[77] Harrison, J.F.C., (1988) *Early Victorian Britain 1832-51.* Fontana, p157.

[78] Carder, T., (1990) *The Encyclopaedia of Brighton,* East Sussex County Libraries, section 136.

[79] *Hastings & St Leonards News*, 19 January 1856.

[80] *Hastings & St Leonards News*, 26 Jan 1855.

[81] *Hastings & St Leonards News*, 19 August 1864.

[82] Carder, T., *Op.Cit.*, section 136.

[83] Wright, J.C., (1902*) Bygone Eastbourne* pp144-5.

WOMEN
AND
THE LAW

FEMALES IN HASTINGS GAOL IN 1850

Name	Age	Offence	Sentence
Elizabeth Meek	31	Misbehaviour in the workhouse	14 days hard labour
Esther Brooker	34	Vagrancy	7 days hard labour
Ann Ellis	32	Uttering forged & counterfeit coin	Discharged
Elizabeth Easton	45	Assault	Fined
Harriet Miller	30	Vagrancy	7 days hard labour
Henrietta White	13	Larceny (i.e. theft)	1 month hard labour
Ann Blackman	25	Larceny (previous conviction)	Discharged
Martha Veness	30	Wilful damage	Fined
Catherine Egan	53	Larceny (previous conviction)	8 months hard labour; partly solitary
Elizabeth Uptaine	20	Vagrancy (previous conviction)	7 days hard labour
Mary Moon	37	Larceny (previous conviction)	6 weeks hard labour
Caroline Upton	18	Vagrancy (2 previous convictions)	1 month hard labour
Georgiana Palmer	13	Assault	14 days
Charlotte Payne	40	Larceny	3 months hard labour; partly solitary.
Martha Veniss	30	Assault (previous conviction)	Fined
Sarah Kent	52	Assault	10 days
Elizabeth Windser	17	Larceny	2 months hard labour; partly solitary.
Harriet Beale	16	Rogue and Vagabond	14 days
Jane Tollhurst	53	Assault	Fined

3: Women and The Law

When women became involved with the law they were put in the hands of men, from the arresting officer to the High Court judge. No woman was permitted to wield any legal authority.

Mid-19th century women in Sussex committed a wide range of offences under criminal law including theft, robbery, assault, drunkenness, using obscene language, sleeping out, being an idle person, keeping an illicit still, uttering (trying to spend) counterfeit coins, wilful damage, receiving stolen goods, keeping a brothel, burglary, bigamy, arson, infanticide and murder.

In Hastings in the 1850s one in four of the people summonsed for being drunk was female but nearly two-thirds of them were discharged compared with just one-third of men. For all other offences 40% of women were acquitted compared with 26% of men. This may indicate that the police were over zealously arresting women without good cause, or that magistrates were more lenient towards 'the fairer sex' than their own.

Women made up one-third of the inmates of Lewes Gaol in 1838. In 1850 they comprised one-sixth of those in Hastings Gaol,* which had seven cells for men and one for women, each cell measuring 14ft x 7ft and containing three beds. Separate day rooms were provided for each sex. The table opposite shows the female inmates in 1850, their crimes and the punishments meted out to them. The list includes only local residents and omits the 19 travellers also incarcerated that year.

In the 1860s about one in five persons arrested in Sussex was female but this rose to one in four of those charged with assault. These assaults were against men as well as women and were usually the result of neighbourhood squabbles or drunkenness, though occasionally the parties were involved sexually or matrimonially. Most of these cases were dismissed

* The latter was a five-storey brick building with a small triangular yard in front, surrounded on all sides by streets. Its site, in the Bourne, is now covered by the tarmac of the A259 adjacent to the *King's Head*.

by magistrates, who seem to have found them occasionally amusing but usually tiresome.

Petty offences for which women were summonsed included failing to whitewash walls, neglecting to sweep in front of their premises, and various offences against liquor licences. One Brighton laundress was prosecuted for letting dirty soapsuds discharge into the street, and several nursemaids were charged with breaching bylaws by 'driving' perambulators on the pavement. (The shilling fine was customarily paid by the employer). If a retailer's iron weights were inaccurate, the customer could be cheated. Martha Comber, a shopkeeper at Findon, pleaded guilty to having in her shop 16 old weights that had been rendered deficient by wear and tear. For neglecting to take them to the Inspector for adjustment she was fined 20s plus 17s 3d costs. Elizabeth Miller, who kept a beer-shop in Westbourne, was found guilty of having pewter measures and stone drinking cups on her premises that were not of the standard measure. Her fine was 10s plus 14s costs.

Some crimes were rare among women. In 1840 Mrs. Wheeler of Rye was fined £30 (or three months' imprisonment in default) for keeping an illicit liquor still with a male accomplice. Bigamy was seldom committed; the only example found was Ann Green, who bigamously married Henry Loft at St Mary Magdalen Church, St Leonards, in 1858. She received six months' imprisonment.

Punishments were extraordinarily severe by today's standards but were much lighter than those meted out in the 18th century. Then, for example, for stealing handkerchiefs worth 10d Ann Colbran was ordered to be 'stript from the Waist upwards' and 'whipt till her back be bloody' at the public whipping post in the Bourne, Hastings. In Brighton in 1795, prostitute Sarah Mitchell was given 450 lashes.[1] The public whipping of females was abolished in 1817.

In the early-19th century, transportation to the colonies for five or seven years was a common punishment for thieves. Until its abolition in 1867, a number of Sussex women were transported. For example, Sarah Gorringe of Buxted received seven years' transportation for stealing three pairs of stockings, two petticoats and some other cheap items. Many convicts were destitute and had not even clothes to pack. In 1827 the ratepayers of one Hastings parish paid £2 12s 6d to buy a set of clothes for Eliza Dean, who was transported for seven years for theft. It comprised: '1 new cotton jacket or gown; 1 new cotton petticoat; 2 new flannel petticoats; 3 new shifts; 2 new neckerchiefs, coloured; 2 pairs of shoes; and 3 pairs stockings, of which 2 worsted.'

Boys up to six and girls up to ten were allowed to accompany mothers but no woman could be transported if she had a child at her breast. Some convict ships ('hulks') were used as prisons and did not, in fact, leave for the colonies. Conditions on board were harsh and primitive, and the ships were usually rat-infested.

From the early 1860s long custodial sentences began to replace transportation. A typical sentence was the eight months with hard labour given to a woman who tried to pawn two stolen tablecloths and a pair of drawers; and the six weeks' hard labour with ten days in solitary confinement meted out to a 56-year-old woman for stealing a shift worth a shilling. Mercy was sometimes shown: a 78-year-old woman found guilty of stealing bacon from a Brighton shop in 1850 was discharged because of her advanced age.

Some of the penalties and punishments seem very incongruous. In 1851 Martha Veness was fined 10s for shouting at her husband that he was a 'whoremonger and a villain' while Joseph Lee paid an identical fine for viciously beating up his ex-girlfriend.[2]

DEBTS AND CIVIL ACTIONS

Civil cases heard in the county courts generally concerned unpaid bills for the supply of various goods or services. Typical examples are a case in 1854 in which Sarah Wheatman, the collector of tolls at Wappingthorn turnpike gate, sued a man for evading payment. In 1853 Jane Farley was sued for £50 because her son had failed to carry out his apprenticeship indentures. An apprentice's father was usually liable but, as Mr. Farley had died, the onus fell upon his widow.

Under coverture, a husband was liable for his wife's debts and contracts and a business 'owned' by a married woman belonged to her husband. This meant that if a wife was owed money, only her husband could take legal action. In 1858, when a lodger owed rent to Eliza Wood, a Bognor lodging house keeper, her husband had to sue him. Likewise, when Mrs. Brockwell failed to register her lodging house in accordance with the regulations, it was Mr. Brockwell whom Hastings magistrates fined £1 plus 13s costs. Hastings lodging house keeper Esther Nash had some hair combs and

stockings stolen by her young servant in 1851, but her husband was named in court as the victim, even though only Mrs. Nash and the accused woman attended the hearing and the stolen items were clearly ones of female attire.[3] When, in 1870, Mrs. Croft, landlady of the *Bohemia Arms*, Hastings, wished to take legal action against Henry Towner, only Mr. Croft could sue. Mr. Towner had boasted loudly in the *Plasterer's Arms* that he had slept with Mrs. Croft. He was found guilty of slander and Mr. Croft was awarded £25 damages.

It was customary for households to run up debts with shopkeepers and to pay them upon invoice at the end of a quarter. A wife would order all the items she needed for the household and the husband was legally obliged to settle the account. However, if his wife left him, a husband could place an advert in the local press warning traders that he would no longer be responsible for her debts. This arrangement was not without its drawbacks. In 1866 widow Jane Eaton, a small shopkeeper at Guestling, attempted to sue Spencer Willard for £4 9s 8d for groceries and flour supplied to his wife. Mr. Willard had published a disclaimer but Mrs. Eaton had not seen it. He refused to pay the bill, and challenged Mrs. Eaton to sue him. The judge ruled that Mrs. Eaton had been 'very imprudent' to supply the goods and found for the defendant. When Mrs. Eaton asked who was to pay her, the judge replied, 'She could not sue the wife, for she had a husband, nor the husband, because he had forewarned her not to supply his wife.'

A judge could also overrule or extend coverture if he felt so inclined and had good cause. A case in which it was overruled concerned married shopkeeper Jane Foster of 104 All Saints' Street, Hastings, who was sued by her greengrocery wholesaler in 1864 for a debt of £8. She pleaded coverture; however, after being subjected to a 'searching cross-examination' by the plaintiff's counsel she admitted that for eight years she had conducted a sexual relationship with her lodger (her husband, presumably, had moved out). The Judge stopped the case, saying that a woman living in adultery could not claim coverture.

Conversely, it seems that a judge could also decide to extend the legal definition of coverture. An example of this occurred in 1861. William Phillips was sued for £1 19s 1d, the total of an account incurred by a woman calling herself his wife with Chichester shopkeeper Martha Clark, for the supply of bread and butter. Mr. Phillips refused to pay, as the pair had not been legally married. The judge told him that, as he had cohabited for twenty years with the woman who had run up the bill and had produced with her a large family, 'he must put up with the consequences'.[4]

No matter how serious the crime, a married woman could not sue. In 1849 railwayman John Storey of Pevensey raped 'the wife of Mr. Frederick Whyborn' in a railway carriage, and for some reason a civil, not criminal action was taken. According to the law it was Mr. Whyborn's 'property' that had sustained the damage and the decision to prosecute was his alone. Although Mr. Whyborn won the case, Mr. Storey was merely fined (£1 with 17s 6d costs), an outrageously lenient punishment.[5]

AFFILIATION

Most non-criminal cases that brought women to the magistrates' courts as plaintiffs were those in which affiliation was sought. A woman who bore a child out of wedlock could apply for a court order to make the father pay a small sum towards the child's upkeep. Women could also claim about 10s for the expenses of confinement, including the midwife's fee, although this was denied to Cordelia Clarke of Hastings in 1852 on the grounds that it was her second illegitimate child. Magistrates did not want to be seen to condone fornication.

Having several children out of wedlock did not, however, disqualify a woman from obtaining an affiliation order. At Rottingdean in 1866 Jane Leany, who had already borne four children by four different men, managed to obtain an affiliation order for 1s 6d a week against a farmer called George Guy in respect of her fifth child. In the days prior to DNA tests, only circumstantial evidence could be brought. The fact that he had 'kept company with her' and, she alleged, promised to marry her, was enough to convince the magistrate that the child was Mr. Guy's. Another spinster with five children, Charlotte Blunden of South Bersted, was described by the local newspaper as 'a very modest, respectable-looking woman.'[6] Her second child was affiliated to a local baker; the first, third and fourth were 'unaccounted for', and the fifth she attempted to affiliate to the father of the second. The magistrates concurred and ordered him to pay 1s 6d a week.

Servicemen were exempt from paying anything towards the keep of their illegitimate offspring. In 1854 John Cluer, who had just been sentenced to 21 days with hard labour for refusing to comply with an affiliation order, was advised by the magistrate – the Duke of Arundel – to 'evade the responsibility by volunteering to fight his country's battles in either the army or navy'.

Those seeking affiliation orders were usually working class but in 1858 a thrilling scandal shot through Brighton high life. It involved a middle class widow and a respected army colonel. Each side engaged an eminent London barrister and battle commenced. Having promised to marry the widowed Mrs. Thatcher, Colonel d'Aguilar 'became a little too intimate' with her and a child was born. He gave her an allowance of £30 for two years and then ceased, prompting the court case. He was ordered to continue the payments. Later Mrs. Thatcher sued him for Breach of Promise of Marriage. While giving evidence, her 14-year-old daughter revealed that her mother often had gentleman friends to stay the night, and the case was immediately dismissed.

A NICE FIX. — *George Tester*, a porter, was summoned yesterday by Emma Thorne to show cause why he should not maintain her illegitimate child. It appeared that he had seduced her by promises of marriage, but had put it out of his power to fulfil them, by recently marrying another woman. Complainant therefore determined to affiliate the result of her intercourse with him; and an order was made upon him to pay 2s. 6d. per week.

An order was made on GEORGE CRAMP, of Burwash, for the maintenance of an illegitimate child born of Ann Mepham Cramp, admitting himself to be the father.

A similar order was made on RICHARD EDWARDS, jun., for the maintenance of an illegitimate child born of Frances Summers, of Burwash, he having also admitted the paternity.

A similar order was made on EDWIN BOURNE, a butcher residing at Salehurst, for the maintenance of an illegitimate child of Sarah Standen. In this case the party charged denied the paternity, but the young woman having been abundantly corroborated by the testimony of her mother, and Bourne having admitted the payment of the doctor's bill for the lying-in, the magistrates adjudged him to be the father.

In each case the payment was to be 1s. 6d. per week and the costs.

Two affiliation cases from Sussex, 1868.

A Disorderly Beer-House.—*Harriet Vinall*, a widow, was summoned on the complaint of Superintendent Glenister, for knowingly permitting drunkenness and disorderly conduct in her licensed house, on Sunday, the 25th Feb.—Superintendent Glenister said the defendant kept the Britannia beer-house, in Bourne-street.—Defendant said the parties did not get drunk in her house.—The Clerk said that was not the charge. She was summoned for allowing drunkenness in her house.—Defendant said she was not guilty.—Superintendent Glenister said he should prove that nearly all the whole of Sunday there was one continual noise, disturbance, fighting, and drunkenness in the house. At a quarter to four the police were called in by the neighbours, and in the back kitchen they found six men and three or four women. Two were drunk, and the rest were the worse for liquor. One of the men had his clothes off, and was bleeding from the face; one of the women had a black eye, 5 panes of glass were broken, and it was one scene of disorder.—Police-Constable Dennis proved these facts, and Charles Moore, who lives next door, and another neighbour, gave evidence of the disorder which prevailed. Very foul language was used.—Defendant said she tried all she could to stop it. The noise broke out in a moment, but it lasted only a few minutes, and was not continued from half-past two till five o'clock, as was alleged.—Elizabeth Williams was called for defendant, and said the parties were all lodgers. There was a dispute, and defendant tried to quell it. No beer was drawn.—George Brannagan was called, but did not assist the case for the defendant.—Superintendent Glenister said there had previously been cautions given. It was a tramps' lodging-house, and he had not, therefore, the same supervision over it as he had over other houses. Beer could be supplied to the tramps at any time, Sundays included. Other houses would be proceeded against, if no improvement took place. He did not wish to press this case harshly.—Defendant was fined 40s., and costs 18s., or a month's imprisonment.—Allowed till next day for payment.—Mr. Putland said such houses were a disgrace to the town.

Beer-shop keeper Harriet Vinall of Hastings falls foul of the law in 1865.

THE EFFECTS OF THE HOT WEATHER.—*Lucy Guest*, an elderly female, was charged with being drunk and assaulting a police officer.

Policeman Starley said he found prisoner lying drunk in Edward street at a late hour last night. On speaking to her she became so violent that witness was obliged to put her into a cart to bring her to the Hall. Prisoner kicked witness several times.

Prisoner said she hoped the Bench would be "mussiful" to her, for, on taking a little beer last evening it got completely over her, in consequence of the weather being so very hot. (Laughter.)

Mr Carpenter : Well, you must go for one month with hard labour to the House of Correction.

Harriet Lowe and *Sarah Winton*, prostitutes, were brought up on the charge of breaking and stealing a root of sweet william from the garden of 120, Western road and also with stealing a geranium plant from another garden in the same terrace.

Prisoners were committed to the House of Correction for two months with hard labour.

ROBBERY and ARSON at EASTBOURNE.

Mary Ann Wickerson was charged with breaking- into the house of Mrs. Ellis, at Eastbourne, and stealing therefrom various articles of wearing apparel, &c. ; she was also charged with setting fire to the house. This case was fully reported in our columns only a fortnight since, the particulars must therefore be fresh in the minds of our readers. Mr. Roupell and Mr. Conolly prosecuted. Prisoner is about 16 years of age.

Mr. Merrifield said in this painful case he was in-structed on the part of the parents of the unhappy girl at the bar, and he feared he could not dispute that she must have had a guilty knowledge of the theft ; but, in his mind, enough had transpired to lead to the conclusion that some other person, a man, had been engaged in the robbery. She would not disclose his name, but those acquainted with courts of justice were well aware of the fidelity with which women clung to those who ruined them. He hoped the jury would at all events acquit the prisoner of the heavier charge of stealing in the house.

The Judge told the jury that if the prisoner had given information to any one else to commit the robbery, she would be equally guilty. The case appeared too plain to doubt. She gave no account of her possession of the stolen property.

The jury found the prisoner guilty of the robbery, but strongly recommended her to mercy.

His lordship sentenced her to be imprisoned with hard labour for two months, and then to be sent to a reform-story for five years ; he, however, afterwards said it was found that there were circumstances about the prisoner's character which prevented that course being taken, and she must undergo a sentence of four years' penal servi-tude. If the Secretary of State found it possible to do so, she might be removed to a reformatory, which no doubt would be the most appropriate punishment ; but he feared it would be impossible.

> INDECENT EXPOSURE.—*Mary Ann Barnes* (known as
> "Portsmouth Poll"), a prostitute, was charged with in-
> decent exposure of her person.
>
> Police-constable Henry Dennis proved having found
> the prisoner committing the act described in the charge,
> on Saturday night about eleven o'clock, in the road at
> the back of the Infirmary.
>
> Defendant attributed her bad conduct to having had
> some intoxicating liquor given her. From the state-
> ments made, it appeared prisoner's conduct was of a
> most shameless character.
>
> It being her first appearance, she escaped with ten
> days' imprisonment only, instead of the full term named
> in the Vagrancy Act.

A Hastings prostitute, and a Brighton brothel keeper.
Both appeared in the magistrates' courts in the 1860s.

> POLICE INTELLIGENCE, JAN. 13.—Present, Major ALLEN, Major WIL-
> LARD, J. C. STRODE and J. BORRER, Esqrs., and Sir G. WESTPHAL, R.N.
>
> A woman named READ, who keeps a notorious brothel at 46, Edward-
> street, was charged by policeman Knight with being drunk and disorderly
> and creating a great disturbance about two o'clock in the morning, to
> the great annoyance of the neighbourhood. The policeman stated that
> he endeavoured to make her quiet, but finding his efforts of no avail, he
> took her into custody.
>
> Major Allen said that there had been several complaints against this
> woman, that her house ought to be indicted, and that the parish officers
> ought to take up the matter, as well as the High Constable.
>
> One of the neighbours handed to the Bench a memorial to the High
> Constable, signed by the owners and occupiers of several houses in the
> vicinity, complaining of the repeated annoyances to which they had been
> subject during the two months that the prisoner had occupied her present
> residence, from the house being the resort of improper characters, and
> from the drunken conduct of the prisoner.
>
> The Magistrates ordered the prisoner to enter into her own recognizance
> of £30, and to find sureties in a like amount for her appearance at the
> Sessions, to answer any indictment that might then be preferred against
> her. [Several of the streets leading from Edward-street towards the
> Downs are crowded with brothels, where scenes of the greatest depravity
> are enacted, and it is deplorable to observe the number of girls, mere
> children, from 12 to 18 years of age, who are nurtured in these hot beds
> of vice and immorality, and who infest our streets in the evening to the
> great annoyance of the respectable portion of the community.]

WOMEN AS PERPETRATORS OF CRIME

LICENSEES

At all levels of the liquor trade, women were summonsed to court for infringements of their licences. In the majority of cases, the landlady had sold alcohol outside of the hours laid down by law. For example, in 1837 Eliza Hammond, a beer-shop keeper at Hornet, Chichester, was fined 40s plus 7s costs for 'allowing persons to drink & smoke on Sunday morning, during the hours of Divine service'. Even respectable hotelier Eliza Green of *Green's Family Hotel*, opposite Hastings station, was fined a shilling in 1860 for selling alcohol at 11:30am on a Sunday. Far more serious was selling beer with no licence at all, for which offence Sarah Bridger was fined £7 10s by magistrates at Midhurst. Elizabeth Cull, of the *Old House at Home* Beer-house, 44 All Saints' Street, Hastings, was given a small fine in 1872 for being open after 11pm, but for being unable to produce her licence she was fined a hefty £10.

Plain-clothes policemen would sometimes keep watch on premises. One Sunday morning in 1874,* three officers were watching Philly Jenkins' *Tiger Inn* in Hastings. They saw Mary Ann Snashall enter at 10:55am, followed her and found, on the counter, a quart of beer in an earthenware jug, and 6d. Mrs. Jenkins was summonsed for selling beer five minutes earlier than the law permitted. The women's defence was that Mrs. Snashall, who had worked casually for Mrs. Jenkins for 14 years, was helping to change the beer barrels. The ale in the jug was the dregs from the dwindling barrel. The 6d on the counter had been left by a little lad who had come in earlier to ask her to change it for smaller coins. The magistrate did not believe them. Mrs. Jenkins was fined £1 and Mrs. Snashall, 10s.

Smuggling was still in evidence in the mid-19th century: Mrs. Ann Miles, who kept a beer-shop in Hammerpot, near Arundel, was fined a very hefty £25 for having contraband spirits on her premises.

For more serious offences, a landlady could lose her licence. One was 'suffering divers persons of notoriously bad character to assemble'. This was the charge brought against widow Harriet Perigoe, the 51-year-old licensee of the *White Lion*, Hastings, in 1872. A policeman spotted two well-known prostitutes – Miss Carey and Miss Thompsett – entering private rooms with men. When magistrates heard that the house was 'notorious'

* This slightly exceeds the time frame of this book, but it was too interesting to omit.

and of a 'most disorderly character', and that this summons was not the first, Mrs. Perigoe was lucky only to be fined: she had to pay £2. 10s, plus 15s costs. Mary Ann Ray, who was granted the licence of the *Hastings Arms* on her husband's death in 1870, was summonsed on a similar charge. The police said that the pub had been well conducted under Mr. Ray but they had already warned Mrs. Ray about the type of clientele beginning to congregate there. Soon the place was full of prostitutes and one had robbed a man. Mrs. Ray explained that they visited the pub while she was out, or entered by the back door while the pub was busy. The police considered her 'unable to conduct a house of this description' and the magistrate fined her £1. Within a year she had ceased to run the pub.

STREET NUISANCES

Women were arrested for various kinds of street nuisance. Two sisters in Brighton, summonsed for 'sitting on a step in a state of destitution' were discharged once they promised to leave town. Also in Brighton, two women wearing red turbans were apprehended in 1860 for 'singing songs of an indecent and disgusting character in the streets'. Although no charges were brought they were given a warning and ordered to leave town.[7] These were rare cases; most women arrested in the street were charged with begging. One beggar, Mary Banfield, was described as 'a young and healthy looking woman, not over meek in the expression of her countenance'. When arrested in Brighton's King's Road in October 1860, she had resisted most vehemently:

> With a strength and fury more characteristic of a Tartar vixen than of a 'weaker vessel' ... [she] set about defending her liberty and plied her 'scratchers', teeth and feet, to such purpose on the person of the unfortunate truncheon-bearer that he was vain to avail himself of the aid of a flyman...on his getting into the fly, prisoner with one blow of her fist at once deprived [him] of his hat, and with it a pretty considerable quantity of his hirsute covering.[8]

Public drunkenness was also very common and penalties were light. Eliza Jeffrey of Brighton was found drunk in the street in 1839. In her defence she related her life story. She had lived 'in sin' with a man who had

promised to marry her 'as soon as he could afford it'. Miss Jeffrey had waited eight years for that day to come; then, one Monday morning, the 'perfidious wretch' went to church and married another woman! Now, she really thought that was enough to vex any woman, and she took a little drop of drink to comfort herself. Upon hearing this tragic tale, the magistrates took pity and discharged her.

PROSTITUTION

While many of the activities of prostitutes led them habitually into conflict with the law, the charge of soliciting for prostitution was rare.

Most offences that landed a prostitute in court were drink-related; sleeping out, brawling and robbery made up the rest. Filled with gin or beer they would totter along the street (drunk and disorderly); accost men in the street (obstruction); tell them in graphic terms what was on offer (using obscene language); sometimes collapse in the street (drunk and incapable). And if they failed to earn enough for a bed in a common lodging-house, they sought refuge in a shed or boat (sleeping out). Under the notorious Contagious Diseases Act,* Caroline Madgwicke was imprisoned for 21 days 'for refusing to comply with the medical officer of the workhouse while under treatment for a certain disease'.

In the mid-19th century, Brighton was undoubtedly the prostitution capital of the south coast, probably because it evolved as a resort of fun, amusement and entertainment, where many men had pocketfuls of cash to spend on whatever pleasure took their fancy. Magistrates ended the fun with harsh penalties; for example, Emily Chapardarze, a Frenchwoman, served 10 days with hard labour in 1865 for 'importuning and annoying gentlemen' in North Street. Second to Brighton came Hastings where, in 1872, about one-sixth of all women arrested were known prostitutes. The smaller towns also had their complement: for example, one of the many in Chichester was 'Cast Iron Sal' (Sarah Kelsey) who was arrested outside the *Royal Oak* in West Street in 1854 for 'conducting herself in a drunken and riotous manner' with a corporal of the guards. Her townswoman, Elizabeth

* Passed in 1864, the CD Acts allowed policemen to arrest women in ports and army towns and force them to be checked for venereal disease. Sufferers were locked up until cured. Josephine Butler led a campaign against the Acts and they were repealed in 1886.

Glue, 'a bloated-looking girl', was charged in 1857 with being a common prostitute, being drunk, and creating a disturbance. She received 21 days with hard labour.

Once they became hardened to the life, many prostitutes defended themselves, their associates and their 'patch' vehemently and, occasionally, with violence. Some thought their activities were on a par with any other trade; for example, Jane Manser, of 59 All Saints' Street, Hastings, when charged with being drunk and using obscene language in Robertson Street, said that she wished 'to get an honest living as far as her calling would allow.' If prostitution was a trade, then Harriet Clapson was shop steward for Hastings. One night Miss Clapson saw Ellen Stanley – 'a showily-dressed woman' – on her 'patch', the *Anchor Inn,* George Street. She marched up to her and accused her of being a rival from London intent on stealing trade from the locals, and announced 'in language unfit for ears polite' that she did not intend to tolerate her and others plying their vocation in Hastings. Miss Clapson then 'proclaimed herself, with a considerable amount of pride, to have been a prostitute in Hastings for ten years'. She invited Ellen to 'step outside for a fight', and delivered 'a violent blow with her fist to Ellen's head'. Miss Clapson was later fined 10s.

Violence between streetwalkers was common. Among the many cases brought before Brighton magistrates was that of Elizabeth Turner, described as a 'nymph of the pavé', who was fined 5s plus costs for blacking the eye of 'a fair sister of iniquity'. Even the small town of Lewes had sufficient streetwalkers in 1837 for three of them (unnamed) to make an assault upon a fourth, for which they were committed to Lewes House of Correction for two months. Another with a propensity to violence was the notorious Ann Colvin, a 45-year-old married woman with seven children, who kept a little grocery shop in Albion Street, Hastings, above which she ran a brothel. In 1866 she sued* Caroline Cornelius, a prostitute living with her, for £1. 3s rent and money lent. Miss Cornelius told the County Court 'in a bold manner and in loud tones' that Mrs. Colvin took 'three parts of what she got whilst she was there' – meaning that Mrs. Colvin took three-quarters of her immoral earnings. In court, she announced unashamedly: 'I get my living by walking the streets.'† A witness, Ann Chapman, was similarly frank: she 'boldly stated herself to be a prostitute'. The Judge did not want to get involved with a scrap between a prostitute and her madam.

* In her husband's name, because of coverture.
† Miss Cornelius had been prosecuted in 1861 for robbing a client during a street 'transaction'.

He simply found in favour of Mrs. Colvin and, when Miss Cornelius refused to pay, he said that she would make 'a valuable adjunct' to Lewes prison.

The following year, Mrs. Colvin assaulted a prostitute attached to a rival establishment:

> Mrs. Colvin went to complainant's house, and after passing the compliments usual on such occasions, challenged Miss Atkins out to fight. The invitation being declined, Mrs. Colvin pushed complainant and her friend across the room, and 'knocked our heads together', tore complainant's dress, and finished her off by administering a bucket of water shower-bath fashion.

For this assault, Mrs. Colvin was fined £1 plus costs.

In Brighton several women were summonsed for keeping a common brothel. One, Hannah Fry, a widow aged 55, had to enter into recognizances of £50 with two sureties of £25 each, to be of good behaviour for 12 months. Another, Mrs. Read, keeper of a 'notorious brothel' in Edward Street, was made to enter into recognizances of £30, and to find sureties of £30. The large sums of money demanded by the magistrates suggests that they knew brothel keepers were prosperous.

While this research failed to find evidence of any prosecutions for brothel keeping outside of Brighton, the law enforcement agencies knew of their existence and did not shirk from openly naming them. In 1833, the Poor Law Commissioners for Sussex described beer-shops as 'receiving houses for stolen goods, and frequently brothels'. In 1856 Sarah Huggett's beer-shop, the *Mackerel*, Hastings, was described by Inspector Battersby as 'a brothel of the worst description'. Police Superintendent Glenister called the attention of magistrates in 1861 to what he called 'a notorious house of ill-fame' in one of the back-alleys leading from the Bourne, Hastings. He described frequent disturbances of the peace and said he felt sure that the owner of the house – Mr. Cox of Halton – knew the character of his tenants. Superintendent Glenister said that, as at least five prostitutes lived there, it was 'to all intents and purposes a brothel'. Mr. Cox told a sergeant that letting the house in this way gained him the most profit, and he intended to continue to do so. Glenister said he would appeal to the parish officers of St Clement to do something, and he felt sure that one of the Acts of Parliament must apply to the situation. There was no reason why he

could not have charged the tenant with keeping a common brothel and it is something of a mystery that he did not.

Magistrates, too, tried to 'clean up' the county. In 1861 Hastings bench decided to make an example of Caroline Hennesey, 'a girl of loose character and dashing appearance' by incarcerating her for seven days with hard labour for the minor offence of being drunk and using obscene language. The magistrate remarked that there had lately been 'many complaints respecting the disorderly conduct of persons of her class' and declared that he and his colleagues 'were determined to put a stop to the evil'.

THEFT AND FRAUD

For simple larceny (stealing) the sexes were convicted in roughly equal numbers. Servants had endless opportunities to steal from employers, customers from shops, lodgers from landladies and laundresses from clients. Indeed, it would be difficult to find one issue of a Sussex newspaper between 1840 and 1870 without at least one report of a woman stealing something. Among the commonest items stolen were stockings, shifts, petticoats, material, towels, pieces of meat, coal and vegetables (especially turnips). These thefts suggest that the motives stemmed from poverty rather than greed. Goods that could not be eaten were sold, often to a pawn-shop, making detection remarkably easy since the pawnbroker could identify the thief.

It was desperate poverty that led Eliza Honeysett to steal a faggot of wood worth 6d from a farrier at Hellingly in 1865. She presented a sorry and pathetic figure, standing in the dock with an infant at her breast. She explained that she had needed the faggot to make up a fire that cold March day, to dry her baby's wet clothing. Just as this sad tale began to soften the hearts of the magistrates, Superintendent Waghorn told them that her husband had absconded from custody some years before, and she had given birth to three children during his absence. Mrs. Honeysett corrected him: she had only borne two. Superintendent Waghorn concluded that 'he believed she got her living chiefly by prostitution' (although he offered no evidence). On hearing this, the magistrates immediately sentenced Mrs. Honeysett to one month's hard labour. It seems that she was being punished more for being suspected of prostitution, and for having children that were clearly not her husband's, than for stealing sixpence worth of

wood. Indeed, the newspaper report of this case was headed 'More Depravity'.

Robberies from employers were very common, although they were not usually as premeditated as the one committed in Rogate by an 18-year-old nursemaid in 1854. She gave notice to leave her job and, the day prior to her departure, she collaborated with her 16-year-old brother to rob her employers of £40 (which represented more than three years' wages for a nursemaid). Margaret Welch and Ellen Norman worked as milk carriers (i.e milk-delivery women) in Brighton. The former stole £5 6s and the latter, 30s, from their employer. Miss Norman shouted out in court that her employer 'put a gallon and a half of water to two gallons of milk,' eliciting laughter from the public gallery.

In 1854 Ellen McDonald Dixon, a homeless, friendless, barefooted tramp-girl of 11, was scraping a miserable existence in the gutters of Chichester. One day she stole a pair of boots that were hanging outside a shoe shop. After sending her to the House of Correction for ten days, magistrates reprimanded the shopkeeper, saying he was more to blame than the thief was, by placing temptation in her way. For this he was made to pay the court costs.

An unusual robbery was committed by a Mrs. Niblett, who sang at threepenny concerts at the *Brewers Arms*, Church Street, Brighton. She eloped with the landlord and, on her way out, helped herself to £30 from the Benefit Society boxes that were held at the pub.

In 1840, Elizabeth Cramp of Hastings was deserted by her husband. Having children to support, and being considered trustworthy and honest by some ladies of her acquaintance, she was encouraged and assisted by them to gain a livelihood by opening a laundry. Thanks to her benevolent friends, she secured the contracts to wash the linen of the local gentry, including eminent surgeon Mr. Ticehurst, and Frederic North, MP. She repaid this trust by stealing a large quantity of linen, shirts, stockings and handkerchiefs placed in her care.

House burglary by women was more common than one might expect. Some worked alone, others in pairs, and a few operated in gangs. In 1840, two women were among a gang of five who carried out an audacious robbery at Halton, Hastings. The victim, Ann Cogger, worked full time, leaving her house unoccupied all day. One morning, Jane Crowhurst called at Miss Cogger's local baker, saying she was her sister come to stay. The assistant told her that Miss Cogger worked at St Leonards and would not be home until 6pm. Miss Crowhurst summoned four friends and a horse-

drawn wagon, into which they proceeded to load every single item of Miss Cogger's belongings, including her clothing and her coal! They left at 5pm, taking the road towards Rye. The outcome of this case could not be traced, but a week later the local paper reported that poor Miss Cogger had been drowning her sorrows and was arrested for being drunk in the street.

Three women joined a gang of notorious house-burglars operating in Sussex in the 1840s, which carried out a string of daring robberies, many of them from the houses of prominent people in Preston, Falmer, Cuckfield and Edburton. The women, who pleaded not guilty, were eventually charged only with receiving stolen goods. One died in prison while awaiting trial; the other two were tried and found guilty. The jury recommended them to mercy as 'it was supposed that they might have acted under the control of the men'. The judge agreed; and whereas the men were sentenced to ten years' transportation, one of the women received two years' imprisonment and the other, 18 months', both with hard labour.

Many female burglars were mere teenagers. In 1837 Harriett Lepper aged 19, and Rachael Breeds, 14, joined with boys of 16 and 17 to burgle a house in Westfield. In the 1850s Jane Fowler of Pevensey, a girl of 16, was transported for seven years for burglary, having stolen a purse, two half crown, a tablecloth and 'divers other articles'. In 1858 Sarah Cobden, aged 15, and her sister Margaret, 13, described as 'two fresh-coloured, simple-looking country children' were sentenced by Chichester magistrates to six months with hard labour for housebreaking and stealing clothes. They joined their sister Mary, who was already in Petworth Gaol for being drunk and riotous.

Traders and others in business 150 years ago were much more trusting – or gullible – than they are today. Shopkeepers routinely allowed goods to be taken by servants on behalf of their employers. These items were 'on approval' and, if they were not returned to the shop, were simply added to the householder's account. It was common for a working class thief to obtain goods from a shop in this way, pretending to be the servant of 'lady so-and-so'. One of the most successful was Eliza Bird of Brighton. She managed to obtain a supply of poultry and game for several weeks in 1840 by claiming to be the servant of the fictitious 'Captain Smith of Old Steine'.

In 1855 Philadelphia Martin, a 37-year-old Ticehurst mother struggling to raise a large family in poverty, used false pretences to obtain, on one occasion, four pounds of mutton and on another eight pounds of mutton and a pound of suet, from a local butcher. The witnesses gave her a good character as to her former conduct. Magistrates accepted that she was

driven to the offence because she needed to feed her eight children, of whom seven were under twelve years of age. She received a very light punishment: a week in prison for the first offence and a fortnight in solitary confinement for the second.

A similar but much less common crime involved running up huge bills at hotels, and then absconding. In 1836 a woman appeared in Worthing masquerading as 'Baroness de Keffenbourg'. For a number of weeks she lived in luxury, staying in one of the best hotels and ordering goods on credit from the most expensive shops. She left town suddenly, leaving behind a large number of unpaid bills, and was never seen again.

A number of Sussex women were charged with uttering counterfeit coins and notes. In Brighton in 1840, two women and a man were caught at the *Tierney's Arms,* trying to spend two forged sixpences. Six similar coins were found at the women's lodgings at 36 Nottingham Street, a neighbourhood notorious for harbouring thieves and prostitutes. One of the women was discharged but the other, Hannah Macdonald, who was just 17 years old, was sentenced to eight months with hard labour with three periods of solitary confinement. That same year, Mary Marshall was indicted for feloniously uttering a forged £5 note at Brighton, but was found not guilty.

Theft and prostitution went together perfectly. Men, stupefied by alcohol and distracted with lust, were often robbed by the women with whom they were doing 'business'. Among the many culprits was Mrs. Harriet Welch, aged 21, who was indicted in 1842. She picked up Thomas Sadler behind a booth at a fair in Bognor. He gave her 2s 6d and they had sex in the field. Afterwards he complained to the police that his watch and nine sovereigns were missing, and a policeman later found the watch hidden in Mrs. Welch's stocking. She was sentenced to six months' hard labour in Petworth House of Correction. Another Hastings woman teamed up with her live-in lover – a burly sailor – to assault a tipsy young carpenter and rob him of £7 10s, for which they each received a year's penal servitude. Perhaps the largest sum robbed from a client by a Sussex streetwalker was the £27* taken by Mary Pennington of Brighton from a Mr. Farncombe. He was, rather recklessly, walking about half drunk with an inheritance he had received that day. The unsympathetic magistrates took the attitude that the robbery was his just desserts for associating with such women and dismissed the case.

* Equivalent to about 2½ years' salary for a housemaid.

One night in 1867 Harry Cotton, a Hastings printer, collected a parcel of meat and suet he had left with a pub landlady for safe-keeping, and began to make his way home. At about midnight, he met prostitute Mary Roberts in George Street and, after treating her to some gin and ale, she took him to her room at Henry Terrace, All Saints' Street, where they conducted the 'transaction'. At about 2am Mr. Cotton got up to leave, but found his parcel missing. Miss Roberts tried to convince him that he had left it in the pub, but he fetched a policeman, who found the parcel in an adjoining room. Miss Roberts claimed that he had given it to her for them to share the next day; however, magistrates did not believe her and she was sentenced to six weeks with hard labour. *

In 1856 Sarah Huggett's beer-shop, *The Mackerel*, in Hastings, described by Inspector Battersby as 'a brothel of the worst description', was the scene of a series of planned robberies. Mrs. Huggett collaborated with Elizabeth Midgley – 'a prostitute of the worst class' – to rob men who came to the beer-shop in search of lodgings. They would get the victim drunk, undress him and put him into bed with Miss Midgley. During these proceedings anything of value was stolen. They were caught when a soldier complained that £3 5s and a silver watch had gone missing while he was 'consorting' with Miss Midgley. In court Miss Midgley admitted taking the money and she received four months' hard labour at Lewes, while Mrs. Huggett received only a caution about the bad conduct of *The Mackerel*.

VIOLENCE

Physical and verbal aggression was common in working class neighbourhoods and was often a public affair. In backyards, streets, courts, beer-shops and kitchens, women assaulted – and were assaulted by – their children, their neighbours, their husbands and other relations. There was a fair amount of face-slapping and plenty of black eyes, and emptying pails of water over people was a common occurrence. Serious assaults were far less common, but they did occur.

* Three years later Miss Roberts was prosecuted for being drunk and obstructing the pavement: in other words, for soliciting.

HUSBAND BEATING

Assault cases between husbands and wives had a special status. As a married couple was one person in the eyes of the law, neither could sue the other. Either could be charged with assault and fined, but a husband was responsible for any fines due from his wife, even if they were levied for assaulting him!

When women appeared in court charged with assaulting their husbands, reporters and members of the public gallery found the proceedings hilariously entertaining. A case that the *Eastbourne Chronicle* headlined 'The Pleasures of Married Life', involved considerable brutality by Susan Nicks, of 39 Kensington Gardens, Brighton, against her spouse, who appeared in the witness box displaying an array of weapons she had used against him: a broom, a flat-iron, a basin, and a hamper full of broken crockery. Susan was only 32 but she already had 15 children. The couple had been married for about eight years, so presumably some of their children were born out of wedlock. Mr. Nicks was a house-painter who in his spare time acted as a canvasser for the Conservative Party. His description of how his wife had struck him with the basin, seized him violently by the whiskers, and threatened to knock his brains out with the flat iron provoked peals of hilarity from the public gallery. He tried to evade her violence, but she jammed his foot in the door and bashed it several times with the iron. When he finally escaped she chased him with the broom and poked it at him several times in the manner of 'the military charge with fixed bayonets' and, finally, spat in his face. Each of these revelations drew 'roars of laughter' from the crowd. The magistrates fined her only 1s, saying that there were faults on both sides, and they ought to be ashamed of themselves. Three years later Mrs. Nicks killed her sixteenth child while her husband was in the workhouse and she was in lodgings (see page 203).

Frances Gearing was habitually beaten by her husband James, a Hastings fish-dealer, but the first time she hit back she was summonsed for assault. Mr. Gearing told magistrates that she was 'a disgrace to her sex': she failed to look after their five children, preferring to stay out late in the company of men and prostitutes. One night she got drunk and used 'expressions such as are not fit for any woman to utter', then threw a piece of broken plate and a tea-tin at him, threatened to burn down the rope-shop in which he sought refuge, and to kill him. She received one month's imprisonment.

OTHER ASSAULTS BY WOMEN

Sarah Hemsley, aged 31, threw oil of vitriol – a very caustic substance that could cause blindness – over her ex-boyfriend in Brighton in 1840. In her defence she explained that having seduced her when she was 14, he took her to London on the promise of marriage. After they had lived together for several years, he had unexpectedly married another woman. Magistrates heard that she had previously served four months for the same offence against the same man. This time, she was transported for life. On hearing this she rushed from the bar towards her ex-lover's wife, shrieking 'I'll kill her, I'll kill her!'

A crime that seldom came to court was child cruelty; no doubt it was much more common than surviving documents suggest. There was no fear of children being removed; parents were fined, and allowed to continue to 'care for' the children who had just given evidence against them.

Mrs. Short, a widow with four children, lived with Mr. King, a railway worker with three children, in Soap Factory Lane, Lewes. One of the children – an eight-year-old girl – was so badly treated that a neighbour, having heard her being flogged, took her first to see a surgeon, then to the magistrates' court, where she was found to be 'a mere skeleton, and one mass of bruises'. The child told the bench that her stepmother had locked her in a room all night and day with just two pieces of bread, and had knocked her down with her fist. Her elder sister corroborated the story, and a surgeon confirmed that the child had been 'most cruelly treated, and half-starved'. A policeman, sent to spy on the family, witnessed Mrs. Short ill-treating the child. Mr. King was summonsed to court, where he stated that he sanctioned the violence. The story has a most unsatisfactory ending: despite the evidence given by the neighbour, the surgeon and the policeman, the case was dismissed, owing to both children changing their story – which they probably did for fear of further beatings.

There were many successful prosecutions; for example, one Arundel woman was fined £5 in 1854 for cruelly beating her child. In the event she could not pay and was sent to prison in default of payment.

Child cruelty was not confined to parents. Mrs. Smithe, who owned a private school at 10 Osborn Villas, Brighton, was prosecuted in 1855 for cruelty to a three-year-old girl whose name was given only as Browne. The child had 'dirty habits in bed', which Mrs. Smithe endeavoured to correct by rubbing the soiled blanket so harshly against the child's mouth that it bled.

To the Editor of the Brighton Herald.

SIR,—With a view simply to putting people on their guard against imposture, I venture to communicate to you a circumstance which happened to me a few days ago.

A respectable-looking woman, dressed in black, called on me about the situation of plain cook which I had advertised in the Brighton papers. We agreed about terms, and she said she lived at Horsham, and gave me the address of the people she last lived with at Guildford.

I wrote twice, but had both my letters returned, there being no such person in Guildford, and I then wrote twice to the woman herself at Horsham, and these letters were also returned to me. She said it cost her about 8s. coming from Guildford after my place, and would feel greatly obliged if I would advance her that sum out of her wages, as she liked my place, and was sure her reference would prove most satisfactory. This money I indiscreetly gave her, and have not since seen or heard from her, and now regard her as a systematic swindler, and almost feel it a duty to caution people against her.

I am, Sir,
Yours obedient servant,
A LADY HOUSEKEEPER.

Medina-villas, Hove,
August 1st, 1868.

HOW THE LADIES SETTLE THEIR DISPUTES AT HOLLINGTON. — On Saturday, *Elizabeth Fry*, tollgate keeper at Hollington, was summoned for assaulting Mary Chapman, a laundress, on the previous Saturday evening. The two ladies "fell out" about some children, during which complainant called defendant a "nasty hussy." Defendant, under the impression that a much more obnoxious epithet was used, struck complainant a blow in the mouth, which drew blood.—Fined 2s. 6d. and costs, making 25s. altogether. Defendant paid the money.

ROBBERY BY A GIRL.—A little girl, 12 years old, named ELIZA CAPLIN, was charged with stealing half-a-sovereign and two shillings in silver, from the house of John Pitcher, at Eastbourne, on the 6th of September. Prisoner wished the bench to try the case, and pleaded guilty, saying her sister stood at the door and took half the money. The magistrates wishing to hear the circumstances,

Jane Pitcher, wife of prosecutor, was called, and deposed to missing the money from her dress pocket, in her bed room. on the day in question, at one o'clock, having seen it safe earlier in the day.

Ann Moon, who lives in the same house as the last witness, said she had had prisoner's sister to and fro to the house to nurse her child. On the morning the money was missed at about nine o'clock, she saw the prisoner in the passage making towards the door; a man was at the door with some wood, and she took it voluntarily and carried it up stairs; she then left the house.

Other evidence of a similar description having been given, the magistrates sentenced her to a week's imprisonment, and then to be confined for three years in a reformatory.

ROBBERY AT A BROTHEL.—A man named Farncombe, who stated that he resides at Wivelsfield, charged MARY PENNINGTON, a street walker, with having robbed him of £27 and some silver, on Thursday evening. According to the evidence of the prosecutor he had taken a small legacy on Thursday morning, and afterwards indulged too freely in libations to the "jolly God," and being flush of money, and *flushed* with liquor, he fell in with the "naughty woman," who decoyed him to her lodgings. He had not remained long with her when all at once she started up, and fairly bolted out of the room. Prosecutor involuntarily thrust his hand into his pocket, and discovered that he was eased of his cash. He immediately commenced a pursuit, and passed two men on his way out of the house, and succeeded in coming up with the prisoner, when he gave her into the custody of a policeman, but none of his money was found upon her. The girl now denied ever having seen the prosecutor, and as he appeared to have been very drunk, and unable to point out the house where he lost his money, the Magistrates discharged the prisoner, but not without expressing their belief that she was the guilty party. The prosecutor was told by the Magistrates that he must put up with the loss, as a reward for his folly.

CROSS-SUMMONSES BY LADIES.—*Mrs Mary Smith* summoned *Mrs. Harriet Leper* and *Mrs. Susan Taylor* for an assault, and they in their turn summoned *Mrs. Smith* for a similar infringement of the laws. Mr. Davenport-Jones represented Mrs. Leper and Mrs. Taylor. The parties, to use the words of the advocate, are all "fish women," and Mrs. Leper and Mrs. Taylor are sisters; they are also partners in business, the one carrying the tray and the other pushing the barrow. There seems to have been a jealously in connection with professional affairs existing between them for some time, and matters came to a climax, when they met at White Rock, on Saturday the 29th ult. Sundry civilities were exchanged and sundry bows, and then there was a race for the office of the Magistrates' Clerk for the "taking out" of summonses. — The Bench fined Mrs. Smith 10s. and costs £1. The others were dismissed.

FEMININE PUGNACITY.—*Louisa Thomas* (21), a prostitute, was charged as follows :—P.C. Henry Voke saw the prisoner about eleven the night before with her bonnet and jacket off fighting another female. She was also making use of very bad language. He took her into custody, and "conveyed" her to the station—that was he had to drag her. She kicked and bit on the road. She got his finger into her mouth, but he "did not leave it there long enough for her to bite it." He didn't charge her at the station with an assault as she did not hurt him much.—In reply to the prisoner the constable admitted he tore her sleeve out of her frock, but it was done in consequence of her resistance. — There had been a previous conviction against the prisoner for the same offence, for which she suffered one month's hard labour.—She was now fined 10s. and costs.

An assault case from a Hastings newspaper, 1861; and the court case of a Brighton prostitute who, in July 1854, kicked a man so violently she broke his leg.

She had once placed the girl naked in a coal cellar with very little food, and another time had left her naked in the wash-house, where she threw buckets of ice-cold water over her 'until her breath seemed stopped'. She also beat the child severely. Mrs. Smithe served just two months in prison, a far lesser sentence than that meted out for theft.

Many assault cases were dismissed if magistrates thought there was provocation, or fault on both sides. In one such case Mrs. Gany Bowley was charged with assaulting Elizabeth Bachelor in 1854. Magistrates heard that while teenager Miss Bachelor was lodging with Mrs. Bowley, she became pregnant by Mr. Bowley, a gentleman in his sixties. In reply to a question put by the mystified magistrates, Miss Bachelor said 'I went to his bed because he persuaded me to do so'. One day Mrs. Bowley sent for Miss Bachelor and, calling her a 'good-for-nothing strumpet', took hold of her nose and screwed it around. The magistrates remarked that Miss Bachelor's conduct had been 'scandalous', and dismissed the case.

Perhaps the strangest case of assault by a woman upon a member of her own sex was that committed by Mary Ann Hudson upon Lydia Wood. Magistrates in Brighton heard that Mrs. Hudson helped to support her family by fighting for gain. Her husband, a woodcutter, proudly advertised that she would fight any female 'for a half-gallon' (of ale) and that 'neither size, weight nor age was restricted'. A Mrs. Stephens took up the challenge and Mrs. Hudson's entourage cleared a taproom in the *Hereford Arms*, the chosen battlefield. After the chairs and tables were put out of the window 'in order to give Mary Ann free scope to exhibit her pugilistic talent', the landlady, Lydia Wood, appeared and immediately ordered all parties off her premises. Mrs. Hudson then assaulted her. She 'slipped into Mrs. Wood, "moused" her under the right "ogle", and planted a "hot 'un" on the "kisser"'. She was fined 2s 6d.[9]

Another unusual case concerned Robert Roper and Eliza Gibbs. In 1850 Miss Gibbs, a streetwalker, picked up Mr. Roper on Brighton beach at midnight and they went to his first floor front room at 47 Kensington Place. At this point, an independent witness heard Mr. Roper shouting at Miss Gibbs, 'Give me the sovereign you robbed me of.' He locked the door, and she opened the window and shrieked, 'Murder!' At this point either he pushed her out, or she jumped out or, in the tussle, she fell out, sustaining multiple injuries. The magistrates believed Miss Gibbs and fined Mr. Roper £5 plus costs or, in default, three months in the House of Correction.

Sometimes a prostitute was assaulted by the wife of a client.

Magistrates, ideologically supporting the family, sided with the wife. One day in 1858 a 'girl of the town' called Louisa Ogburn – described by the press as 'a fine young woman' – was sitting on a sofa at her dressmakers in Chichester when Mary Ann Liffe charged into the shop, flew at her, scratched her face and tore her bonnet to pieces. In court Mrs. Liffe said that Miss Ogburn was 'a bad character living at a notorious old bawd's' and accused her of 'always trying to seduce my husband away from his allegiance'. She was given a very small fine, just 2s 6d plus 8s costs. At the *Queen's Head Inn*, Fishmarket, Hastings, in 1864 prostitute Ann Taster was viciously attacked by Ann Casey, sustaining two black eyes and a badly swollen face. When the magistrate heard that the victim had spent the afternoon 'consorting' with the defendant's husband, he fined Mrs. Casey just 5s, because she had suffered 'great provocation'.

SUICIDE

Although attempting suicide was a crime, mid-century Sussex newspapers reported a suicide on average every other week. Methods favoured by women included taking oxalic acid, laudanum or arsenic, hanging themselves – usually at home from a bedpost or beam – drowning themselves in the sea, a pond or a well, and cutting their own throats or wrists. One Arundel woman managed to kill herself by sitting with her head in a saucepan of water, having previously failed to succeed by cutting her throat.

Sarah Budd, of Warningcamp, near Arundel, got herself into debt. One day in 1839 she went to her husband's workplace and, pretending he had sent her, collected his wages. She used them to repay the debt, then, terrified of the violence she knew he would inflict upon her when he found out, she bought arsenic and killed herself. In 1845, prostitute Elizabeth Duval, who was living in sin with (and cruelly treated by) her lover, tried to hang herself from a beam in a toilet in Union Street, Brighton. When she was found in the nick of time and cut down by a fisherman she begged God to forgive her sins.

Some women pre-empted death by starvation by killing themselves. One, 25-year-old Harriet Rogers, drowned herself in Shoreham Harbour in 1850 after having failed to find work as a domestic servant for 12 months.

Some suicides were very young. In Hastings, Charlotte Nickerson tried to kill herself in 1860 after being seduced, made pregnant and abandoned by James Douglas. She was 15. In 1841 Abigail Sale of Lamberhurst committed suicide at the age of 14 by drinking a 3oz bottle of laudanum,

which she had bought for 2s. She was found dead in her grandfather's garden. The reason for her suicide seems to have been her parents' objection to her courtship with a much older man, but the verdict of the coroner's jury was that of insanity. The youngest suicide discovered during this research was a 12-year-old domestic servant in Lindfield who cut her throat in her bedroom soon after being caught stealing from her employer.

HOMICIDE

While suicide was much more prevalent amongst men, women greatly outnumbered them as killers. In the mid-19th century a small number of Sussex women killed their husbands and a very large (but unknown) number killed their children.

Mary Ann Plumb was born at Westfield around 1800, the daughter of agricultural labourers. She went into domestic service at Coghurst Farm and became pregnant by Richard Geering, a farmhand, while still a teenager. After a forced marriage at Westfield Church, the couple set up home at Harmer's Cottages, Guestling, and had eight children during their 30-year marriage. Both were volatile characters and they were always arguing. Mrs. Geering found it difficult to submit to a husband's authority and had once asserted 'No man will rule me!' After many years of poverty, frustration, violence and unhappiness, Mrs. Geering subjected her husband to repeated arsenic poisoning until she had killed him. Thought to be a victim of heart disease, he was buried without a post-mortem. Mrs. Geering applied for and received the appropriate sickness and death benefits from the Guestling Friendly Society.

She then carried out the same procedure on her 21-year-old son, then on his 26-year-old brother. After their deaths, she began to poison her 18-year-old son. When the boy became ill, surgeon Frederic Ticehurst became suspicious and had him removed from his mother's care, whereupon he recovered. The police and coroner were notified, the three bodies were exhumed, and Mrs. Geering was arrested. Described as a 'quiet looking country woman', she claimed to be 'as innocent as my Almighty Creator' when indicted on three counts of murder and one of attempted murder. However, after being found guilty she confessed. Her execution at Lewes in 1849 was witnessed by 4,000 people.

Public executions were believed to act as powerful deterrents to others but, three years later, 27-year-old Sarah Ann French poisoned her husband in the village of Chiddingly. She, too, was hanged at Lewes in front of a couple of thousand people. Geering and French were the last Sussex

women to be hanged.

In 1853, during a drunken quarrel in their squalid one-room dwelling in Harold Mews behind the *Horse and Groom* in St Leonards, Sarah Smith (née Taught) stabbed her husband with a broken cheese knife. She was sentenced to 10 years' transportation; however, due to her ill-health the Secretary of State allowed her to stay at Lewes Gaol infirmary until she was well enough to make the journey. She died there in 1854.

While most serious assaults by women were upon the men with whom they lived, occasionally there was an example of extreme violence being directed towards other women. Mary Hutchings, better known as 'Nut Polly', a drunken beggar, was charged in 1870 with the manslaughter of Sarah Wilkins, a woman who got her living by selling rabbit skins or, when she had none, by begging. The two were lodging in the *Ship Inn*, East Grinstead. One night Nut Polly got drunk and smashed Miss Wilkins on the back of the head two or three times, because 'I catched her in bed with my old man'.

Women also murdered children. One woman – unnamed – walked into the sea at Hove with her 14-month-old child tied to her, killing both herself and her child. In one strange case, 20-year-old Lucy Miles threw her two-year-old nephew over a 105-foot cliff at Rottingdean in 1868. There being no apparent motive, Miss Miles was sent to a lunatic asylum.

One Brighton woman accidentally killed a small boy. Christiana Edmunds, who lived with her elderly mother at 16 Gloucester Place, had a brief romance with Dr. Beard, whose surgery was opposite her lodgings, at 64 Grand Parade. Miss Edmunds became obsessed with the doctor and decided to murder his wife by poisoning her with a box of strychnine-laced chocolate creams. However, Mrs. Beard spat out the first chocolate and said she felt ill. Dr. Beard's suspicions caused Miss Edmunds to attempt to show that somebody else was responsible for the poisoned chocolates, in the hope of regaining the doctor's affection.

To this end she began a campaign of discrediting the chocolate creams sold by J. G. Maynard (39-41 West Street). She purchased some strychnine from local chemist Isaac Garret (10 Queens Road) on the pretext of killing stray cats. She stood from time to time at the corner of Cranbourne Street and West Street and hired boys to call at Mr. Maynard's and buy chocolate creams for her. She inserted poison into the chocolates, and then asked the boys to return them, saying she had changed her mind. Miss Edmunds purchased so much poison that, to allay suspicion, she also hired a local milliner to buy some on her behalf, as it had to be signed for.

Soon Mr. Maynard began to receive complaints from customers who found that his products made them ill. Then, in June 1871, Sidney Miller, a four-year-old boy on holiday in Brighton, ate some of the poisoned chocolates, which had been bought for him by his uncle as a treat. He died in agony. At the inquest the jury returned a verdict of accidental death.

Miss Edmunds began to send poisoned food parcels to prominent people and, cunningly, reported receiving such a parcel herself. At this point Dr. Beard told police of his early suspicions and Miss Edmunds was arrested. While initially charged with attempting to murder Mrs. Beard, she was eventually tried at London's Old Bailey for murdering Sidney Miller. Found guilty and sentenced to death, she made a desperate attempt to gain a reprieve, by claiming to be pregnant, but this was proved false. Her mother testified that there was madness in the family and Dr Maudsley* pronounced that Christiana was indeed insane. Her sentence was commuted to life in an asylum and she was sent to Broadmoor, a prison for the criminally insane, where she died in 1907.[10] Miss Edmunds was universally hated, and an effigy of her was burned at the Cliffe Bonfire in 1872.

A famous and puzzling murder case connected with Brighton concerns Constance Kent, born in 1844, who was suspected of killing her three-year-old half-brother at their home in Somerset when she was 16. Suspicion fell on each member in the household in turn, but none was charged. The mystery was reported all over England. Miss Kent moved to Brighton in 1863, found work as a probationer nurse at St Mary's Home for Penitent Prostitutes,† and asked to be received into the church and confirmed. The Reverend Arthur Wagner was troubled that she has once been suspected of murder and invited her to make confession. The next day, the Reverend and the female Superior of the home presented Miss Kent to the Chief Magistrate at Bow Street, together with a written statement of guilt that was not in Miss Kent's handwriting. At her trial in Salisbury Miss Kent quietly pleaded guilty but, in accordance with the rules appertaining at the time, she was not allowed to speak in court and was sentenced to death unheard. When sentence was passed, Miss Kent burst into a violent flood of tears, sobbing aloud. There followed a public outcry; even the Home Secretary considered the verdict unsafe.

There were no witnesses at the trial and the Reverend Wagner had

* Dr Henry Maudsley (1835–1918), after whom London's famous Maudsley Hospital was named.
† Some sources say she was a paying guest.

refused to repeat what Miss Kent had told him, because this 'could not be given without violation of the seal of confession.' This caused a 'storm of rage' during which:

> The Sisters of St Mary's Home, and even ladies attending the church, were insulted and pelted with stones. Abuse and vituperation of the most vehement character were heaped upon the devoted priest, who himself did not escape acts of physical violence. The whole question of sacramental confession was brought into prominence, and discussed with irreverence and blasphemous freedom in every tavern.[11]

The Sisters of St Mary's Home were also abused by mobs in the Brighton streets and the Reverend Wagner even had a gun fired at him. Because of her age Miss Kent's death sentence was commuted to life imprisonment in Millbank Penitentiary. During her imprisonment she made mosaic panels for the Chapel of the Bishop of Chichester, for the floor of the north chapel of St Katharine's Church, Merstham, and for the sanctuary of a church in East Grinstead. After twenty years she was released and left England forever, joining her brother in Australia where, under the name Ruth Kaye, she worked as a nurse and in education for wayward girls. She died, aged 100, in 1944.

The case has fascinated people ever since, mainly because many believe that Miss Kent was innocent. At first, a ballad was written about her, which included the lines 'To the dirty closet I did him take/ The deed I done caus'd my heart to ache / Into the soil I did him thrust down / Where asleep in death he was quickly found'. The famous Charles Spurgeon preached a sermon about her in London in 1865. Three years later, Wilkie Collins wrote his now famous novel *The Moonstone*, inspired by the case. Miss Kent's story was recently televised in a programme called *A Question of Guilt: Constance Kent*. The story's appeal has even crossed the Atlantic: Cecil Street wrote a book called *The Case of Constance Kent*, which was published in New York in 1928, and in 2002 an exhibition at Brooklyn Public Library centred on 'the enigmatic figure of Constance Kent'.

INFANTICIDE

The most common serious crime of women was the murder of unwanted babies. Infanticide, defined as a mother killing her child before it reached 12 months of age, was a capital crime until 1938; nevertheless, parish registers all over England have for centuries recorded baptisms of bastard children followed shortly afterwards by burials. As has been explained previously, deaths of illegitimate infants were disproportionately high, and coroners did not investigate them with any care. Illegitimate children were more likely than those born in wedlock to enter workhouses at the expense of parish ratepayers and so the death of one was of little concern to the authorities.

In 1864, the illegitimate infant of a servant, born on the floor of her squalid room above Frances Hope's beer-shop in Hastings, died of head injuries. The coroner and the jury accepted the claim that the child had 'fallen on its head during delivery' and a verdict of accidental death was swiftly returned. In 1870 the Hastings coroner merely issued a caution to a Mrs. Birt and her young daughter, even though it was obvious that they had suffocated the girl's unwanted child at birth.

Having an illegitimate child so devastated the lives of unmarried women that many thousands committed horrific acts out of sheer desperation. Some of them induced miscarriage by the administration of various substances, and some women died as a result. Others gave their infants to a 'baby farmer', who killed it for them at a fee of about £10, customarily paid by the father of the child.

Other women, often domestic servants, would hide both pregnancy and birth, and then abandon, expose or kill with their own hands the newly born child. The sufferings of these women, many of whom were mere teenagers, can scarcely be imagined. Filled with shame, anguish and anxiety, and in an era in which women were kept in complete ignorance of the functions of their bodies, they gave birth, alone and terrified, in their employers' kitchens, basements, attics, or in outside privies, unattended by doctor or midwife, while having to maintain silence, despite the pain. After enduring such a horrendous ordeal they would deal with the mess, and somehow dispose of the infant and the afterbirth, all without being caught.

Some women died during the procedure. Elizabeth Ball, a 47-year-old housekeeper at 3 East Ascent, St Leonards, gave birth to a child on the floor of the kitchen in the basement, killed it, then died of haemorrhage while trying to remove what she thought was the placenta but which was, in fact, the child's twin.

The Sussex press proliferated with sickening stories of dead babies being found in woods, ponds, beaches and privies all over the county throughout the Victorian era. The practice was known as 'child-dropping' and some reports were rather gruesome. Occasionally, tiny bodies were hidden within the fabric of a house, for example under floorboards or behind walls. One described an infant found in two parts – one half stuffed down a privy, the other in a stew-pan in the house in King's Road, Brighton. In 1853 five infant skeletons were discovered in a house in Ditchling that was being remodelled by a new occupant. They had been hidden within two chasms in the walls each side of a fireplace. Suspicion immediately fell upon the previous inhabitants: James Gatland, his 40-something daughter Harriet – who had two illegitimate children – and a teenaged youth who lodged with them. However, there was insufficient evidence and no prosecution entailed. In Woolbeding in 1837, a tramping woman, described as 'heavy with child', was seen entering a shrubbery. Some weeks later the remains of a newborn child, mutilated and decomposed, were found there.

It will never be known exactly how many 'dropped' infants were successfully concealed in the woods, the sea, at the bottom of wells or deep in the countryside. A survey of the newspapers of Hastings and St Leonards between 1850 and 1870 revealed that an average of two infants a year were found 'dropped' – a shocking statistic for such small towns. In 1858 one was found in a well; in 1859 two were left on the beach within a few weeks of each other, a third was discovered in Eft Pond on the West Hill, and a fourth – a well-dressed and well-nourished three-month-old boy – was found 40ft down a well at the rear of 7 Cross Street. At this point the coroner announced with considerable concern that this was the sixth such case in just 18 months – then another was washed up on the beach opposite Pelham Place. Another was discovered in a basket in a hedge in Deudney's field and, as it was clear that the infant had been killed deliberately, a £50 reward was offered, publicised on posters all over the county – with no result. During the icy winter of 1860 a newborn baby was found completely frozen on the path from Tackleway to the East Hill. In 1863 one baby was 'dropped' behind a toilet seat in Hastings station and another was found drowned in a stream at the bottom of Newgate Wood, sewn neatly and tightly into a dress-lining. A third was discovered lying by a gate leading to the rear of 11 Magdalen Road. The marks on its neck and 'other indications of unnatural treatment' led the coroner's jury to return a verdict of 'wilful murder', but in most cases the child was said to have been

'found dead' even when it was obvious that it had not died of natural causes. At an inquest into the death of an infant discovered by a beach scavenger in a WC near the Fishermen's Church in 1864, the surgeon could not say whether or not the child had breathed. The coroner advised the members of the jury that if they believed that the child had been born dead, the case could be closed. The jury swiftly gave the desired verdict. In 1866 a baby girl was found strangled on the Castle rocks, and another was found in a hedge in Stonefield Road, wrapped in a copy of the *Daily Telegraph*.

In none of the cases mentioned above was the perpetrator traced. If a woman was caught, she would be delivered into the hands only of men – police officers, surgeons, counsel, judges, jurors, and magistrates – who rarely asked about the father of the child. This state of affairs incensed an anonymous correspondent to a local paper to put forth a point of view rarely heard – that of unfettered rage against the fathers. The letter also criticised the double standard that welcomed male fornicators into respectable society while ostracising and condemning the women that they had seduced and abandoned. The letter is reproduced on page 202. While juries did not condone infanticide, many sympathised with the women's desperation and were reluctant to return verdicts of murder, because of the extreme sentences judges would be compelled to give.

Unmarried housemaid Hannah Moore became pregnant in February 1851 while in the service of the Duchess of St Albans at 5 Grand Parade, St Leonards. Subsequently she was housemaid to the Reverend Abercrombie Gordon, of St Andrew's Presbyterian Church, West Hill Road. Miss Moore lived in the minister's house, which adjoined the west end of the church. Here, she gave birth in secret on 15th November. On 28th, a coroner's jury of 18 men viewed a tiny, lifeless body at Mercatoria Police Station. At the inquest at the *South Saxon Hotel*, Grand Parade, the jury heard from 16-year-old Catherine Pulford, of 6 North Street, who lived with her grandparents. There were two tiny houses in their back yard and all three dwellings shared a privy. The yard gate opened into Victoria Passage, which connected North Street to Shepherd Street.

One dark evening Miss Pulford saw a bundle of clothing stuffed inside the privy. Her grandparents called Constable Barnes, who pulled out the body of a baby, sewn in a cloth, wrapped in a lilac apron, with a glass cloth twisted tightly round its neck. Police enquiries led to Hannah Moore, who denied all knowledge. However, after a placenta was found in the presbytery's water closet, a local doctor recalled seeing Miss Moore when she was three months pregnant and had asked him for an abortifacient.

Miss Moore submitted to a doctor's examination and admitted that the baby was hers. Labour had begun at 3am, but she had worked until 1pm. She gave birth in her room at 1:30, cut the placenta with scissors, bound a cloth around the child's mouth, strangled it with thread and a glass cloth, wrapped it in her apron and hid it in a box under the bed. She placed the placenta in the water closet and returned to her duties. No one noticed any change in her behaviour. Over the weekend the cook even shared Miss Moore's bedroom but suspected nothing. Four days after the birth Miss Moore took the infant's body to Victoria Passage and hid it inside the Pulford's privy.

The jury consulted for just five minutes before returning a verdict of 'wilful murder'. While awaiting trial at Lewes Assizes, Miss Moore told her nurse that she had not intended to kill the baby 'but by some irresistible impulse she couldn't help it'. Miss Moore was so ill that she was held in the gaol infirmary until March 1852. At the trial she pleaded not guilty but the jury found her guilty of murder. The judge ordered them to reconsider, and after a further 50 minutes' deliberation the twelve men returned a verdict of 'guilty of concealment of birth' but 'not guilty of wilful murder' since they were 'not certain of the prisoner being in complete possession of her faculties at the time'. She was sentenced to two years with hard labour: a lenient sentence compared with that given in a similar case in Surrey in 1859 in which a 19-year-old rape victim was sentenced to death for infanticide.

Many other servants were known to have killed their illegitimate babies. In the Hastings newspapers there were eight local cases between 1852 and 1865. Sarah Judge, a 17-year-old servant at White Rock Brewery, killed her baby in 1852 by cutting its throat with scissors. Emma Sutton, a 15-year-old fisherman's daughter, was kitchen maid at an eating house at 8 Robertson Street. One day in 1858, while dining with the rest of the staff, she visited the water closet where she gave birth to a child and strangled it with a piece of string she was using as a garter, before quietly returning to her duties. A petition for leniency was submitted to the authorities. The petitioners cited her extreme youth, her lack of a mother and her having been too overcome to offer any defence. In the event, she was found not guilty of murder and only guilty of concealment of birth. At Lewes Assizes she received six months with hard labour.

In 1860 Caroline Martin did killed her 'infant female bastard child' at 4 Carlisle Parade. After secretly giving birth in her employer's house she pushed part of a steel crinoline hoop into the baby's throat then placed the child in her wooden servant's box at the foot of her bed. Another servant

heard gurgling and although found alive the child later died. Miss Martin was found guilty of wilful murder and sent to prison for four years. Some press cuttings relating to this case can be found on pages 200-201.

In the absence of evidence of deliberate killing, juries had no choice but to return verdicts other than infanticide, as the following cases illustrate. In 1860 Mary Ann Looker, the cook at 79 Marina, St Leonards, gave birth in secret. She wrapped the baby in muslin, placed it in a small wicker basket and put that into her carpet-bag in the servant's hall, where it lay, undiscovered, for a fortnight. Miss Looker was found guilty only of concealment of birth, because the coroner accepted her claim that the baby was stillborn. She died while awaiting trial.

In 1861 servant Eliza Thomas, of 6 Castledown Avenue, Hastings, killed her baby and hid it in her servant's box, nailing down the lid. She then left her employer and returned to her family home some miles away. By the time the body was found it was impossible for the coroner's jury to return any verdict other than 'found dead.' Miss Thomas escaped with just one month in prison for concealment of birth. The following year, a laundress in St Leonards exposed her baby and let it die but, again, the coroner had insufficient evidence to prove it was born alive and no charges were brought. In 1865 servant Ellen Cornford, of 58 George Street, Hastings, killed her newborn child, wrapped it in the sleeve of a black alpaca dress and 'dropped' it in West Street. The surgeon deposed that the child had breathed, and a black alpaca* dress with a sleeve missing was found in Miss Cornford's possession. Despite this she was charged only with concealment of birth and of unlawfully disposing of an illegitimate child, for which she served just one week in prison.

All the above cases occurred in the Hastings area between 1850 and 1865. Even more infants were 'dropped' in Brighton, but to catalogue dozens more stories similar to those listed above would serve no purpose.

The discovery of dead infants all over Britain peaked in the 1860s. They were so common that an Act was passed in 1867 stipulating that they must be conveyed to the nearest public house and the Secretary of State offered a £50 reward for information leading to the arrest of any woman responsible.

Women found guilty of infanticide faced four years' imprisonment but, as we have seen, many cases were reduced to 'concealment of birth' and the women sentenced to just a few weeks or months in prison. Many felt these sentences were too lenient. Among them was Hastings Police Superintendent Glenister, who wrote in 1860:

* A glossy cotton or rayon and wool fabric.

If this most serious crime were more severely punished it would be of less frequent occurrence and I do not think that the sympathy of some (perhaps well-meaning) persons towards offenders of this class has a good effect upon those who are likely to commit such a crime.

His advice was not heeded; on the contrary, punishments seem to have become lighter, judging by two cases from 1874. In the first Jane Furner, a 19-year-old cook at 14 Markwick Terrace, Hastings, killed her newborn boy and locked his body in her servant's box in her attic bedroom. Local magistrates, having heard the surgeon's evidence that 'he had not the slightest doubt' that the child was born alive and had been strangled, found her guilty of wilful murder. The second case was almost identical: Keturah Holter, aged 35, a servant at 2 Warrior Square, St Leonards, admitted strangling her newborn child with an apron string and hiding the body in a drawer. She too was found guilty of murder. Both women were sent for trial at Lewes Assizes where, amazingly, both were cleared of the murders they had admitted and were instead found guilty of concealment of birth, for which they each served sentences of just a few months.

After serving her sentence, a woman convicted of concealment of birth or infanticide was usually unable to return to her previous life. Saddled with a ruined reputation, her prospects – both with regard to matrimony and employment – were severely reduced, if not totally destroyed. This drove many to take the only course open to them: a life of prostitution and, frequently, of crime and alcoholism.

The only reference found to male involvement in infanticide was during an affiliation case brought in 1840. Mary Parker, aged 22, cited Charles Theobald, a livery servant, as the father of her child. Mr. Theobald, who claimed to be just 17 years of age, had written to Miss Parker, 'I hope you won't forget to tell the nurse not to bring the child into the world, for you know what a burden it will be to us.' Just before entering court he told her that 'it had no business to come to this', alluding to his instruction to destroy the baby at birth. When her solicitor asked, 'Would you have her throw it over the Pier and murder it?', Mr. Theobald replied, 'If I have to keep it I shall do something of the kind with it.' He was bound over to keep the peace in his own recognizances of £20 and was ordered to pay 2s 6d a week towards the support of the child.[12]

CONCEALMENT OF BIRTH AT WORTHING.—*Susan Tullett* (20), domestic servant, for attempting to conceal the birth of a child, of which she had been delivered, by secretly disposing of the dead body of the same, at Worthing, on the 22nd February.—Mr. Lumley Smith prosecuted; Mr. Burford Hancock defended.—Prisoner had been in the service of a Mr. Heaver, whose daughter, noticing a change in her appearance, and suspecting what had happened, instituted a search, and found the dead body of a child under the prisoner's bed. It appeared that the prisoner had made provision for the child, but told her mistress that she had been delivered prematurely.—Mr. Burford Hancock, in addressing the jury, contended that there had been no concealment of birth within the meaning of the statute.—The jury acquitted the prisoner.

A SIMILAR OFFENCE.—*Betsy Ann Grayling* (20), servant (on bail), was indicted on a precisely similar charge, at Battle, on the 14th July.—Mr. Merrifield prosecuted; Mr. Grantham defended.—In this case, prisoner, who lived in the service of Mr. Mannington, of Battle, as cook, had repeatedly been taxed with being in the family way. She had, however, always denied it, but finally the suspicions of her mistress, Mr. Mannington's niece, were excited. She closely questioned the prisoner, and the latter then showed her the dead body of a child concealed under the bed.—This child, according to the evidence of Mr. Roger Duke, surgeon, had breathed, he having placed the lungs in water, when they floated.—In answer to his Lordship, Mr. Duke said, however, that the test he applied was an unerring test of the child having breathed, but not that it had breathed after it was born.—Mr. Grantham, for the defence, contended that the prosecution had not proved any concealment on the part of prisoner.—The jury found the prisoner guilty, but recommended her to mercy.—Two months' hard labour.

SERIOUS CHARGE AND VERDICT OF MANSLAUGHTER AGAINST A SERVANT

We are sorry to be called upon to record the perpetration of a crime of an unnatural character, in one of the most respectable parts of this usually quiet and orderly borough. The facts of the case are shortly these: - a female servant at No. 4, Carlisle Parade, named Caroline Martin (and who was unknown to have been enciente until two days previously), was delivered of a female child early on the morning of Friday last. When her condition became known, surgical assistance was obtained and it was found the mother had placed the infant in a common clothes box. The babe was rescued from death by suffocation; but there is reason to suppose that its unnatural parent had endeavoured to deprive it of life previously by strangulation and also by forcing some object – suspicion pointing to a piece of steel hoop, such as used for expanding a certain article of feminine apparel – down the little innocent's throat, which produced two wounds, and no doubt was the ultimate cause of death.

Above and overleaf: cuttings relating to the case of Caroline Martin, a Hastings domestic servant, who was sentenced to four years' imprisonment in 1860.

INFANTICIDE.

SIR, - Society — Hastings society — has been somewhat moved at this case of Caroline Martin, now a convict. This instance having come to light, has afforded an opening to talk on the subject, and many and various are the 'says' one has heard ; but among them all — neither in *this* case nor in any of the undiscovered ones — have I heard the query, *'Who is the father of the child,?'* and yet this is a most important question ; for I do not, I cannot believe that any woman in this country would destroy her infant (though illegitimate) if she had the sympathy and support of the father of that child.

It is just because *he* is a sneak and a coward — because *he* is so mean as to leave her to her trouble — so selfishly debauched as to care for only the gratification of his own passions — so cowardly as to shirk any part of the burden — so dastardly as to add *his* contempt to that of the world, - it is because of this that such murders do take place ; and, therefore, *whoever* the father of such 'slaughtered innocents' may be. He is not only a villain and a coward, but *accessory* to the murder ; as *he*, and, mark you, he only, might have prevented it. If any such should read this, and have still any manhood left in them, I hope they will ponder its truth.

A striking contrast to this cowardice is the courage so constantly exhibited by women who have been convicted of infanticide. Without exposing or even naming those whose villainy has made them criminals — without trying to include *them* in the crime (though probably the crime itself may have been *suggested* by the man) — without uttering a complaint against *them* — these have borne the trial, the contumely, the punishment in silence. This is courage, if nothing else. I don't believe our 'fashionable' men would have souls large enough for this.

Society, too, had no need to put its dear self in a flurry and wonderment at such murders, unnatural as they may be. You, Sir, know, *it* knows, that a seducer or debauchee, is not repudiated by this said society ; nay, the veriest rake is admitted into respectable (?) society, and society's charming Arabella — Belindas don't refuse to be caressed by such, though they know them to be the companions of common prostitutes. But when a girl has fallen, then society is indignant ; and in excess of modesty and virtue (!) I suppose it perhaps may be, kicks her and her child, too, to the streets — to starvation — anywhere ; and *pretends* to wonder why such should, in dread of all this, conceal her infant's birth, and, to save her own social, if not natural, life, destroy that. This is an old tale, I know ; one often told, but a true one, still.

It is a hypothetical mockery to talk severely of child-murder, *while* the partner of the first crime goes unscathed. It is adding injustice to misery to punish *that* severely, *until* society demands vigorously chastity in *men* as well as chastity in women.

And it is not a stupid, sanctimonious farce to jealously exclude from public balls, soirées, &c., some females of somewhat tarnished reputation, *while* the partakers of their iniquity are admitted, courted, and honoured? Sure I am, if these are good enough to associate with, the others are not too bad.

Hastings is not exactly the purest place under the sun, at least one would sincerely hope not. The first evil, here, is disgustingly open or badly concealed ; and, unless some great alterations takes place, we shall have no right to wonder if the place should become notorious for infanticide.

Yours, &c.,

April 4, 1860 ONE OF THE 29TH

SINGULAR CHARGE OF CONCEALMENT OF BIRTH. — On Wednesday, *Susan Nicks*, 35, the wife of Mr James Nicks, a well-known political (Conservative) agent in this town, was charged with concealing the birth of a child. Her husband, through misfortune and affliction, has been an inmate in the Workhouse Infirmary for nearly two years; but prisoner had been lodging recently with two of her children at the house of a person named Wood, in Hanover-street. About six weeks ago she left the house, but retained possession of the key of the room. Perceiving, however, a bad smell in the place, the landlord opened prisoner's room door and in a pail in a cupboard found what appeared to be the remains of a child. Mr Penfold, Surgeon to the Borough Police, said the contents of the pail were the body of a full grown child, but in such a state of putrefaction and decomposition that the sex was not distinguishable. He believed it had been born about two months; and from appearances of things in the room he believed some woman had been confined there. He had also examined the prisoner, who had made a statement in reference to her being unwell and having kept to her room a few days before she left the house, to the effect that a vein in her leg had burst, and he was certain that no vein had burst during that time. She had, he said, enlarged veins, and there was a scar on her leg, but it was a very old one. Prisoner also stated that the daughter of her landlady was taken ill about two months ago, on, as she alleged, a false plea of dropsy, and, to meet this insinuation, Mr White (the Chief-Officer of Police) produced a medical certificate proving that Wood's daughter had been suffering from dropsy. After being twice remanded, to complete the case, prisoner was yesterday fully committed to take her trial at the next Assizes for concealment of birth.

Concealment of birth in Brighton in 1868.

ABORTION

Abortion was illegal but widespread. No instance was found in Sussex of a woman being charged with procuring an abortion. This is hardly surprising, since if the act were successful it would not come to the attention of the authorities. If it went wrong, and treatment was sought, the doctor or nurse might not report the matter. The following examples are the only two references to abortion in Sussex found during this research.

In 1850, agricultural labourer William Alcorn of Rotherfield, a married man in his 30s, was charged with attempting to procure a miscarriage. Women were ordered out of the court while evidence was heard that was deemed 'unfit for publication'. The newspapers did report, however, that Mr. Alcorn gave his 19-year-old pregnant mistress Elizabeth (surname not published) six grains of chloride. When it made her ill, he said that he would rather have the child born and affiliated to him than have her harmed. Although the judge could have transported him, owing to his previous good character he received just three years with hard labour.

In 1868 Brighton stonemason Richard Chapman was sued for divorce on the grounds of cruelty. His wife Elizabeth, the mother of six children, said she was in bodily fear of his violence, while Mr. Chapman stated that she 'condoned it'. As well as being habitually violent, he had asked her to procure an abortion and 'on her refusal he threw her violently on a sofa'. He also 'called her filthy names, because she had shown a tumour on her knee to a medical man; making his meaning quite clear that he insinuated her conduct to be that of an infamous character.' [13]

WOMEN AS VICTIMS

Of the crimes that came to court, the commonest committed against well-off women was theft, either by burglars or, more often, by their own domestic servants. The most common crime committed against poor women was undoubtedly assault by their husbands.

Violence was common in Victorian marriages, particularly among the working classes, where drunkenness played its part and social niceties were lacking. Within working class communities it was to a degree tolerated. Violence in middle or upper class marriages was probably less frequent, and incidents were, in any case, kept hidden because publicising such behaviour would have been regarded as bringing a family into disrepute.

By far the most common cases of assault against women heard by Sussex magistrates were perpetrated by men against their wives or, to a lesser extent, their girlfriends. In a single issue of the *Hastings & St Leonards Chronicle* (2 October 1858) there are three such cases. In one, Mr. Sinden had been unemployed for two years, during which time his wife had, 'by her own industry, supported him, herself and their three children'. In return, she 'had received the greatest abuse and ill-treatment from his hands.' It was his custom to spend his wife's earnings upon drink, and then to go home and physically hurt her. During the incident that led to the court appearance, he had 'taken her by the hair and continued to beat her until some neighbours rendered her assistance'. He even openly threatened his wife in court when given six months' imprisonment.

The second case concerned a Mr. Maplestons who, in 'mad fits of intoxication', would hurl at his wife's head 'anything he could get hold of'. He was bound over in sureties to keep the peace. In the third case a man called Selves struck his girlfriend Emily Baker so hard across the head that she was left insensible and 'suffering from hysterical convulsions'. The magistrate declared it 'a most unjustifiable and cruel assault upon a weak young woman', adding, 'We feel it our duty to protect females'. Fining Mr. Selves 20s he remarked that this was 'lenient'.

One of the most extreme cases occurred in 1852. George Terry, a Brighton coffee-house keeper, dealt his wife two violent blows to the head with his fist, pressed her throat with his hands and then struck her three violent blows with a poker, only ceasing when blood gushed from her head. He was charged with attempted murder.

Money was a frequent battleground. In one case in 1868 George Ruff, a basketmaker, wanted £80 that his wife had saved from her earnings prior to marriage. Having taken £54 of it he demanded the rest, in accordance with his rights under coverture. When she refused he struck her. He told Brighton magistrates: 'A man must not be annoyed!' and suggested that they would have done the same in his position. He was bound over in sureties to keep the peace or, in default, to serve two months in prison. 'They will be the two happiest months I ever spent,' he retorted; however, he paid the sureties.[14]

The domestic violence that came to court was surely the tip of the iceberg. Physical attacks on wives by husbands were not treated by any of the parties concerned as straightforward criminal assaults. Complex emotional, social and financial considerations muddied the waters. A wife had two legal remedies: she could prosecute her husband for assault and battery or apply for a court order binding her husband over to keep the peace. For financial reasons, most poor wives did not want their husbands sent to prison, because they depended upon his wages to support the family. Nor did they want them to be fined, for the burden would fall upon the wife to find the money out of her housekeeping, which was often already stretched to the limit. Battered wives preferred, therefore, to apply for an order. Magistrates would usually bind the man in sureties of about £20 for six months. If he re-offended in that period he could be sent to gaol.

If a working class woman fell short of being the model of the ideal wife (as defined by the middle classes) she might not get any sympathy from magistrates. A case in Brighton typifies the attitude held by the average bench. John Welch was charged with a violent assault upon his wife, who had borne him nine children during their 28-year marriage. She brought the case because she had had enough of his 'habit of knocking her about and kicking her'. She stated that she did not want him sent to prison, but sought the protection of the magistrates; doubtless she was expecting them to issue him with a warning and bind him in sureties. Mr. Welch said he struck her because she was 'an everlasting drunk'. She replied that she drank 'a little ale' only because of his ill treatment. The magistrates evidently thought that any woman who drank alcohol did not deserve the protection of the law, because they immediately discharged the case, 'advising the wife to give up drink and attend to her husband, and the husband to give up ill-using her.'

One cause of marital strife was the husband's consorting with prostitutes. Many wives became jealous and angry about the time and

money husbands spent on 'street-girls' while neglecting their families. In 1859 George Money, a travelling harp-player living at the *Derby Arms*, Union St, St Leonards, was arrested for assaulting his wife Elizabeth. Mr. Money had brought a prostitute home and ordered his wife to 'pretend he was a single man'. When she refused he struck her in the face leaving her with a black eye and covered in blood from her nose and mouth. Mr. Money then walked out, leaving his wife penniless and hungry. The couple lived in abject poverty but, when arrested, Mr. Money was treating two prostitutes to a meal out. The two girls waited outside the court for Mr. Money but he did not emerge; he had begun two months with hard labour. The Mayor, calling the assault 'disgraceful and unprovoked', took pity on Mrs. Money and even gave her 2s 6d out of the Poor Box, remarking that she was 'a deserving object'.

Maria Taught of Hastings refused to sleep with her fisherman husband because he used prostitutes. She shared a bed with their children. One night he rolled in at midnight, drunk, and ordered her to his bed. When she declined he threw her bedclothes on the floor and threatened to throw her and the children out of doors 'as he had before'. Seizing his wife by the hair he hauled her out of bed, smashing her head against a wooden box, and then dragged her round the room by the arm and hair, striking her several times, while she screamed and struggled. He smothered her screams with a pillow, tore off her nightdress, spat in her face and raped her. She had him summonsed to the magistrates' court, and displayed a night-dress torn to shreds, and a great clump of hair that he had wrenched from her head. The magistrate expressed disbelief that her screams brought no assistance, but a neighbour gave evidence that he had heard 'scuffling' for a considerable time. Mr. Taught claimed that his wife had 'drunken and idle habits'. Upon hearing this, the magistrate remarked that there were 'faults on both sides' and fined Mr. Taught just 5s plus costs.

HARTFIELD.—HIGHWAY ROBBERY.—On Monday last between two and three o'clock in the afternoon, as the female servant of Mrs. Payne, Bolbrook farm, was returning home from a shop in the village, she was stopped on the Turnpike road, near the Long bridge, by two villains, who demanded the contents of her basket, and her money ; but being told that the former was salt which in truth was sugar, they declined insisting on that article, and took from her all the money she had, which was a sixpence that had been given her a few days previous. The fellows ran off by way of the fields.

ASSAULTS AND MURDERS

This first murder within the scope of this study occurred in 1831. John Holloway of Brighton was 18 when he met 31-year-old Celia Bashford, a dwarfish servant with a malformed head. He said he was 'ashamed to be seen with her until after dark'. Nevertheless, he made her pregnant and the Town Overseers locked him up in Lewes Gaol for five weeks until he agreed to marry her. The baby arrived stillborn and Mr. Holloway felt himself trapped in a futile marriage. While spending four years away on Blockade Service (tracking smugglers) he met and bigamously married Ann Kendell. They returned to Brighton and lived at 7 Margaret Street, while his first wife Celia lived with her sister in nearby Cavendish Street. In July 1831 Mr. Holloway enticed Celia, with her belongings, to a rented house at 11 Donkey Row, off Edward Street. She was eight months pregnant.

In his own words: 'I asked her to sit down on the stairs and then in the pretence of kissing her I passed a line around her throat and strangled her.' His other wife emerged from the shadows and helped him to hack off Celia's head and limbs. They dropped these in the outside privy of their home in Margaret Street, and placed the torso in a trunk, which they buried in the woods near Lover's Walk. However, it was found and Mr. Holloway later pleaded guilty to murder and bigamy. He was hanged and Celia's remains were reburied at Preston Church. The case came to be known as the first 'Brighton Trunk Murder'.

Thanks to a verse written by journalist Thomas Brett, we know that a woman was murdered about 1834 in the mews behind the *Albion Hotel* in Hastings:

> In a timber-yard of Ball's – now Albion Mews
> One "Mud-Jack's" wife some brute did badly use
> Whose lifeless form as seen by morning light
> Had undergone ill treatment in the night
> A fallen creature was that "Mud Jack's" wife
> Yet God alone should take away life.

In 1837 the body of an 'unfortunate, depraved female' known as 'Portsmouth Poll'* was discovered at her residence at Broyle Road, Chichester. Her throat had been cut 'in a dreadful manner' and a razor was

* She was the third 'Portsmouth Poll' to emerge during this research. The nickname appears to have been applied to any prostitute who came from that area.

lying nearby. She was buried in the yard of the cathedral, and the crime was mentioned by many vicars in that week's Sunday sermons. Charles Horne was later charged. He had lived with the woman, named only as Harriett, above Turner's beer shop, while her husband was away at sea. Harriett, who was about 23, had told people she intended to bestow her sexual favours on another man. The verdict of the case was not traced, but Mr. Horne must have been acquitted because in 1844 he prosecuted Jane Holt for calling him a murderer and spitting in his face. She served 14 days in gaol.*

Julia Johnson and her husband came from Dublin and set up home at 80 Nottingham St, Brighton, a neighbourhood described by the police as 'the chosen resort of tramps and vagrants'. The Johnsons ran a common lodging-house in which tramps were their main clientele. Both were heavy drinkers. Mr. Johnson, a devout Roman Catholic who attended church regularly, was said by neighbours to be a 'good-tempered and kind-hearted man'. Despite this, he killed his wife and was committed to trial for wilful murder.†

Elizabeth Mann died in 1839 after nine years of violence from her husband, landlord of the *Bedford Shades*, Brighton. The coroner's inquest concluded that, although she died of natural causes, her death had been accelerated by years of ill treatment by her husband. At the time of her death he was in Lewes Gaol as a consequence of earlier violence towards her. Despite her injuries, in his absence she continued to run the pub while single-handedly raising six children.

One night in 1853, Westbourne Common beer-shop keeper Emery Spriggs held a party. When it ended at 04.30am, he took a double-barrelled shotgun from above his fireplace and discharged it at his wife. When the parish constable called later that morning he found

> The unfortunate woman lying in the passage and her brains scattered all over the floor. Spriggs himself was smoking his pipe in a doggedly composed manner, and unhesitatingly acknowledged the fact of the matter, and gave himself up.[15]

Mr. Spriggs was transported for life.

In 1863 Mary Ann Day, a 45-year-old mother of eight, died at her home at 14 Rock Street, Brighton, after eating a mince pie laced with

* On her release Miss Holt went on a drinking binge, was arrested for being drunk and was sentenced to seven days' imprisonment.
† The outcome of this case could not be traced.

arsenic. Her boyfriend was William Sturt, a profoundly deaf, 46-year-old house painter. Mr. Sturt was wealthy; she was destitute. He promised to look after her and her family if she would marry him and on that basis she cohabited with him. Her family claimed that Mr. Sturt killed her with a poisoned penny mince pie he had bought from a Kemptown pie shop, and that he did so to avoid the marriage. Others suspected that Mrs. Day was given arsenic by one of her daughters as they ate bread and drank gin together.[16] *

There were two murders of women in Brighton in 1866. The first was committed by Captain John Leigh of the Royal Navy. He was the son of the American consul stationed in Brighton, and had fought as a soldier in the Crimea. Known as 'Mad Leigh', it was said that he routinely treated his wife in a brutal fashion, and had thrown her out of their home. While he was in prison (for violence) his wife moved in with her sister, Mrs. Harriet Harton, 26-year-old landlady of *The Jolly Fisherman* beer-shop at 35 Market Street. Mrs. Harton had advised her sister never to see Captain Leigh again. For this reason he entered beer-shop one night and shot Mrs. Harton through the head with a six-barrel revolver. He fired a second shot as she ran out of the room, crying, 'He has killed me. He has killed me' before she fell down the cellar steps. Four bullet wounds were found in her corpse. Captain Leigh was found guilty of wilful murder and executed. [17]

The second murder was committed by a doctor called Warder, who secretly administered, over a period of a month, large quantities of the poison aconite to his wife. She became ill and her brother, a local surgeon, suspected that her husband was not dispensing the correct medicine to remedy the mysterious illness. When Mrs. Warder died, another doctor considered the circumstances to be so irregular that he refused to sign the death certificate. A coroner's inquest, held at *The Rockingham* public house in Sillwood Street, heard that aconite had been found in the body. Dr. Warder booked himself into *The Bedford Hotel*, where he committed suicide by drinking prussic acid. Staff found his naked body in bed the following morning. It transpired that he had been married twice before, and that each of his wives had died in unnatural circumstances.[18]

Most assaults and murders of women were committed by men known to them, but occasionally a woman was attacked by a complete stranger. Although operating on the wrong side of the law, prostitutes nevertheless sought its protection. One who was smacked in the face and verbally

* The outcome of this case could not be traced.

abused by a man she solicited in Robertson Street, Hastings, went straight to the police. The man, having previous convictions, was sentenced to two months with hard labour. In 1854 a man knocked on the door of Mrs. King of Chichester and requested a drink of water. She obliged and, as he handed her back the mug with one hand, he used the other to smash her in the temple with a stone wrapped in his handkerchief. Luckily, her daughter heard her screams and came out. The man ran off, and Mrs. King survived.

Jane Cannon, a 56-year-old cook, had been in the service of the same family at Catherine Villa, West Hill Road, St Leonards, for 26 years. One Sunday in 1848 she was performing her duties while the family was at church. Burglars entered and during the robbery one of them – a man named Pearson – coshed Miss Cannon three times over the head. After attending the evening service at St Clement's Church he was arrested while having a beer in the nearby *Hastings Arms*. Miss Cannon died two days later.

SEXUAL CRIMES

In the mid-19th century, the concept of victim anonymity was unheard of. A single woman who was raped would have to think very carefully before she told anyone or began legal proceedings, because her loss of virginity would be broadcast in the newspapers. Virginity was very highly prized and a girl who was known to be sexually 'impure' was ruined, as far as marriage prospects were concerned. Because of this, even if she won the case, a woman stood to lose more than she gained. This may explain why the only rapes publicised, and thus uncovered during this research, were those committed against married women.

Rape posed a particular problem for the courts. Not only was there the ever-present problem of the lack of witnesses, but even consenting women were expected to put up what was termed 'coy resistance' to sex, both physically and verbally. This made it difficult to establish whether a case really was one of rape, and also it was one person's word against that of another. On balance, magistrates tended to think that a woman would not willingly engage in sex with a stranger, unless she was a prostitute, but that she might do so with a boyfriend, especially if he had offered her marriage.

In 1857, a married Irishwoman who sought temporary lodgings for a night in a low-class Brighton beer-shop was put into the same bed as the landlord's daughter. The landlord slept in the same room. In the middle of

the night he dragged her into his bed and raped her. In court, his daughter claimed that the woman had got into his bed 'willingly'. Thinking this unlikely, the magistrates sent him to gaol for two months.

In 1868, the landlady of *The White Horse Inn*, Chichester, a mother of seven children, was raped by a customer in her husband's temporary absence.*

Attempted rapes were often reported in the press. In Worthing, Frank Berry struck down his girlfriend Ellen Boxer and tried to rape her. When he could not 'gain the mastery of her' he squeezed her throat. Miss Boxer called out and a couple came to her rescue. Magistrates told Berry it was his duty to protect his girlfriend, not to insult her. He was fined 40s with 18s costs. In Arundel in 1854, a man called at a neighbour's house to borrow a pipe. The owner of the house was out and his wife was sitting by the fire. The caller attempted to force her skirts above her head, and, when she screamed and threatened him with her fire-tongs, he offered her sixpence for her sexual favours. In court he was fined £3.

Women were supposed to be kept completely ignorant of sexual matters and so, when crimes of a sexual nature were heard, they – along with children – were told to leave the court before the evidence became graphic. This of course left the victim with no member of her sex present whilst the sordid details were revealed to the court. The local press relied on two overworked sentences: 'The details are unfit for publication', and 'The evidence was too revolting to publish' to explain obliquely that sex was involved. The most explicit comment they would make was to say that the evidence was of 'a disgusting nature'. This sometimes makes it very difficult to guess exactly what the cases were about, as the term 'assault' is ambiguous.

The age of consent was 12 during the period covered by this book† and it was not unusual to find girls of 12 and 13 the victims of sex crimes. In Brighton, Thomas Welfare, a 70-year-old man, was charged with making a girl of 13 drunk before raping her. The case was dismissed, as there were no witnesses. In 1862 the minister of the Croft Chapel, Hastings, was charged with several counts of rape of his 13-year-old servant. The court was crammed with what the local paper described as the 'Cream of the East End'.‡ It was a very important case with much local interest but the

* The outcome of this was not traced.
† It was raised to 13 in 1875.
‡ An expression used to describe the working folk of the Old Town, especially the fishing community.

distressed child had to give evidence without a single member of her sex present, the magistrates having ejected all women from the courtroom. Owing to the lack of witnesses (which, in a rape case, is not surprising) the charge was reduced to 'aggravated assault' and eventually the minister was cleared. Women were also banned from hearing the trial of a servant at *The Anchor Inn,* Hastings, who was charged in 1858 with repeatedly raping his employers' nine-year-old daughter over several months. The details of the 'revolting offence' were deemed too disgusting for publication. He received six months with hard labour.

There were many more cases of sexual assault on little girls. A 21-year-old lodger attacked his landlady's seven-year-old daughter; a Worthing man aged 70 molested a five-year-old, and a 16-year-old boy assaulted an eight-year-old girl. Henry Toule, a Brighton bricklayer, was sentenced to 12 months with hard labour for raping a six-year-old girl in 1850. During a case in Hailsham in 1867, an elderly man of 73 told the magistrate that the eight-year-old girl he was arrested for indecently assaulting had undone her own clothes and asked him to carry out the act. The magistrate replied 'I don't believe one word of it …these are cases which we can scarcely believe to exist until before us'. When sentenced to six months with hard labour, he 'seemed surprised'.

One of the trials that women were permitted to hear was that of William Wood of Hastings, arrested for molesting three little girls in one week in 1860. As the girls were too young to identify Mr. Wood, he was discharged. However, when he left the court he was followed by 'a crowd of the élite of the Fishmarket (feminine gender) who give him the credit of having previously occupied himself in an equally disgusting manner'.[19] Mr. Wood's fate at the hands of a mob of furious fishwives was, unfortunately, not recorded. Roger Kennet, a St Leonards butcher, sexually assaulted a seven-year-old and exposed himself to her nine-year-old sister. The girls in this instance, being older, were able to make a positive identification and he received six months' hard labour.

A 60-year-old hawker in Brighton (described by the newspaper as 'An Old Beast') was summonsed in 1868 for indecently assaulting his own 12-year-old daughter. In evidence her sister, aged 19, testified that he had done the same to her when she was 11. He was sent to gaol for six months with hard labour – the maximum sentence.[20] To put this punishment into context, it is worth noting that on the same day the same magistrates sentenced a 17-year-old youth to the same penalty for stealing a small brass ornament from a shop front.[21] Similarly, in 1855 a Hastings man, seen by

two witnesses to indecently assault a four-year-old girl, was fined £1 or one month hard labour in default while, in comparison, in 1852 Sarah Ann Burden, aged 18, served six weeks with hard labour – the final week in solitary confinement – for stealing two pairs of boots.

Cases involving sexual assault resulted in light sentences or acquittals so often that the editor of the *Hastings & St Leonards News* was provoked to write,

> Magistrates and juries have a wonderful sympathy with many male ... offenders and pass some strange sentences at times ... when the evidence is strong enough to prove a criminal charge (of rape for instance) the jury prefer convicting on a lighter charge to avoid apparently the infliction of a heavier penalty. This is a false mercy to society as well as a gross injustice to the woman. The consequence is that beasts in the shape of men take less trouble to control their passions and violent assaults on women in defenceless circumstances are numerous enough to disgrace a country pretending to be civilised and religious. It would be well sometimes for jurymen to remember that they have wives daughters sisters and friends of their own ... [22]

The outcome of a case involving sex depended on the perceived moral status of the victim. For example, when a man was fined 15s for 'annoying females by approaching them and uttering obscenities', the magistrate remarked that 'it was bad enough to annoy unfortunate girls (prostitutes) in this manner but respectable women must be protected from such conduct.'[23] Another man was acquitted of rape the instant the court heard that the unmarried victim had not been a virgin at the time of the attack.

The only case found in which women were implicated in a sexual assault upon one of their own sex involved Ann Lewis, aged 30, and Elizabeth Brown, aged 15. In 1845 they 'did feloniously and maliciously aid and counsel a man, whose name is unknown, to make an assault upon a girl aged between 10 and 12 years'. Both were transported 'for the term of their natural lives'. As the facts of the case were 'totally unfit for publication' we are left to guess the exact nature of this incident. Most likely, the two had procured the child for the purposes of prostitution, and supplied her to the man. Ann Lewis may have been a brothel keeper and Elizabeth Brown was perhaps a prostitute. Judging by the phrasing and the severe penalty, the likelihood was that they locked the girl in a room with the customer or may even have physically restrained her while the assault was committed.

THOMAS STENT, a hair dresser, residing at 39, St. James's-street, who stood remanded from Saturday, was charged with committing a felonious assault on Ellen George, a girl 13 years of age, who had been in his service about three weeks. The offence was alleged to have been committed on Saturday se'nnight, and repeated on Tuesday. Mr Dempster attended on behalf of the prisoner, and called witnesses to invalidate the testimony of the prosecutrix.—The prisoner was committed for trial on the capital charge.

Victor Cope, 62, a Frenchman, charged with assaulting Madeline, his wife, and threatening to do her some bodily injury, was placed at the bar. The prisoner had just paid the penalty of 12 months imprisonment for want of securities, for similar brutality, notwithstanding the forgiving and even affectionate conduct of his victim. Articles of the peace exhibited by the wife were put in and read, and the prisoner was ordered to find sureties, himself in 50*l*., and two in 20*l*. each, or four in 10*l*. each, or in default to be imprisoned for the term of two years.—The prisoner, in default of sureties, was committed.

James Allwright, 42, butcher, was charged with assaulting Maria Creed. The prosecutrix exhibited articles of the peace against him, with whom she had formerly cohabited as his wife, in which were detailed a series of persecutions and assaults of the most aggravated description, by which she had not only been severely punished and injured bodily, but in consequence of the persecuting visits of the prisoner had, in addition, lost her situation, and being compelled to seek medical assistance in the County Hospital. She therefore prayed that the prisoner might be compelled to enter such sureties as would protect her life against him.—The prosecutrix, an interesting looking young woman, habited in deep mourning, went into hysterics after she had sworn to the truth of the articles exhibited, and was obliged to be removed out of court.—The prisoner was ordered to find sureties, himself in 20*l*., and two in 10*l*. each, or in default to be imprisoned for the term of two years.

Two cases from Brighton Magistrates' Court in the 1860s.

References

[1] Brent, C., (1993) *Georgian Lewes*. Colin Brent Books, p70.

[2] *Hastings & St Leonards Chronicle,* 17 November 1851.

[3] *Hastings & St Leonards News,* 6 May 1851.

[4] *West Sussex Advertiser,* 7 September 1861.

[5] *Hastings & St Leonards News,* 20 October 1849.

[6] *West Sussex Gazette,* 17 May 1857.

[7] *Brighton Gazette, 27* March 1860.

[8] *Ibid.*

[9] *Brighton Gazette,* 1 July 1865.

[10] Thanks to Richard Witts. www. hedweb.com.

[11] Project Canterbury: (1933) *The Rev. Arthur Wagner.* The Catholic Literature Association, London.

[12] *Brighton Herald,* 27 April 1840.

[13] *Eastbourne Gazette,* 26 February 1868.

[14] *West Sussex Advertiser,* 27 April 1868.

[15] *West Sussex Advertiser,* 15 Jan 1854.

[16] *Ibid.*

[17] Thanks to Richard Witts. www. hedweb.com.

[18] *Ibid.*

[19] *Hastings & St Leonards News,* 27 May 1860.

[20] *Brighton Gazette,* 26 February 1868.

[21] *Ibid.*

[22] *Hastings & St Leonards News,* 21 August 1863.

[23] *South Eastern Advertiser,* 20 January 1872.

Lewes House of Correction, 1857

EMANCIPATION

IMPROVEMENTS IN WOMEN'S LEGAL STATUS, 1832-1870

During the period covered by this book various pieces of legislation were passed affecting women's rights, much of it in their favour.

1832 First Reform Bill. This extended the vote to men who owned or rented property worth an annual rate of £10 or more (about 18% of the adult male population). It introduced the word 'male' into suffrage legislation for the first time.

1839 Infant and Child Custody Act. This allowed women who were divorced or separated but who had not been proved adulterous to apply for custody of children under seven. Custody of those over seven always went automatically to the father.

1857 Matrimonial Causes Act/Divorce Act. This established secular divorce in England. The new law provided that (1) a court could order maintenance payments to a divorced or estranged wife; (2) a divorced wife could inherit or bequeath property, enter contracts, sue or be sued, and protect her earnings from a deserting husband; (3) a man could secure a divorce on the grounds of his wife's adultery. For women, a husband's adultery alone was insufficient grounds.

1867 Second Reform Bill. This doubled the electorate by extending the vote to almost all working men except agricultural day-labourers. An amendment by John Stuart Mill to include women was overwhelmingly defeated.

1869 An amendment to the Municipal Franchise Act enabled women ratepayers to vote for local municipal councils. Such women formed up to a fifth of the municipal electorate.

1869 Women were allowed to stand for Poor Law Boards, and thus to become Poor Law Guardians.

1870 Education Act. The first step towards compulsory and free education for all children. The Act established local School Boards. These took control of most schools and opened new ones. Children had to attend school from the age of five to 13, by which time they should have reached a certain standard of basic education.

1870 Elementary Education Act. This enabled all qualified rate-paying women to vote for members of School Boards, and enabled any woman to stand.

1870 Married Women's Property Act. This mandated that women could keep their earnings and could inherit personal property and small amounts of money. Everything else (whether acquired before or after marriage) still belonged to their husbands·

4: EMANCIPATION

Although we may have been led to believe that women in Britain were perfectly content with their lot and made no protests about male power during the first half of the nineteenth century, this reveals more about the processes of 'selective history' than about women's activities.

DALE SPENDER [1]

Modern day readers may ask: 'Why did women put up with being treated so poorly in the 19th century?' The answer is threefold. First, the vast majority of people accept and adopt the customs of the society into which they are born. This is true of both sexes and all eras, worldwide. Order in society depends on people swimming with the tide. And that is exactly what happens, in most cases. Conditions of life in the past perhaps seem worse to us, looking back from the enlightened 21st century, than they did to those who were accustomed to them and knew no better way of life. John Burnett, a professor of social history, has remarked on the labouring classes' 'uncomplaining acceptance of conditions of life and work which to the modern reader seem brutal, degrading and almost unimaginable', an observation that could apply equally to women.

Secondly, most women realised they could do nothing to change the system. Not only had it prevailed for centuries, but all women were excluded from its decision-making processes. The only woman within the system who had any great influence was Queen Victoria, a vehement opponent of women's rights. A working woman who was dissatisfied with the status of women had no access to any method of airing her beliefs, let alone the time to campaign for change. She could do little but scrub the floor more vigorously or beat the carpet harder to vent her annoyance.

No doubt some women did make certain personal life choices for feminist reasons – the decision to stay unmarried, for example – but unless she published her reasons, we have no evidence of individual women's intentions or feelings. The educated speculations of others are enlightening. Richard Jeffries, writing in the 1870s, stated that he believed that many young mothers in rural Wiltshire chose to remain unmarried and to continue to work as farm labourers in order to retain their independence.[2]

Furthermore, admitting to any feminist leanings would have subjected a woman to considerable ridicule, or even to social or financial sanctions. When Sussex-born Octavia Wilberforce refused to marry, stating that she wanted instead a career in medicine, her father was so angry that he cut her out of his will.

A girl growing up in Victorian England may have felt it monstrously unfair that her brother was the spoilt darling of the family, that he had more personal freedom, a better education and could attend university, and that he inherited the family title, home, wealth, land or business. Unless she had wealth of her own, all that loomed in her future was to become a wife, living under her husband's rule, and if that didn't suit her, there was no attractive alternative. She could become a pitied old maid living on her relatives' charity, or a nun, or she could enter the job market, and try to scrape a living performing 'women's work'.

To emancipate herself, a woman needed a large private income, which brings me to the third part of my answer. Some of the women who had sufficient funds and leisure to do so published pamphlets, tracts and books criticising the status quo and suggesting various ways in which women might improve their condition.

This emancipation movement, if it may be so termed, began long before the period covered by this book. Dale Spender catalogued 37 women born before 1800 who expressed their feminist sentiments in writing.[3] In *The Feminist Controversy in England 1788-1810*, Gina Luria brought together no fewer than 44 English publications advocating women's rights, all of which were printed in the short space of just 22 years.[4] There were many more after 1810 – far too many to list here. Indeed, all the major feminist campaigns began in the 19th century, although many did not bear fruit until the 20th century. Some the women involved in these campaigns were connected with Sussex.

AN INTRODUCTION TO SOME SUSSEX FEMINISTS

The founder of the organised women's rights movement in England was undoubtedly Barbara Leigh Smith, later known by her married name of Madame Bodichon. She was born near Battle in 1827 and later her family moved to Pelham Crescent, Hastings, where she lived for 17 years. As an adult, Miss Leigh Smith built a house of her own near Robertsbridge.

Her father, a radical MP, broke with tradition by leaving her a large inheritance. In the 1850s she studied and wrote about the degraded position of women, and campaigned to remove married women's legal disabilities. She wrote books and articles, organised petitions and gave evidence to a House of Commons committee on the legal position of wives. The committee resulted in the Matrimonial Causes Act of 1857, which made divorce easier and protected the property rights of divorced women. In 1857, just after marrying Dr Bodichon, an equally radical Frenchman, she wrote *Women and Work*, in which she argued that a wife's dependence on her husband was degrading.

In 1866 she formed the first Women's Suffrage Committee, the members of which organised a petition for votes for women that was presented to the House of Commons by John Stuart Mill MP. Madame Bodichon gave speeches on women's rights all over England, and co-founded and raised funds for the first women's college in Cambridge, which later became Girton. She also provided handsomely for it in her will. After enjoying two parallel careers, one as a painter and the other as a social and political campaigner, she retired to her Sussex home. She died in 1890 and is buried at Brightling.

Bessie Rayner Parkes (1829-1925), a poet and author, lived for part of her young life almost next door to Barbara Leigh Smith in Hastings, and the two became friends. She, too, campaigned for married women's rights and votes for women, and she was particularly interested in extending women's education and employment possibilities. In 1854 Miss Parkes published *Remarks Upon The Education Of Girls*, and in 1865 *Essays On Women's Work*. After Barbara's marriage the two established (in 1858) the *English Woman's Journal*, to advance ideas on women's education and their legal rights. She opened a women's employment bureau, a reading room and a clerical school, and co-founded the Victoria Press, a printing company that employed only female compositors. After spending much of her life in London she retired to Slindon, near Arundel, in 1876.

Frances Power Cobbe (1822-1904) attended school in Brighton for two years and also lived there as an adult. A keen advocate of votes for women, and for universities to accept them, she also championed the cause of battered wives. From 1861 she produced a large number of articles and pamphlets on the plight of poor women and children. She once said of women's rights: 'Ours is the old, old story of every uprising race or class or order.'

Sophia Jex-Blake, who pioneered the acceptance of women to medical

studies and became one of the first qualified female doctors, was born at 3 The Croft (now 16 Croft Road)[5], Hastings, in 1840 and was christened in St Clement's Church. She was educated at home until leaving for boarding school at the age of eight. Three years later she and her family moved to 13 Sussex Square, Brighton.

While in the USA Miss Jex-Blake met Dr Lucy Sewell, who inspired her to become a doctor. She began to study, assisted by Dr Elizabeth Blackwell, who later came to live in Sussex.* Before long, however, her father died and Miss Jex-Blake returned to England to look after her mother.

After a while Miss Jex-Blake tried to obtain training to be a doctor, but she met with considerable obstruction from medical schools because there was huge resistance from men against female doctors. She and four others were admitted to a medical school Edinburgh in 1869 but they were repeatedly hindered by male students, lecturers and members of the General Medical Council. They tried to arrange women-only anatomy lessons but 'Certain all-powerful members of the Colleges of Physicians and Surgeons had resolved to ostracise any medical men who agreed to give us instructions.' When they tried to join the men's class, 'The same phalanx of opponents raised the cry of indelicacy'. In 1871 Miss Jex-Blake reported:

> The authorities had pledged themselves from the first to defeat our hopes of education ... The ill feeling culminated in an incident in which '...those [students] who had hitherto been quiet and courteous became impertinent and offensive; and at last came the day of that disgraceful riot, when the College gates were shut in our faces and our little band bespattered with mud from head to foot.

Under such stress, it is no surprise that she failed her exams. She eventually took her degree at Berne University and, because of a new rule forbidding the holders of foreign degrees to practise in Britain,† Sophia Jex-Blake had to be re-examined in Dublin. She became the fifth woman on the British medical register. As Dr Jex-Blake she founded the London School of Medicine for Women and set up the first female practice in Edinburgh in 1878.

In the 20th century, Dr Jex-Blake became an active member of the

* By strange coincidence, she lived just a few hundred metres from the Jex-Blakes' former residence.
† The new ruling was enacted specifically to keep women out.

women's suffrage movement. She never married, because: 'I believe I love women too much ever to love a man.'[6] In 1899 she retired to Windedene, Mark Cross, Sussex, with her long-term companion Dr Margaret Todd. She died there, aged 72, and is buried at St Denys Church, Rotherfield.[7]

Clementina Black (1854-1922), the daughter of the coroner for Brighton, was born at 58 Ship Street in 1854. She wrote her first novel, *A Sussex Idyll,* when she was 23. Later she moved to London and was friends with Karl Marx's daughter, Eleanor. Miss Black became secretary of the Women's Trade Union League, and travelled the country making speeches to encourage women to join unions. At the Trade Union Congress in 1888 she brought the first-ever resolution for equal pay for women. She co-founded the Women's Trade Union Association and when it became the Women's Industrial Council she was its President. She also became Secretary of the Women's Protective and Provident League. For twenty years she collected and publicised information on women's work, concluding that the root evil of women's employment was the low wages they received. She gave evidence to Parliamentary Committees on women's work, and passionately advocated both a minimum wage and wages boards to enforce it. She co-wrote one book, *Married Women's Work*, and wrote several others such as *Sweated Industry and the Minimum Wage* and *A Case for Trade Boards.* Clementina Black also campaigned for votes for women and was an active member of the National Union of Women's Suffrage Societies, for a time editing its journal, *The Common Cause*. She returned to Brighton in later life and died there in 1922.

Mrs. Louisa Martindale (1839-1914), a resident of Lewes, was passionate about women's rights and believed that girls should have the same educational opportunities as boys. To this end she tried to start a school for girls in Lewes, but she experienced so much opposition from the people in the town that she had to abandon the idea. She was widowed in 1875 while three months pregnant with her second daughter. In 1885 she moved to 2 Lancaster Road, Preston, near Brighton, to enable her two daughters to attend Brighton High School for Girls. Mrs. Martindale formed 'The Practical Suffragists', which became a branch of the National Union of Women's Suffrage Societies, and wrote several pamphlets on women's emancipation. As her two daughters – Hilda and Louisa – grew up they, too, took a passionate interest in women's rights and the family home in Brighton became a centre of the women's movement in Sussex. One frequent visitor was Margaret Bondfield, then a young shop girl, who lived in Brighton from 1887 to 1894. No one guessed she would one day be

Britain's first female Cabinet Minister.

Mrs. Martindale was also very interested in women's health, and was one of a group which set up a dispensary for women in Brighton. The others were her daughters Hilda and Louisa, Elizabeth Robins and Octavia Wilberforce. In later life Mrs. Martindale moved to Cheely's, a house in Horsted Keynes, from where she continued her political and missionary work. She helped set up Roedean School and raised money for the New Sussex Hospital for Women and Children in Brighton. She actively encouraged her daughters in their careers. Louisa studied medicine and became the first female GP in Brighton; Hilda became one of Britain's first female factory inspectors.

Anna Bronwell Jameson (1794-1860) lived for a short time in Brighton, moving there in 1854. Although not an activist herself she encouraged other women to form and join women's rights organisations and it was she who suggested buying the *Englishwoman's Journal* and using it as an organ to promote the ideals of the women's movement.

Eleanor Marx (1855-1898), the daughter of Karl, lived for a year in Brighton in 1872, working as a schoolteacher. She later became involved in the women's rights movement and among her many activities she worked with Clementina Black in the Women's Trade Union League.

Dame Millicent Garrett Fawcett (1847-1929), president of the National Union of Woman's Suffrage Societies for many years and probably the most influential feminist of her generation, was slightly associated with Brighton. She married the town's MP, Henry Fawcett, and worked closely with him, helping with his political work, because he was blind. She became 'for all intents and purposes, a working (if unpaid and unacknowledged) politician.'[8] Indeed, she wrote *Political Economy for Beginners* and *Essays and Lectures on Political Subjects.* Her first public speech on women's suffrage was made in Brighton in 1868.

References

[1] Spender, D., (1982) *Women of Ideas,* Pandora, p385.
[2] Quoted in Perkin, J., (1993) *Victorian Women,* John Murray, p179.
[3] Spender, D., *Op.Cit.*
[4] Luria, G., (1974) *The Feminist Controversy in England 1788-1810,* New York.
[5] Unfortunately, the plaque on the house is today often obscured by a hedge.
[6] Todd, Dr Margaret., (1918) *Life of Sophia Jex-Blake* p.65.
[7] Wojtczak, H., (2002) *Notable Women of Victorian Hastings,* The Hastings Press.
[8] Spender, D., *Op.Cit.*, p485.

APPENDICES

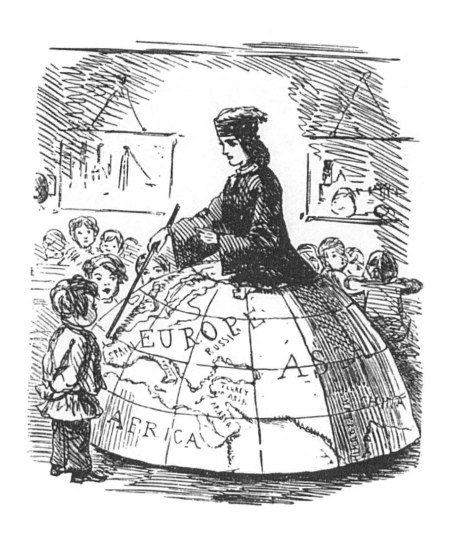

THE MODERN GOVERNESS

A Young Lady's Idea of the Use of Crinoline!

APPENDIX 1: SUSSEX WOMEN IN TRADE 1839-1855

This list includes female retailers, tradeswomen and artisans. It excludes employees, school proprietors, general shopkeepers, dressmakers, milliners and needlewomen, as they were too numerous. Plumbers, painters, glaziers, postmistresses, blacksmiths, goods carriers and farmers appear in appendices 2-6, and publicans, innkeepers and hoteliers are listed in appendix 7.

Note: 1/6, etc, denotes that 1 of the 6 persons listed in that trade was female.

Alfriston
Grocer / draper
Arlington
Farmer & Limeburner, and Limeworks)
Mrs. Mary Martin, Polhill Farm,
Alceston)
Barcombe St
Proprietor of houses
Brighton
Artificial Florists & Wax Modellers 2/6
Artists 2/13
Baby Linen and Ladies Outfitters 4/9
Bakers
Booksellers 2/50
Boot & Shoemakers
Boy's Cap Maker
Brass Founder & Gas Fitter (Mrs. Mary
Ann Smith, 18 Nile St)
Bread & Biscuit Baker
Brewer
Brush & Turnery Warehouse
Butchers
Cabinetmakers
Cane Worker
Carriers
Carver & Gilder
Cheesemonger
Chemist
Child-Bed Linen Warehouses 3/4
Children's Tennis Ball Maker
China & Glass dealer 2/18
Chiropodists 4 (Every female
chiropodist listed in Sussex was in
Brighton)
Circulating Library
Coachbuilder
Coal Merchant
Coffee & Eating Rooms
Confectioner

Corn and Flour Dealers 2
Corn Chandler
Cowkeepers
Cupper
Cutler
Dairywomen
Eating House Keepers 3/8
Elastic Stay & Belt Maker
Fancy & French Repositories
Feathermaker & French Florist
Fishmonger
French Polisher (Mrs. Eliza Cloweser)
French Shoe Dealer
Fruiterer
Furniture Warehouse
Furrier
Glovers 1/5
Greengrocers
Grocery partnership (Harriet and Mary
Ann Langley 13 Russell Place)
Haberdasher
Hosier/Glover
House Agents (4) Three of them were
Mrs. Hannah Brightwell, 22 Regency
Square; Sarah King, 41 Regency Square;
and Maria Stimpson, 45 Waterloo Street
Insurance Agent for *Pelican & Phoenix*
Ironmonger & Stationer
Juvenile Warehouse
Label Manufacturer
Lace Repairer
Lacemaker
Ladies' Hair Restorer
Library proprietor
Licensed To Let Horses, and
Undertaker
Lime Burner: Mary Bennett, 45 Middle
St
Linen Draper

Miller (Mary Vine, Church Hill)
Mourning Milliners 2
Music and Instrument Sellers
Oil & Italian Warehouse
Patent Medicine Warehouse
Plumasier
Portrait Painter
Professional Rubber
Professor of Music
Proprietor of Wood's Original Warm Baths
Ready Made Linen Warehouse
Silk Hatter
Smith & Bellhanger
Stationer
Straw bonnet makers
Tailor
Tea Dealer
Tobacco Pipe Maker (Ann Pitt 11 King St)
Tobacconist 1/14
Undertaker
Upholstress
Wardrobe purchaser
Wine Cooper
Woodcutter

Bognor & Felpham
Booksellers and Billiard Rooms (The Misses Binstead, Promenade)
Butcher & Game Dealer
Maltster (Elizabeth Cousens)

Burwash
Cabinet Furniture Dealer (Ann Manktelow)

Chichester
Baker
Bookseller
Bootmaker
Brewer
Butcher
Calenderer
Clear starcher
Clothes dealer
Coach proprietor
Corn dealer
Dairy woman
Draper
Farmers
Fishmonger
Fruiterers (2/6)
Grocer/Tea dealers (2)

Harnessmaker (Mrs. Ann Marchant)
Hatter
Laceworker
Mortgager of land
Music sellers
Painter
Poulterer
Shoe seller
Shoebinder
Shoemaker
Tailoress
Tea dealer
Watchmaker

Crawley
Butcher
Hairdresser
Tobacconist
Wheelwright (Mrs. Sarah Bex)

Cuckfield
Currier (Elizabeth Francis)
Druggist & Stationer
Hairdresser
Stationer
Tailor

Eastbourne
Baker
Billiard Rooms (Mary Heatherley)
Butcher 1/6
Druggist 1/3 (Jane Gasson)
Insurance agent, London Assurance Corporation (Miss Gosling, Seaside Road)
Toy Dealer
Vapour Baths Proprietor (Mrs. Ingledew)

East Grinstead
Confectioner
Corn Chandler
Cooper (Mrs. Elizabeth Pace)
Spirit Merchant (Ann Wilson)
Toy Dealer

Frant
Baker
Butcher
Tea & Coffee Room Proprietor

Hailsham
Baker; Chymist & Druggist; Haberdasher

Hastings (1830-1870)
Artist
Artists' repository keeper

Author
Baby linen dealer
Baker
Bathing machine proprietor
Baths manager
Baths proprietor
Berlin wool dealer
Bookseller
Bootbinder
Broker
Butcher
Cabinet maker
Carrier
Chair bottomer
Chair caner
Chair maker
China & glass dealer
Cloakmaker
Clothier
Coal merchant
Coffee house keeper
Confectioner
Corset maker
Cow keeper
Curative mesmerist
Currier
Dairywoman
Drapers
Earthenware dealer
Eating house keeper
Egg merchant
Embroiderer
Fancy repository keeper
Farmer
Feather dresser
Fish carrier
Fish hawker
Fishmonger
Fish seller
Flower seller
Fruiterer
Furniture dealer
Furrier
Fly proprietor
General dealer
Greengrocer
Hairdresser
Hatter
Hosier
Ironmonger
Juvenile warehouse proprietor

Lacemaker
Lace runner maker
Laundress
Laundry proprietor
Library proprietor
Mantlemaker
Marine store owner
Milk vendor
Newsagent
Novelist
Outfitter
Paper-flower maker
Pawnbroker
Perfumier
Printer
Professor of singing
Professor of music
Professor of languages
Pork butcher
Poultry fancier
Poulterer (licensed)
Secondhand clothes dealer
Sedan chair proprietor
Servants' registry office proprietor
Shell artiste/worker/dealer
Shrimp hawker
Slop seller
Stationer
Stay maker
Straw hat maker
Tailoress
Tallow chandler
Tea dealer
Tobacconist
Toy dealer
Undertaker
Upholsterer
Wardrobe dealer
Washerwoman
Watchmaker/mender
Wine merchant
Heathfield
Coffee & Tea Dealer
Umbrella Makers (a widow and her two
daughters)
Henfield
Butcher
Hellingly
Pedlar - 'attends fairs'
Poultrywoman
Washerwoman

Horsham
Baker
Bookseller
Boot & Shoe Maker
Confectioner
Cooper (Sarah Burgess, Carfax)
Ironmonger
Ladies' Shoemaker
Maltster
Pastrycook
Pattenmaker
Rope Manufacturer (Mrs. Harriott Lambert, East Street)
Stationer/Toyshop
Hove (Market Square and around the Market, 1845)
Four poulterers, three fishmongers, two greengrocers, a toy dealer, a tailor, and one woman who was a stationer, ironmonger and tin-plate worker (Mrs. Collier)
Hurstpierpoint
Saddler & Harnessmaker (Mrs. Jane Brown)
Lewes
Bakers
Boot & Shoe Maker
Cabinetmaker/Upholsterer
Clockmaker (Mary Hooker, 12 High St, Cliff)
Miller (Martha Weller, Southover)
Perfumer & Hairdresser (Ann Grayling, 42 High St)
Staymaker
Subscription Library (3 Albion St)
Tea dealers 2/6
Lindfield
Baker
Boot & Shoe Maker
Cooper (Sarah Burgess, Carfax)
Ironmonger
Miller (Widow Hurst, Cockhaise Mill)
Littlehampton
Ship's Chandler (Elizabeth Gales)
Ship Owner and Coal Merchant (Mrs. Mary Lawson, Surrey Street)
Midhurst
Baker
Wine & Spirit Merchant (Mary Ann Colebrook)

Petworth
Baker-Shopkeeper
Baker-Pastrycook
Baker-Confectioner
Linen Draper
Saddler (Catherine Ede)
Tailors (Ann & John Luxford)
Pulborough
Coal Dealer; Grocer/Draper;
Shoemaker
Rye
Account Book Manufacturer
Baker
Butcher
Carpenter (at Rype)
China & Glass Dealer
Corn & Seed Dealer
Eating House Keeper
Furniture Dealer
Gardener (a widow aged 64)
Gloveress
Land Agent
Lapidary
Leather Cutter
Maltster & Brewer (Mrs. Elizabeth Golden, who was also the Sub-Post Office Mistress at Ashburnham)
Miller
Saddler
Seaford
Fancy Repository
Laundress
Warm & Cold Baths Proprietor
Shoreham
Customs Agent (Sarah Kirton, who was also a publican)
Steyning
Bookseller
Storrington
Fellmonger (Rachel Hughes)
Glover
Straw Bonnet Maker
Uckfield
Bootmaker
Cooper (Sarah Gaston)
Miller (Rebecca Diplock, at Fletching)
Bookseller
Victualler
Worth
China Dealer

APPENDIX 2: LOCATION OF SOME POSTMISTRESSES, 1839-1859

Albourne, Barbershall, Beckley, Broadwater, Chichester, Cuckfield, Duncton, Easebourne, Eastbourne, East Dean, Felpham, Hailsham, Hellingly, Henfield, Herstmonceux, Horsted Keynes, Hove, Hurstpierpoint, Isfield, Laughton, Midhurst, North Chapel, Ore, Ovingdean, Portslade, Pulborough, Rye, Seaford, Selsey, Shoreham, Slinfold, Steyning, Wadhurst, West Grinstead, Willingdon.

APPENDIX 3: LOCATION OF SOME FEMALE BLACKSMITHS, 1792-1855

1792: Arundel
1828: Newhaven (also a farrier)
1839: Chailey, Barcombe, Horsham and Newhaven
1845: Preston, Findon, Framfield, Mandling, West Hampnett, Keymer, North Mundham, North Chapel, and Hornet (in Chichester).
1851: Burwash (employing two), Rusper, Waldron, Bolney St (employing two, and shown in the Census as a 'blacksmith mistress') and Warninglid (employing three).
1855: Bury (in Arundel) Felpham, West Hoathly, Poynings, Laughton,Westmarden, Midhurst, Brighton, Lindfield, Newhaven, Patching, Shermanbury, Steyning, Cowbeech and Houghton

APPENDIX 4: LOCATION OF SOME FEMALE PLUMBERS, ETC, 1828-1860

Brighton: Rebecca Vick, plumber, painter & glazier (1859)
Chichester: Harriet Cobden, plumber, glazier (1839)
Chichester: Sarah Stallard, painter, plumber, glazier (1828)
Cuckfield: Ann Knowles, 'painter, plumber, etc' (1839)
Horsham: Martha Aldridge, plumber & glazier, house, sign & decorative painter (1855)
Horsham: Widow Richardson, painter & glazier (1828)
Lewes: Elizabeth Davey, painter-plumber (1828)
Midhurst: Mrs. Martha Clare, plumber & painter (1845)
Newhaven: Ann Stone, painter & glazier (1845 & 1855)
Petworth: Mrs. Charlotte Cragg, painter & glazier (1845)
Ringmer: Mrs. Lydia Berry, wheelwright and carpenter (1845)
Rye: Mrs. Elizabeth Laurence, plumber & glazier (1855)
Walburton: Elizabeth Farnden, painter & glazier (1841)
Worthing: Widow Elliott, painter & glazier (1828)

APPENDIX 5: SOME FEMALE GOODS CARRIERS, 1830-1862

1839
Lewes to Burwash: Mrs. Eastwood.
Lewes to Seaford: Mrs. Mary Lower (still operating 1845).
Rye to Maidstone & Cranbrook: Mary Piper.
Battle to Hastings: Elizabeth Gander (still operating 1855).
Brighton to Horsham: Mary Hughes, leaving from the *Unicorn*.

Worthing to Brighton: Jane Caplin (still operating 1845).
1845
Balcombe to London: Mrs. Mary Steadman.
Battle to Rye: Katharine Hood.
Brighton to Rottingdean: Ann Mason.
Brighton to Rottingdean: Ann Hamper.
1855
Battle to Hastings: Charlotte Collins.
Hastings: Mrs. Bridget Barton (still operating in the 1860s).
Seaford to Lewes: Mrs. Ann Earl.
1859
Brighton General & Railway carrier: Mrs. Penelope Gander.
West Grinstead to Hailsham: Mrs. Emma Hoad.
1861 Sidlesham to Chichester: Mrs. Prior.
1862 Amberley to Arundel: Mrs. Mary Ratley.

APPENDIX 6: SOME FEMALE FARMERS

Elizabeth Collyer, 200 acres, employing 30, Rye. (Grazier)
Ann Chapman, 20 acres, Lower Horsebridge. (Unmarried.)
Ann Stollery, 39 acres, employing 1, Ashburnham.
Anne Newington, 115 acres, employing 6, Hazlehurst Farm, Ticehurst.
Caroline Hall, 200 acres, employing 7, Withyham.
Elizabeth Bridger, 31 acres, employing four men and a boy, Chichester.
Elizabeth Hyland, 460 acres, employing 24, Lodge Farm, Etchingham
Elizabeth Walls, 150 acres, employing 4 plus her son, Littlewort, Chailey.
Emma Preston, 104 acres, employing 6, Sinder Farm, Chailey.
Emily Catt, 230 acres, employing 6, Ringmer.
Fanny Elliott, 100 acres, employing 4, Withyham.
Fanny Hallett, 400 acres, employing 10, Arlington.
Harriet Bryder, 50 acres, employing 3 men, Chichester.
Mary Ann Andrews, 43 acres, employing 1 Labourer and her two sons, Chichester.
Mary Ann Snashell, 37 acres, employing 2, Withyham.
Mary Beard, 285 acres, employing 14, Cuckfield.
Mary Everest, Brewer & Farmer, 85 acres, Herstmonceux.
Mary Sharp, 'Farmeress', 365 acres, employing 12, Gravenhurst.
Mary Smith, 38 acres, employing two men, Chichester.
Matilda Willsher, 347 acres, employing 17, Etchingham.
Phoebe West, 36 acres, employing 2, Cowfold.
Sarah Dudeney, 73 acres, employing 3, East Chiltington.
Sarah Packham, 160 acres, employing 8, Hurstpierpoint.
Sarah Potten, 100 acres, employing 1, Heathfield.
Sarah Wickham, 100 acres, employing 16, Hurstpierpoint.
Sophia Simmons, 70 acres, employing 3, Chiddingly.
Charlotte Peters, 33 acres, employing 4 men, West Blatchington.
The Hon Mrs. Huskisson owned most of the 2110 acres that comprised Eartham, a parish near Chichester.

Appendix 7: Premises with Female Licensees

This list is incomplete because there is no central record of licensees. The information was trawled from many sources including license applications, trade directories, court reports, Censuses and secondary sources. This is of course very hit-and-miss and there are sure to be many more that were not discovered.

Brighton

From the 1862 and 1870 directories
Albion Hotel, Mary Ann Eastey
Barley Mow
Battle of Trafalgar
Brighton Packet, 8 Steine St
Bristol Hotel Shades, Paston Place
City of Brunswick, Golden Lane
Colonnade Shades
Crown & Anchor, Preston
Crown & Sceptre
Denmark Tavern, Brunswick St West
Devonshire Arms, 52 Carlton St
Dolphin, King's Road, Hove
Eight Bells, 49 West St
Fishmongers' Hall
Flowing Stream, 33 Surrey St
Free Butt, 22 Richmond St
Gloucester Hotel
Half Moon
Hare & Hounds, 75 London Rd
Horse & Groom
Kerrison Inn, 3 Waterloo Place, Hove
King & Queen, and Excise Office, Marlborough Place
King's Arms
King's Head, 9 West St
Little Globe, 153 Edward St
London Tavern & Coffee House, 131 North St
Mariner's Inn, Hove
Mason's Arms, Seymour St
Nelson Inn, Trafalgar Street
New Ship Hotel, Ship St, Sarah Pollard
North Star, 33 Brunswick Place
Northern Tavern, 40 Brunswick Pl
Pavilion Shades, 3 Steine Lane
Pilot Tavern, 51 Upper Bedford St
Prince of Wales, 1 Clarence Place
Queen's Head
Red Lion, 24 Upper Park Place
Rock Inn, 7 Rock St
Royal Oak, 36 Chapel St

Royal Pavilion Hotel, 3 Steine Lane
Royal Sovereign, 66 Preston St
Royal Yacht, 129 Sussex St
Sea House Hotel, 1 Middle St
Seven Stars, Ship St
Ship, Hove St
Spread Eagle Inn, 20 Albion Hill
Star of Brunswick, Brunswick St West
Star, 7 Manchester St
Sun Tavern, 76 East St
Thatched House, 33 Black Lion St
The Engineer, Cheapside
Telegraph, 11 Richmon Street
Tierney's Arms, 64 Edward St
Union, Gloucester Lane
Victoria, 18 Upper North St
Wellington Inn, Pool Valley
White Lion, North St
Wick Inn, 41 Gloucester Rd

HASTINGS & ST LEONARDS
1830s –1860s
Castle Hotel & Posting House, Wellington Sq, Frances Emary
Conquerer Hotel, Marina, Sarah Johnson (1841)
Duke of York, 5 Union Road, Mrs. Hill (1867)
Green's Family and Commercial Hotel, Havelock Rd, Mrs. Leeks, (later Mrs. Blamire)
Halton Tavern, Elizabeth Goodwin (1863)
Hope Inn, Halton Place, Mrs. Mary Rummons (or Rumens) (1861)
Jolly Fisherman, East Street, Mrs. James Mann
Jolly Fisherman, East Street, Mrs. Swaine (1864)
Marina Inn, 3 Sussex Road, Mrs. Helen Bennett (1862)
Prince Albert, Rock-a-Nore Road, Mrs. Rachel Pomphrey (1862; until 1865)
Priory Family Hotel, 24 Robertson Street, Mary Ann & Ellen Eldridge (1851& 54)
Provincial Hotel, 18 Havelock Road, Mrs. Montague (1869)
Railway & Commercial Hotel, 20 Havelock Road, Mary Ann Eldridge (1854 & 55)
Royal Oak, Castle Street, Ann Sargent (1825-29)
The Albert, 17-18 Undercliffe, Mrs. Ann Hutchings
The Albion Hotel, Marine Parade, Harriet Bowles (1866)
The Albion Hotel, Marine Parade, Mrs. Ellis (1869)
The Anchor, Mews Road, East Ascent, Miss Mary Ballard (1852)
The Angel, St Mary's Terrace, Miss Barbara Ticehurst (1852)
The Angel, St Mary's Terrace, Mrs. Lucy Scott (1864 - died 1866)
The Bricklayer's Arms, Bohemia Terrace, Miss Young (1853)
The Britannia, Bourne Street, Harriett Vinall (1866)
The Bull, Bulverhythe, Elizabeth Wilkinson (1833-34)
The Bull, Bulverhythe, Miss Sheather (Aug 1851-1852)
The Cinque Port Arms, All Saints' Street, Judith Wood (1828-30)
The Crown, Courthouse Street, Sarah Smith (1815-1832)

The Cutter, 12 East Parade, Mrs. Elizabeth Bell (1823-1836)

The Cutter, 12 East Parade, Mrs. Harriet Dunk

The Dun Cow, 29 Albion Street, Halton, Jane Cox (1867-before 1871)

The George, 120 All Saints' Street, Mrs. Rebecca Wood (1852 & 1854; until 1861)

The George, 120 All Saints' Street, Rebecca Furby (1833-35)

The George, 120 All Saints' Street, Sarah C. Gorley (1867&169)

The Hastings Arms, 2 George Street, Ann Sargent (1821-1824)

The Jenny Lind, High Street, Mary Robinson (1866)(until 1870)

The Lion Inn, Stone Street, Ann Bean (1865 - 1866)

The Norman Hotel, Norman Road East, Elizabeth Benton Young (1853)

The Royal Oak, Castle St, Mrs. Ann Yates (June to September 1864)

The Swan, High Street, Elizabeth Carswell (1858-1873)

Warrior's Gate Inn, Norman Road West, Catherine Pilcher (1841)

Wheatsheaf Inn, Spittleman Down, (Bohemia Terr) Mrs. Sarah Gorring (1848-52)

York Hotel, (?) 17 York Buildings, Mrs. Osborne (until 1870)

1870-1872

Bo-peep Inn, Elizabeth Payne (1871) (Also the freeholder)

Coach & Horses, East Ascent, Jane Taylor (1872) (Also the freeholder)

Commercial Hotel and Dining Rooms, Mrs. Linney (1871)

Duke of Cornwall, Post Office Passage, Charlotte Wenham (with husband)

Duke of York, 5 Union Road, Mrs. Mary Fairhall (1871)

Green's Family and Commercial Hotel, Havelock Rd, Mrs. Eliza Green

Harrow Inn, Hollington, Mary Robertson

Lord Nelson, Bourne Street, Charlotte Clarke (1872)

Plasterers Arms, South Street, Mary Ann Ranger (1872)

Prince of Wales, 9 Melbourne Terrace, Bohemia, Harriet Hayden (1872)

Provincial Hotel, 18 Havelock Road, Miss Mary Ann Montague (1871)

St Leonards Arms, 6 London Road/Shepherd Street, Miss Mary Semark (1872)

The Albion Hotel, Marine Parade, Susan Emary

The Cricketers Arms, Waldegrave Street, Mary Ann Mitchell (until 1870)

The Crown Inn, Courthouse Street, Mrs. Catherine Stride (1872)

The Globe, Meadow Road, Harriet Turner (1872)

The Hare and Hounds Inn, Ore, Frances Tritton

The Hastings Arms, 2 George Street, Mary Ann Ray, (1870-1871)

The New Ship, West Street, Frances Hope (lost license 1874)

The Norman Hotel, Norman Road East, Mrs. Elizabeth Palmer

The Stag Inn, 15 All Saints' Street, Mrs. P. Jenkins (1871)

The Tiger, 13 Stonefield Road, Mrs. Philly Jenkins

White Lion, 7 St Michael's Terrace, Mrs. Harriet Perigoe

BREWERY TAPS, LICENSED VICTUALLERS AND BEER- SHOPS.
HASTINGS & ST LEONARDS, 1840-1871

Albert Inn Beer-shop, 33 North Street, Elizabeth Cull (1861)

Alma Beer Shop, All Saints' Street, Mrs. Ann Tyril (Tyrell?) (with husband)

Beer retailer, 30 West Street, Mrs. Frances Burton

Beer retailer, 32 West Street, Frances Hope (1861)

Beer retailer, West Beach Street, Mrs. Jane Piper

Beer-house, 6 St Mary's Terrace, Jane Pilcher (1872)
Beer-seller, 1 Waterloo Place, Lucy Scott (1851)
Beer-shop keeper, 9 Lavatoria, Caroline Barnes
Beer-shop, 25 Bourne Street, Mrs. Maria Elphick
Beer-shop, 1-2 Dorset Place, Elizabeth Collins (1871) (Also the freeholder)
Beer-shop, 2 Stonefield Road, Charlotte Bourne
Beer-shop, 4 Hill Street, Mary Glyde
Beer-shop, 8 Dorset Place, Mrs. Jane Rose
Beer-shop, East Beach Street, Ann Tassell
Beer-shop, Pelham Street, Mrs. Ebeneezer Cobby
Beer-shop, Wellington Court, Martha Card (1873)
Beer-shop, West Beach Street, Mrs. Jane Piper
Diamond Inn Beer Shop, Bourne Walk, Elizabeth Pomphrey Sargeant (1864)
Fisher's Refreshment Bar, High Street, Mrs. Fisher (1871)
Fisherman's Home, 6 East Hill Passage, Ellen Lester (1872)
Licensed victualler, 3 Sussex Place, Helen Bennett (1865 & 1867)
New Inn Beerhouse, Market Place, Miss Frances Burton
Refreshment bar, 50 George Street, Miss Lock (1864)
Talbot House beer-shop, 16 Lennox St, Halton, Ann Friend, licensed victualler
The Black Horse Beer Shop, Shepherd Street, Harriet Stephenson (1864)
The Bricklayer's Arms, Bohemia Terrace, Fanny Jenks (Jinks?) (1865)
The Castle Brewery Tap, Mrs. Paine
The Castle Brewery Tap, 11 Wellington Terrace, Harriet Cheale (1869) & 1872)
The Dun Cow (or Horse), Albion Terrace, Halton, Mrs. Jane Cox (1863-1867)
The Forester's Arms Beer-house, 6 East Parade, Frances Hope
The Mackerel beer-shop, Mrs. Huggett (1856)
The Old House at Home Beer-house, 44 All Saints Street, Elizabeth Cull
The Privateer, Wellington Mews, Mrs. Helen Brazier (Sept 1851-1852)
The Railway, Gensing Station Road (now King's Road), Mary Campbell (1872)
The Sussex Tap, Mrs. Jemima French
The Swan Tap, High St, Miss Mary Rosina Willett (1861)

PUBLIC HOUSE OWNERS IN HASTINGS, 1872
Kate and Frances Burfield (11 owned)
Elizabeth Ridley
Mary Heathfield
Harriet Fisher
Mary Creasy Vickery
Ann Yates (lived in London, owned the Royal Oak)
Charlotte Mann
Mary Reeves
Mary Ann Adgo
Mary Heathfield, The Stag Inn, 15 All Saints' Street

FEMALE BEER SHOP OWNERS IN HASTINGS, 1830-1870
Mrs. Jane Harvey - Eagle, Bourne St
Mary Dowsett, Market Tavern
Mary Heathfield

Kate & Frances Burfield (owned 3, including the British Queen, North Street)
Harriet Cheale (also the licensee)
Frances Kingsnorth, 8 Castle Terrace
Eliza Lord, 32 West Street
Mary Ann Dowsett, 14 Hill Street
Eliza Collins (also the licensee)
Ann How, Prince of Wales, 9 Melbourne Place

SUSSEX PUBS WITH FEMALE LICENSEES, 1830-1870

Alciston, Barley Mow
Aldingbourne, Prince of Wales
Arundel: Newburgh Arms, Royal Oak, Swan, Black Horse, Old Ship, Windmill
Ashington, Swan
Battle, George Inn
Birdham, Hotel
Bognor: Royal Hotel, Sun, Red White & Blue, Rainbow, Sussex Commercial & Family
Hotel, White Horse, York Inn
Bolney, Eight Bells
Bosham, Black Boy
Brightling, Fuller's Arms
Burwash, Railway Tavern, Bell
Buxted, Maypole Inn
Burwash, Rose & Crown
Catsfield, White Hart
Chailey, Five Bells, King's Head
Chichester: Crown, Fountain Inn, Richmond Arms, Swan Tap, Sun Inn, Star Inn,
Wellington Arms, Unicorn, Canteen, Wheatsheaf, Star & Garter, Good Intent, King's
Arms, Three Tuns, Black Horse
Climping, Black Horse
Crawley, Plough
Cuckfield: Jolly Tanners Inn, Ship Inn
Ditchling, Bull, White Horse
Duncton, Swan
Funtington, Horse & Groom
East Dean, Selsey Arms
East Grinstead: The Ship, Swan Inn
Eastbourne: New Inn, Carpenter's Arms, Castle, Lamb, Marine Hotel, Marine Tavern,
Pier Hotel, Red Lion, Volunteer
Emsworth, Dolphin Inn
Ewhurst, White Hart
Findon, Gun
Fishbourne, Black Boy
Forest Row, Roebuck
Frant: Nevill Crest & Gun, Turk's Head
Funtington, Horse & Groom
Goring, Bull's Head
Hailsham: Black Horse, Woolpack Inn, Grenadier
Hapsted Green, Greyhound

Hartfield, Dorset Arms

Hastings – see separate list

Hawkhurst: Queen's Head, Roebuck, Rose & Crown, White Hart, Duke of York, Five Ashes, George Inn & Posting House

Haywards Heath, Queen's Head

Henfield, White Hart

Herstmonceux, Woolpack Inn

Horsham: Black Horse, Dog & Bacon, King's Head, Wheatsheaf, King's Head Commercial Inn and Posting House, Cock Inn (Southwater)

Hurst Green, Queen's Head Inn

Hurstpierpoint: Royal Oak, Station Inn, Wheatsheaf, White Horse, Bull, Fox & Hounds, Jolly Sportsman

Itchenor, Ship

Jevington, Eight Bells

Laughton: Old Bell, Roebuck

Lewes: Ship, Swan, Dorset Arms, Five Bells, Running Horse, White Hart Hotel, Lewes Arms, Brewers' Arms, Black Horse, Bear

Linchmere, Railway Tavern

Lindfield: Red Lion, Bent Arms Family & Commercial Hotel, Tiger

Littlehampton: Beach Htl, Norfolk Htl, Ship & Anchor, King's Arms, White Hart

Lurgashall, Noah's Ark

Mayfield, Royal Oak

Newhaven: Ship Inn, Bridge

Newick, Bull Inn

North Chapel, Half Moon

North Mundham, Walnut Tree

Nutbourne, Bell & Anchor

Offham, Blacksmith's Arms

Ore, King's Head

Oving, White Horse

Patcham, Halfway House

Petworth: Horse Guard, Star, Digger's Arms, Swan

Pevensey, Royal Oak

Poynings, Royal Oak

Ringmer, Railway Inn

Rottingdean, Royal Oak

Rogate, White Horse

Rustington, Windmill

Rye: George Tap, Union, Old Bell, Cinque Port Arms, Jolly Sailor, Hope & Anchor, Pipemaker's Arms, Globe

Salehurst: Queen's Head, Old Eight Bells

Seaford, New Inn Hotel

Shoreham: King's Hd, Swiss Cott, Crown, Royal Sovereign, Dolphin Htl, Schooner

Sidley, New Inn

Slaugham: Old White Horse, Old White Swan, Red Lion, Half Moon

Slinfold, King's Head

Sompting, Marquis of Granby

Southover, Swan

Steyning: George Inn, Three Tuns
Storrington: Anchor, White Horse
Tarrant St, King's Arms
Tarring, George & Dragon
Telham, Black Horse
Tillington, Horse Guards
Uckfield: Maiden's Head Inn, King's Head, Griffin, White Hart
Upper Beeding: Fox, Rising Sun
Wadhurst: Hare & Hounds, Mark Cross
Walberton: Royal Oak, Horse & Groom, White Horse Inn
Washington: Swan, Red Lion Inn
Waterbeech, Richmond Arms
West Dean, Selsey Arms
West Harting, Greyhound
Westfield, Plough
Wilmington, Black Horse
Winchelsea, New Inn
Withyham, Half Moon
Worthing: Norfolk Arms, Pier Htl, Railway Htl, Buckingham Arms, Steine Tap, Horse
& Groom, Jolly Brewers, Spaniard Htl, Marine Htl, King's Arms, Sea House Htl
Yapton: Shoulder of Mutton & Cucumbers

APPENDIX 8: CAUSES OF PROSTITUTION, BY WILLIAM ACTON

From *Prostitution, considered in its Moral, Social, and Sanitary Aspects*, 1870.

We have seen that many women stray from the paths of virtue, and ultimately swell the ranks of prostitution through being by their position peculiarly exposed to temptation. The women to whom this remark applies are chiefly actresses, milliners, shop girls, domestic servants, and women employed in factories or working in agricultural gangs. Of these many, no doubt, fall through vanity and idleness, love of dress, love of excitement, love of drink, but by far the larger proportion are driven to evil courses by cruel biting poverty.

It is a shameful fact, but no less true, that the lowness of the wages paid to workwomen in various trades is a fruitful source of prostitution; unable to obtain by their labour the means of procuring the bare necessaries of life, they gain, by surrendering their bodies to evil uses, food to sustain and clothes to cover them. Many thousand young women in the metropolis are unable by drudgery that lasts from early morning till late into the night to earn more than from 3s to 5s weekly. Many have to eke out their living as best they may on a miserable pittance for less than the least of the sums above-mentioned. What wonder if, urged on by want and toil, encouraged by evil advisers, and exposed to selfish tempters, a large proportion of these poor girls fall from the path of virtue? Is it not a greater wonder that any of them are found abiding in it?

APPENDIX 9: LIFE AS A VICTORIAN DRESSMAKER

From *The Effects of Arts, Trades and Professions, and of Civic States and Habits of Living on Health and Longevity, with Suggestions for the Removal of Many of the Agents which Produce Disease and Shorten the Duration of Life,* by C. Turner Thackrah, 1832.

Milliners, dressmakers and strawbonnet-makers are often crowded in apartments of disproportionate size, and kept at work for an improper length of time. Their ordinary hours are ten or twelve in the day, but they are confined not infrequently from five or six in the morning till twelve at night! The bent posture in which they sit tends to injure the digestive organs, as well as the circulation and the breathing. Their diet consists too much of slops, and too little of solid and nutritive food. From these causes collectively we find that girls from the country, fresh-looking and robust, soon become pale and thin. Pains in the chest, palpitation, affections of the spinal and ganglionic nerves, and defect of action in the abdominal viscera, are very general. The constant direction of the eyes also to minute work, affects these organs. Sometimes it induces slight ophthalmia, and sometimes at length a much more serious disease, palsy of the optic nerve. The remedies are obvious, – ventilation, reduction of the hours of work, and brisk exercise in the open air. The great cause of the ill-health of females who make ladies' dresses is the lowness of their wages. To obtain a livelihood they are obliged to work in excess. Two very respectable Dress makers, who charge more than the generality, state that they earn but 12s each per week, though they sew, on the average, fifteen hours per day. The seamstress who goes out to her work rarely receives more than a shilling a day, in addition to her board. Can ladies, humane in disposition, and prompt in their support of charitable institutions, reflect on the miserable hire they afford to the persons they employ, – persons of their own sex, – persons often reduced by the faults or misfortunes of others from a comfortable situation in life, and sometimes even from apparent independence, to work for daily bread?

APPENDIX 10: CORNELIA CONNELLY

Foundress of the Society of the Holy Child Jesus.

Cornelia Peacock was born in Philadelphia on January 15, 1809. Aged 22, she married a minister, Pierce Connelly, and moved to Massachusetts where he was Pastor of Holy Trinity Episcopal Church. Four years later they converted to Roman Catholicism and moved to Los Angeles. While raising a family, Cornelia tutored and taught music in the school for girls run by the Sacred Heart sisters. She gave birth to three boys and two girls. Two died in early childhood and the eldest as a young adult.

In early 1840, while grieving the death of a baby daughter, Cornelia made her first retreat, of three days. She felt herself touched by God and her life was changed. She gave herself to God, desiring to do His will. At this point her son, just two years old, was scalded in an accident and died in Cornelia's arms. From this was born in her a devotion to Mary as Mother of Sorrows.

One day Pierce told her he felt called to the priesthood. This would mean living a celibate life, away from his wife. Cornelia was pregnant with their fifth child, and urged her husband to reconsider, but said that if God asked her, she would make the sacrifice.

In 1845 Pierce was ordained in Rome. Cornelia went there with her children, intending to join the Society of the Sacred Heart. Finding no peace there, she prayed to know God's desires for her. Pope Gregory XVI asked her to go to England and found a new religious order to educate young Catholic women.

The following year Cornelia, with her two youngest children and three companions, arrived in Derby. Soon they were running a number of schools for young women of privilege as well as for working class girls. The Sisters held day, night and Sunday schools to accommodate factory workers, gave retreats, and helped in the parishes. The Society of the Holy Child Jesus had begun.

Pierce renounced both his priesthood and his Catholic faith, removed their three children from their schools and denied Cornelia all contact with them, intending to force her to return to him as his wife. He even pressed a notorious lawsuit against her, but lost the case.

In 1992, the Catholic Church proclaimed Cornelia as Venerable.

Today, Sisters of the Holy Child Jesus are an international community operating in fourteen countries and striving to live the apostolic life. They are engaged in education and related spiritual and pastoral ministries.

The Life of Cornelia Connelly 1809-1879: Foundress of the Society of the Holy Child Jesus was published in 1922.

APPENDIX 11: DUTIES OF A WORKHOUSE MATRON

To oversee the admission of female paupers and pauper children under seven.

To oversee the employment and occupation of female paupers, and to assist the schoolmistress in training the children to make them fit to become servants.

To inspect the female sleeping wards daily.

To visit the female sleeping wards before 9pm in winter and 10pm in summer, to see that all female paupers are in bed, and all fires and lights not necessary for the sick, or for women suckling their children, are extinguished.

To pay particular attention to the moral conduct and orderly behaviour of the females and children, and to ensure that they were clean and decent in their dress and persons.

To superintend the making and mending of the linen and clothing supplied to the inmates, and ensure that all such clothing was properly numbered and marked on the inside with the name of the workhouse.

To see that every pauper had clean linen and stockings once a week, and that all the beds and bedding were kept in a clean and wholesome state.

To superintend the washing and drying of all linen, stockings and blankets, and to ensure that they were not dried in the sleeping-wards or sick-wards.

To take proper care of the children and sick paupers, and to provide the proper diet for the same, and for women suckling infants, and to provide any necessary changes of clothes and linen.

To assist the Master in: enforcing the observance of good order, cleanliness, punctuality, industry, and decency of demeanour among the paupers; cleansing and ventilating the sleeping-wards and the dining-hall, and all other parts of the premises; placing in store and taking charge of the provisions, clothing, linen, and other articles belonging to the Union.

When requested by the Porter, to search any female entering or leaving the workhouse.

I am indebted to www.workhouses.org.uk for this list of duties.

APPENDIX 12: SOME CHARITIES IN BRIGHTON RUN BY WOMEN

Institution for Training Female Children for Servants.
Each child paid £21 per annum, with music £5 extra. They had to be members of the Established Church. Uniform cost £3 on admission, thence free.

Chichester Diocesan Association, 76 West St.
Trained teachers for work at parochial Schools. Two-year residential course. Fee £6 per annum, which included everything except books and stationery. Applicants had to pass an entrance exam set by government examiners.

Swan Downer's School.
Provided a schoolhouse for poor girls aged six to 12, for instruction in needlework, writing and reading, and the charity supplied two sets of clothing a year. 'The children of such parents as do not receive parish relief to be the first objects of this charity'. There were 50 girls in the school by the mid-century.

Female Penitentiary, Wykeham Terrace.
Rescued prostitutes and trained them for domestic service.

Pupil Diocesan Institution, 4 Temple St.
Trained girls to be servants.

St Mary's Hall, Kemp Town.
For educating the daughters of clergymen.

Female Orphan Asylum.
For the reception of about 30 poor, friendless children.

Servants' Friend Institution, 29½ West street.

Lying-in Institution & Dispensary.

Maternal Society.

Society for the Relief of Widows.

Hibernian Society for Female Children.

Servants' Institution, 23 Western Cottages.

Temporary Home for Friendless Girls, 36 West Hill Road.

Lewes Deanery Committee of the Society for Promoting Christian Knowledge.

Depository at the National Schools, 106 Church street.

Percy Almshouses (for poor widows), Hanover Place.

Home for Young Women, 59 West Street.

Ladies' Branch Association for the Diffusion of Sanitary Knowledge, & Preservation of the Health of Children, 21 Gloucester Place.

Brighton & Hove Girls' Industrial Home, 12 Egremont place.

Brighton Society for the Relief of Distressed Widows, 20 Middle Street.

FURTHER READING

Women's history:

Adams, C., (1982)*Ordinary lives a hundred years ago.* Virago.

Boucherett, J., (1862) *On the Choice of a Business.*

Burman, Sandra, (1979)*Fit work for women* Croom Helm.

Clark, A., (1982)*Working life of women in the 17th century.* Routledge & Kegan Paul.

Cobbe, F.P., (1869) *The Final Cause of Woman.*

Foster, D., *Albion's sisters: A study of trades directories and female economic participation in the mid-nineteenth century.* Unpublished PhD thesis, Exeter University, 2002.

Hiley, M., (1979)*Victorian working women: portraits from life.* Gordon Fraser Gallery.

Hillam, C., (1991) *Brass Plate and Brazen Impudence,* Liverpool University Press. (Female dentists.)

Holcombe, L., (1973) *Victorian Ladies at Work.* USA, Archon.

Holcombe, L., (1983) *Wives and Property.* University of Toronto Press.

Lamb, A. R., (1844) *Old Maidism!*

Leigh Smith, B., (1854) *A Brief Summary in Plain Language of the Most Important Laws Concerning Women.* John Chapman, London.

Marx, E., and Aveling, E., (1887) *The Woman Question,* London, Swan Sonnenschein.

Pennington, S., and Westover, B., (1989) *A hidden workforce: home workers in England 1850-1985.*

Perkin, J., (1993) *Victorian Women* John Murray.

Pinchbeck, I., (1981) *Women workers and the industrial revolution.* Virago.

Roberts, Elizabeth, (1988) *Women's work 1840-1940.* Macmillan.

Spender,D., (1982) *Women of Ideas.* Pandora.

Taylor, B., 'The men are as bad as their masters':socialism, feminism, and sexual antagonism in the London tailoring trade in the early 1830s. (Feminist Studies; v.6 no.1, 1979).

Tilly, L., and Scott, J.W., (1987)*Women, work and family.* Methuen.

Vicinus, M., (Ed.) (1980) Suffer and be Still: *Women in the Victorian Age.* Methuen.

Walkley, C., (1981) *The ghost in the looking glass: The Victorian seamstress.* Peter Owen.

Sussex history:

Ascott, K.,(1998) *The Education of Wadhurst.* The Book Guild.

Beswick, M., (1993) *Brickmaking in Sussex.* Middleton Press.

Bishop, J.G., (1860) *Brighton As It Is.*

Brent, C., and Rector, W., (1980)*Victorian Lewes,* Phillimore.

Brett, T. B., *Histories* and *Historico-Biographies,* unpublished, held at Hastings Library.

Carder, T., (1990) *The Encyclopaedia of Brighton,* East Sussex County Libraries

Dale, A., (1967) *Fashionable Brighton.*

Elleray, Robert, (1979) *Hastings: A pictorial history.* Phillimore.

Jenks, G.S., (1839) *Report on the Sanitary Condition of Brighton.*

Gooch, J., (1980) *The History of Brighton General Hospital.* Phillimore.

Holter, G., (2001) *Sussex Breweries,* SB Publications.

Manwaring Baines, J., (1955) *Historic Hastings.* Parsons.

Marchant, R., (1997) *Hastings Past.* Phillimore.

Musgrave, C., (1981) *Life in Brighton,* John Hallewell.

Peak, S., (1985) *Fishermen of Hastings.*

Searle, S., (1995) *Sussex Women* JAK Books.

Shearsmith, J., (1824) *A Topographical Description of Worthing.*

Thornton, D., (1987) Hastings: *A living history.* David Thornton.

Wells, R., (ed.) (1992) *Victorian Village,* Alan Sutton.

Wojtczak, H., (2002) *Notable Women of Victorian Hastings.* The Hastings Press.

Wojtczak, H., (2002) *Women of Victorian Hastings.* The Hastings Press.

Wright, J.C., (1902*) Bygone Eastbourne.*

White, Sally, (2000) *Worthing Past* . Phillimore.

INDEX

RAILWAY WOMEN
The Story of a Forgotten Workforce

Helena Wojtczak

Here for the first time is a comprehensive history of the British railway woman, charting her progress from exploited drudge in the 1830s to steam engine driver by the 1990s. Exhaustively researched and lavishly illustrated with photographs never before published, the book acquaints the reader with the women who worked in railway operating, workshops, laundries, hotels, shipping and administration. It reveals the viewpoint of managers, unions and railwaymen, and of the women themselves, to the female pioneers in a male-dominated industry. Special attention is given to their protracted quest for equality of pay and opportunity, and to those who performed traditional men's work on the railways during both World Wars.

> Railwaywomen is beautifully written from what has clearly been meticulous research. The book is a tour de force. This is a chronicle of injustice and corresponding courage, which is long overdue for the telling. It is an unbiased, academically excellent, and very entertaining work of history. The author's concern for honesty and justice shines forth.
>
> ADRIAN VAUGHAN
> Railway historian

> There has been far too little tribute paid to the women who dedicated their working lives to our railways, and too little opprobrium heaped on those who, for too many years, denied or ignored the contribution women made. This book plays a major part in telling the true story.
>
> GLENDA JACKSON MP

Hardback, 372 pages, plus 16 photographic plates. ISBN 1-904-109-047

PRICE – £24 INCLUSIVE OF SHIPPING. PUBLISHING DATE – SPRING, 2004

The Hastings Press

0845 45 85 947
PO Box 96 Hastings TN34 1GQ
hastings.press @ virgin.net
www.hastingspress.co.uk